FOLK ART

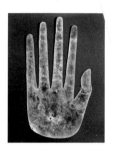

Publisher and Creative Director: Nick Wells
Picture Research: Melinda Révész
Project Editor: Sonya Newland
Designer: Robert Walster

Special thanks to: Chris Herbert, Vic Newland and Claire Walker

FLAME TREE PUBLISHING
Crabtree Hall, Crabtree Lane
Fulham, London, SW6 6TY
United Kingdom

www.flametreepublishing.com

Produced for Flame Tree Publishing by
BIG BLU LTD
mail@bigbludesign.co.uk

First published 2006

07 09 10 08 06

1 3 5 7 9 10 8 6 4 2

Flame Tree is part of the Foundry Creative Media Company Limited

The CIP record for this book is available from the British Library.

ISBN 1 84451 290 8

Every effort has been made to contact copyright holders. We apologize in advance for any omissions
and would be pleased to insert the appropriate acknowledgement in subsequent editions of this publication.

While every endeavour has been made to ensure the accuracy of the reproduction of the images in this book,
we would be grateful to receive any comments or suggestions for inclusion in future reprints.

Printed in China

FOLK ART

Author: Susann Linn-Williams Foreword: Stephen Wehmeyer

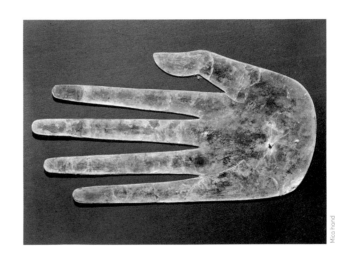

Mica hand

FLAME TREE
PUBLISHING

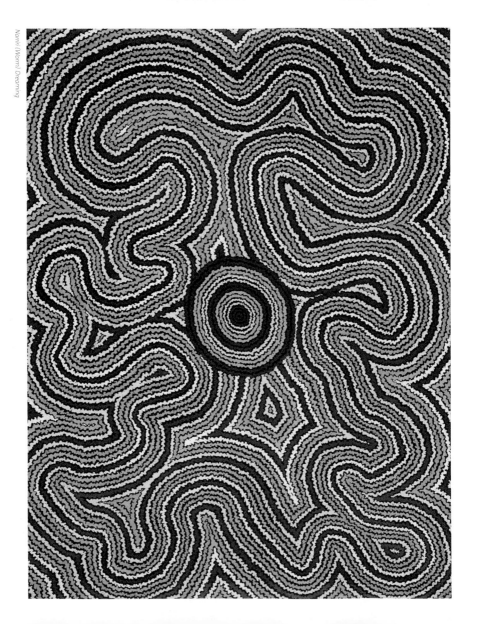

Contents

How To Use This Book 8

Foreword 10

Introduction 12

Aboriginal Art 20

Pacific Art 70

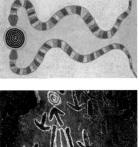
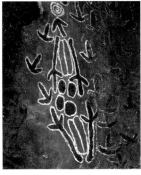
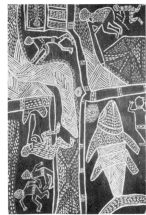

Journey of the Soul bark painting; Emu cave painting, *Snake Dreaming*

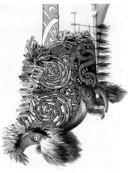
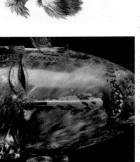
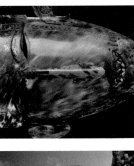

Easter Island monolithic statues; Torres Straits Mask; Maori war-canoe head

North American Art ... 150

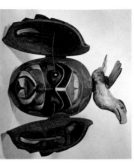

Kwakiutl revelation mask; Buffalo hunt pictograph; Inuit shaman's mask

Central & South American Art ... 238

Totonac relief from ball court; Huari discs; Mexican Day o' the Dead costume

Comparative Art .310

Algerian rock painting; Turkish embroidery; Viking church carving

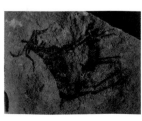

Biographies & Further Reading .378

Index by Work .380

General Index .382

How To Use This Book

The reader is encouraged to use this book in a variety of ways, each of which caters for a range of interests, knowledge and users.

- The book is organized into five sections: **Aboriginal Art, Pacific Art, North American Art, Central & South American Art** and **Comparative Art**

- **Aboriginal Art** provides a snapshot of the art of the indigenous peoples of Australia, from ancient rock paintings to twentieth-century acrylics.

- **Pacific Art** looks at the art of the peoples of the Pacific islands, from the great stone statues on Easter Island to the carvings and ornaments still created today.

- **North American Art** investigates the social and cultural significance of the diverse pieces produced by the different tribes of Native America.

- **Central & South American Art** delves into the pieces created by the peoples of Mesoamerica and South America – the ancient Olmecs, Mayans, Aztecs, Cuna, and many others.

- **Comparative Art** provides an overview of the folk art created by other world cultures, the styles and techniques used, and how they have influenced one another.

- The text provides the reader with a brief background to the work, and gives greater insight into how and why it was created.

Tlingit shaman's rattle, c. 1800s

2. Date of work
 (if known)

3. Information about
 the work and the
 context in which it
 was created

Tlingit shaman's rattle, c. 1800s

REGION
North-West Coast

MEDIUM
Wood

RELATED WORKS

1. Title of work

7. Picture credit

6. Place where the work
 was created
 (if known)

5. Medium in which the
 work was created

4. Similar or related work
 to the one shown

Foreword

The legendary 'first encounters' between the peoples of Europe and those of the four great geo-cultural regions represented in this volume are first and foremost, aesthetic encounters. Initial contact with Native peoples meant contact with their diverse material arts. The written accounts of European explorers venturing into the terra nova of Hispañola, 'Otaheite' or North Queensland abound with descriptions and images of decorated bodies, new architectural styles, and embellished clothing; of artifacts both beautiful and utilitarian; of personal adornments that embodied social prestige or sacred power. Likewise, the oral, pictorial or otherwise recorded histories of American, Oceanic and Australian indigenous peoples speak with equal wonder of the appearance, clothing, and artifacts of arriving Europeans. The Old and New worlds meet first in one another's eyes.

The ultimate effects of those mutual, world-shattering glances have not been uniformly positive. On the one hand, the Colonial fascination with indigenous concepts of beauty often led to the appropriation or theft of artifacts in the name of 'collecting' or 'preservation'. On the other, the encroaching European presence maintained a stony ethnocentricity (if not outright revulsion for Native art) that frequently resulted in the destruction of art objects (particularly those with spiritual or political significance) or the wholesale repression of Native art forms in favour of those practised by the dominant culture.

Despite this unfortunate situation, this volume stands (alongside the many other collections devoted to the arts of any one of these four regions) as a testimony to the resourcefulness, resilience, and adaptability of traditional indigenous artists, both before and after contact. Even under considerable cultural pressure from a colonial hegemony, members of these Native cultures continued to create a profusion of arrestingly beautiful objects and images in traditional styles, while at the same time adapting and developing those styles in response to a radically changing environment. Moreover, since that moment of first contact, traditional indigenous arts have profoundly and irrevocably made their mark on European popular and fine arts. The New World taught the Old new ways of seeing and making beauty.

One of the more important lessons learned from this interaction, and certainly one which informs the collection presented here, challenges those conceptions of art which characterize its processes and products as somehow separate or distinct from other aspects of human life and experience. Many of the objects presented in this book are everyday tools for the ordinary tasks and needs of life: a cradleboard, a feasting dish, a fishhook, or a pipe bowl. That such objects

are also made beautiful, that they are crafted to embody a range of human ideas and emotions, from horror to humour, suggests a core principle of these traditional arts: that a thing worth making is worth making beautiful. In the case of those objects and images that address the extraordinary facets of human life, and thus belong to the categories of ceremonial or ritual arts, we find that the aesthetic qualities of such objects are intrinsic to their function. This is art intended to do rather than to be. A Tlingit shaman's carved rattle, an Iroquois Gajihsah mask, or a Kashaya Pomo prayer basket: each is a powerful aesthetic tool for individual and communal healing, not merely a pleasing object to look at.

Another core principle of the traditional arts of Oceania, Australia and the Americas involves the intense and inextricable relationship between environment, artist and art. Each of these objects – in subject matter, media, style and execution – is intimately tied to the specific natural landscape of its production, to the sights, sounds, smells and feelings of the territory inhabited by its maker or makers. This is art that is so deeply imbued with a sense of place that it demands a visceral experience of its associated landscape in order to fully divulge its mysteries.

It is clearly, then, no easy task to survey, within a single volume, the artistic traditions of the manifold cultures and diverse topographies of Native North and South America, Oceania and Aboriginal Australia. And yet, it is vitally important that the traditional arts and artifacts of these indigenous peoples be represented in any serious discussion of World arts – but not because this inclusion will somehow accord them value or status. They have not in themselves, regardless of their place or position in the existing Eurocentric canon. We need to first affirm their intrinsic merit, and then secondarily their considerable cross-cultural impact. These are all profoundly sophisticated arts and art forms. Whatever their cultural source, we find in them a dynamic dance between realism and abstraction, a running dialogue between the marvellous and the mundane, and a fusion of the sacred and the sensuous which might seem at first remarkable, but which is normative to cultures which tend to view sacred power as immanent in the manifest world.

A collection like this one is admittedly introductory, admittedly cursory, but nonetheless it opens a powerful window through which we too can look on New Worlds with wonder and amazement.

Stephen C. Wehmeyer

Japanese Noh mask

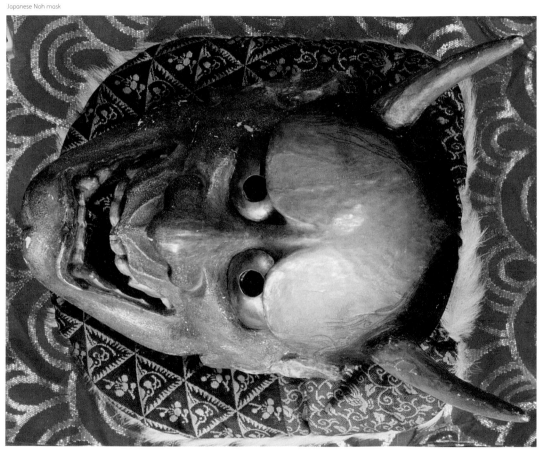

Introduction

The definition of Folk Art has grown ambiguous and in many ways controversial in recent years. In its broadest sense – the sense we have applied in making this selection – it simply means any works of a culturally homogenous people, produced by artists who have received no formal training in the art. It is intimately connected with the craft and culture of a people, and for this reason the pieces usually take on more than simply an aesthetic appeal. Folk Art is inextricably linked with the religion, beliefs, rites, rituals, practices and everyday life of the people who create it. Applying this criteria, Folk Art encompasses the traditional arts of cultures and communities across the globe, from the earliest times to the present day – anything that does not fit under the heading 'Fine Art'. From the barely discernible figures and shapes scratched on the walls of centuries-old caves, to the colourful, stylized graffiti sprayed on the railway siding – all could be considered Folk Art to some degree. And who is to say which has the greater artistic merit? Each has its own cultural significance.

Clearly, then, a book on Folk Art could be enormously diverse and weighty. We have therefore focused here on four key regions of what might also be termed 'Traditional Art'. This does not mean 'old' – some of the pieces included here have been created by artists still working today – but rather works that draw upon and reflect traditional methods, styles and beliefs of the community to which they belong.

The first great culture investigated here is that of the Australian Aboriginals. Humans settled in this region at a time when the continent was linked by land to the islands of Papua New Guinea and Indonesia. The earliest recorded presence comes from Western Australia and dates from almost 40,000 years ago. Here, the Australian Aboriginals lived a relatively isolated life, largely unaffected by outside influence for thousands of years. The Aboriginals lived in a society in which kinship and organization were the dominant factors, and where ceremonial functions, initiation rites and secret religious knowledge, passed down through the generations, were extremely important. Aboriginal mythology is largely based around the concept of the Dreaming or Dreamtime – the period of Creation, when Ancestor Beings wandered the Earth creating the landscapes, natural features, humans and animals. These beings still inhabit this world and leave their mark. Aboriginal Australian mythology cannot be separated from the art of the peoples of this island continent. Sacred artifacts such as churingas are inscribed with patterns that represent the totemic spirits of the Dreaming. Rock carvings and bark paintings, using natural pigments, show mythical creatures –

both human and animal in form. Emus, snakes, dingoes, kangaroos, and many other animals, all have their place in the Aboriginal pantheon, and are still represented in the dot paintings and acrylics of modern Aboriginal artists.

While living in relative isolation, some artistic influences found their way to the Aboriginal lands by way of the Pacific Islands. The two cultures had trade links, and slowly the beliefs – and consequently artistic imagery – began to integrate to a small degree. It is interesting, however, that the mythical and artistic influence seems to have been more pronounced moving in the opposite direction. For example, the phallic imagery so evident in the bull-roarers and other art of the Aranda people, found its way into the art of New Guinea, as did the importance of the snake in myth. However, in its own right, the culture of the Pacific islands was largely based around their shamanic origins, and the air of mystery that surrounds many pieces of the Oceanic region reflects this. Here, too, myth and art cannot be separated. Visual representations of the Pacific gods are ubiquitous in the art found here. Masks, enormous stone monoliths, small carved wooden figures – all were intrinsically related to Pacific mythology. Even objects used in everyday life were decorated to give them religious significance, from war clubs, through canoe-prowheads and paddles, to elaborate carvings on buildings, and even the body art of the people.

In a similar way, the art of the native peoples of North America included shamanic pieces, and was encompassed in items such as tomahawks, pipes and masks. Here also, ancestor worship was important, and pieces of spiritual significance were carefully crafted and intricately decorated to honour the gods and ancestors. In a similar way to the Australian Aboriginals, everything had a spirit, and one could not separate the animate and inanimate worlds. The origins of this animist belief lie in the Native Americans' perceived helplessness in the face of the awesome power of nature, and many charms survive – in the form of tusks, claws or pieces of horn – that were believed to provide protection against these hostile forces. Even the clothing worn by the Native Americans deserves a place in their artistic tradition. Ceremonial costumes, headdresses and masks worn to perform sacred rites and dances, all had a mythical significance. Different tribes used varying decorative materials, depending on what nature provided in their region. The Cree, for example, would fashion ornaments out of dyed porcupine quills and the Blackfoot tribe would create magnificent headdresses from owl and crow feathers. They believed that the animals used in the creation of such pieces passed their qualities to the wearer.

The art of the myriad cultures that flourished and declined in Central and South America is stylistically very different from its northern counterparts. Their mythology was borne of an intimate understanding of their

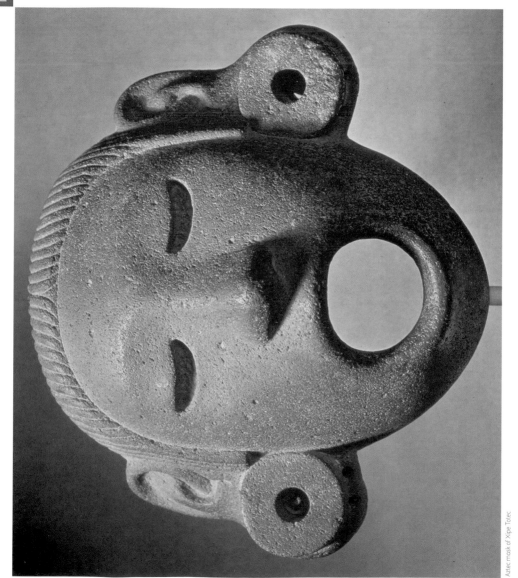

Aztec mask of Xipe Totec

Maori Hei-Tiki pendant

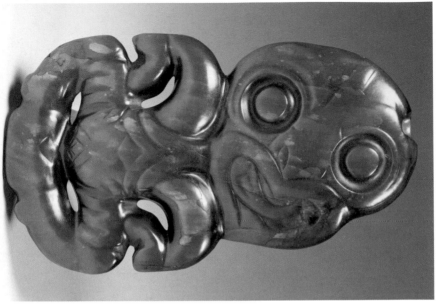

environment, garnered through centuries of a hunter-gather lifestyle. For the Amerindians, landscape was not just physical, but contained mythical and magical qualities, and was crossed and re-crossed by invisible lines of power, all of which lent a spiritual dimension to everyday life. The art of the Amerindians, therefore, really encompasses all forms of sacred expression – from tiny carved figures to the massive step pyramids. Yet the cultures and societies of this region all had their own myths of origin, ideology and, most importantly, ethnic identity, and the art varies accordingly.

The Olmec – the first civilization of Central America – have left behind evidence of their pantheon of half-human, half-animal gods, advanced architectural feats, and several traditions – many of which were subsumed into the art and culture of subsequent peoples of this region, including the Mayans, Zapotecs and Aztecs. In Andean South America, the Chavin began an artistic tradition of statues and carvings showing the jaguar, eagles, decorated pottery and gold, all of which became the hallmarks of subsequent cultures including the Mochica and Inca peoples. Although the tropical lowlands of Amazonian South America never reached the cultural or artistic heights of the Andean civilizations, pieces survive that are typical of this region. By 2000 BC, pottery-making was widespread, and urns and other pieces, carved with spiritual figures, as well as masks and some pieces made from gold, represent the sophistication of artistic tradition in this area.

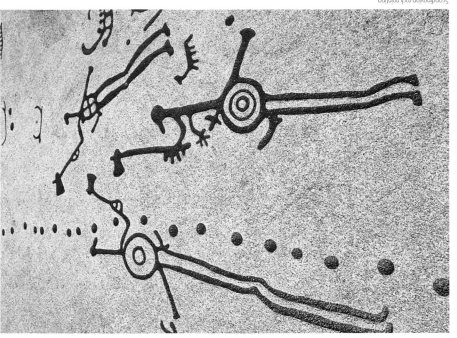

The influences of the art and techniques of the people covered in these four key regions varied. Geographically, artistic influences could only spread so far, or took a long time to reach other parts of the world. However, the cross-cultural significance of many art forms should not be underestimated. Although stylistically unique to their own culture, symbols, myths and associated rituals often found their way into those of disparate peoples. The pieces included in the last section of this book are intended not only to show how these cultures absorbed the styles of the other regions covered here, but also to emphasize the individuality of the art of many cultures. The chronological development of art across the globe provides a fascinating timeline – the art of some cultures can seem simplistic in comparison with the advanced techniques being used by other nations at exactly the same period. It is for this reason that Folk Art, in all its forms, will remain one of the most important artistic movements – if such a term can be applied to the diversity of material that falls into this category. More than any other art form, it reveals a development not only in artistic traditions, but also in human evolution. It is the history of our species.

THE GREAT

Folk Art

Aboriginal Art

Spirit figures rock art

These beautifully executed figures can be found at Nourlangie Rock, in the Kakadu National Park, in Australia's Northern Territory. There are many rock paintings here, many of which depict creation ancestors. This particular painting shows female spirit figures and fish – their graceful forms passing over land and water.

The Aboriginal people believe that ancestral spirits formed the landscape in this part of the country. Two of their Creator Ancestors, in the form of rock wallabies, travelled past here and over the billabong at the lower part known as Angbangbang. They travelled into the upper part, called Burrunggi, where they paused to cut two crevices in the rock. Today, rock wallabies visit these crevices in the early morning and at dusk.

One of the main sites at Nourlangie is the Anbangbang rock shelter, which archaeologists believe the Aborigines have been using for at least 20,000 years. It would have provided protection during the monsoon season, when they would make forays for food and cooking, and pursue leisure activities until the onset of the dry season.

REGION

Northern Territory

MEDIUM

Pigment on rock

RELATED WORKS

Lightning Man rock art, Nourlangie Rock

Bark painting, c. 1960s

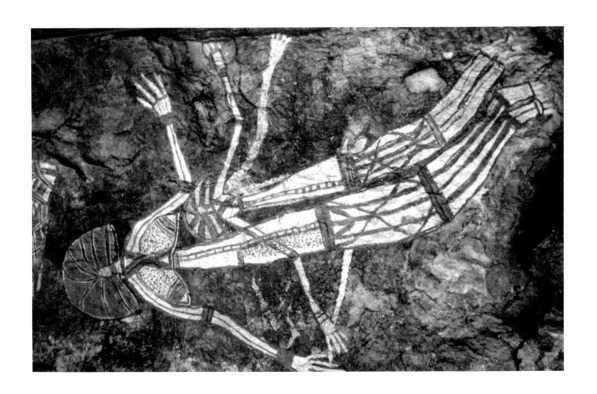

Petroglyph

This incised figure on rock is believed to have been made by clan ancestral beings, who created the landscape during the Dreamtime or Dreaming. In Aboriginal mythology, this is the period of Creation, and thousands of myths exist about the journeys and actions of the ancestral beings. They are believed to have traversed the landscape, creating all the features that still exist – mountains, rock formations, caves and water holes. They are also believed to have brought into being many creatures, human and animal, that now inhabit the Earth. As they went along, the creator beings named the places and the species they created. Sometimes they left parts of their own bodies in the places they travelled, a belief that is central to many Aboriginal rituals.

Situated at a sacred site in New South Wales, it is unclear what this petroglyph is meant to represent. In general, though, humanoid representations of this kind are of a lesser quality than the images of animals that appear in the rock art. This strange design is possibly meant to represent a feature of the landscape.

REGION
New South Wales

MEDIUM
Rock carving

RELATED WORKS
Spirit figures rock art

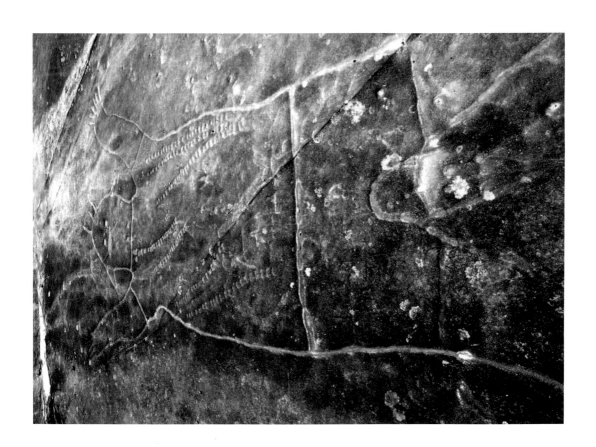

Journey of the soul bark painting

Bark paintings are found all over the Aboriginal lands. The first was discovered in Tasmania in 1800, and many others have since been discovered in Victoria and New South Wales. There are many regional styles of bark painting, some, like this example, are more sophisticated than others. Pigment was used in some paintings, while other designs were simply scratched into smoke-blackened surfaces.

This painting shows the path that the soul took on its journey after death. It was believed that when a person died, the soul made its way to the 'other' world or 'sky camp'. Mourners would sit beside the grave of the deceased, beneath shelters, in order to ensure that the soul followed the correct path. There is no formal religion among the Aboriginal peoples, but they have a belief in a personal soul, which was based on the Dreamtime legends that told of spirit-children entering the bodies of women. Birth and death are a cycle: at death the spirit leaves the body it entered at birth. Bark paintings covered many graves and some coffins were made from bark.

REGION

Unknown

MEDIUM

Charcoal or pigment

RELATED WORKS

Barramundi fish painting

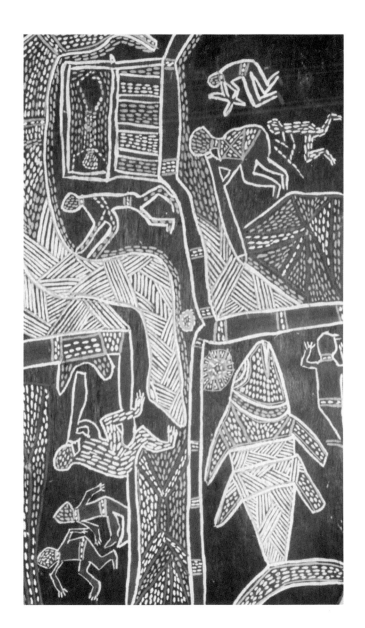

Barramundi fish painting

© Topfoto.co.uk

This cave painting was found at a site, south-east of Darwin known as Nourlangie or Nawurladja, which forms part of a vast sandstone plateau. This area is rich in rock art and it is estimated that some paintings were executed 20,000 years ago. Initially, the paintings took very simple forms, such as hand prints or prints of plants and fibres that were thrown or pressed on to the rock. These representations of Barramundi fish, a species found off the coast of northern Australia, are more recent. The sea-level began to rise almost 10,000 years ago, and the ocean started to encroach upon this escarpment. As the Aboriginal peoples of the area became familiar with this new kind of environment, they began to incorporate marine creatures into their art.

The fish shown here are painted in the 'X-Ray' style that showed the bones and interior organs, as if the creature was represented in cross-section. This way of depicting animals and fish was adopted about 3,000 years ago, and is still in use by the native peoples today. For the Aboriginals, this style reflects their relationship with and understanding of the natural world.

REGION

Northern Territory

MEDIUM

Pigment

RELATED WORKS

Kangaroo bark painting, 1900s

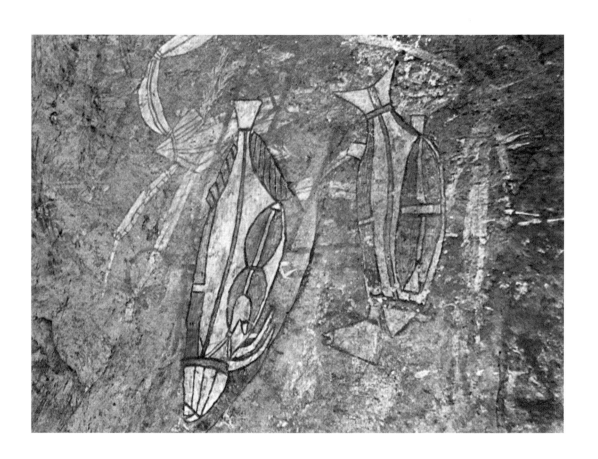

Emu cave painting

The emu and other birds have a phallic significance in Aboriginal art, and are common motifs painted by men, particularly of the Warlpiri people of this region of the Northern Territory. These carvings come from the great Emu Cave, so called because more than 170 carvings have been discovered here, showing what appear to be the footprints of emus and kangaroos. The date of these carvings is unknown, although many of them look very old, and many of the walls of the cave have been covered over by organic matter. The first non-Aboriginal to visit the caves here was the 19-year-old Archibald Bell, who was travelling through the region with Aboriginal guides. On seeing the wealth of carvings here he determined to return and concoct a survey of the art.

The legend of the emu in this region tells how this bird ate all the food that the other birds found, and refused to share any. One day, the other birds grew tired of the emu's greed and tricked her by tempting her with a delicious kangaroo, then flying off with the meat. The emu ate a stone instead, and that is why emus lay eggs today.

REGION

Northern Territory

MEDIUM

Rock carving

RELATED WORKS

Barramundi fish painting

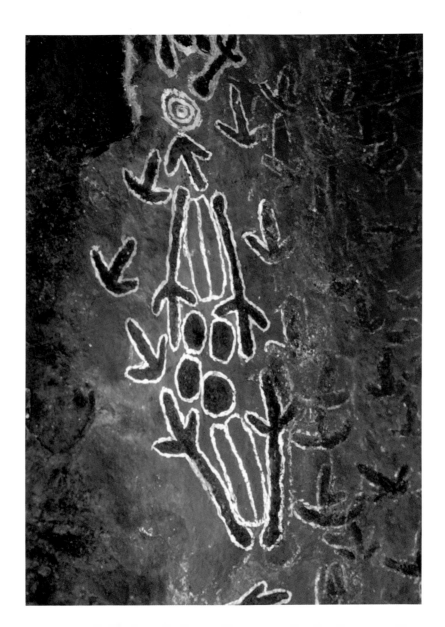

Queensland shield

This Aboriginal shield was made in Queensland, where the artwork of the Aboriginal peoples displays a greater diversity than in any other area. In the north, many items were made from wood and bark, and so presented ideal large, flat surfaces for decoration. Shields were used at initiation ceremonies and during inter-tribal fighting. They were usually constructed by cutting a piece of solid timber about two feet long. This piece was cut from the outside of the tree and the curved side was generally incorporated as the outside of the shield. A handle or grip was cut into the back. Sometimes the piece of timber was used in the reverse, with a loop pulled into the bark to serve as a grip. The bark of the eucalyptus tree is exceptionally tough and thick, and this alone could be fashioned into a protective shield. Shields were generally used to parry and deflect thrown spears rather than to take the full force and stop them.

REGION

Queensland

MEDIUM

Wood and pigment

RELATED WORKS

Murray River broad shield

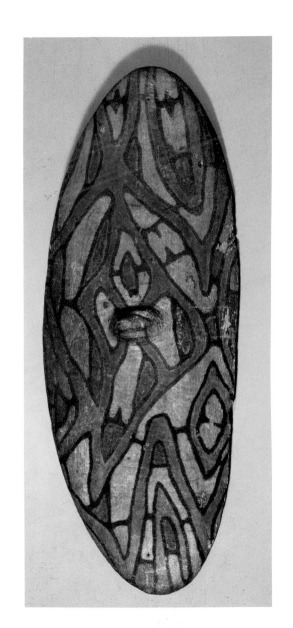

Murray River broad shield

Australian Aboriginal shields vary greatly, as each one was unique to its maker. He would formulate its shape depending on his needs, and choose the decoration according to his tribal beliefs. They were often carved with patterns, such as the herringbone pattern shown here, or painted with pigment. Shields were used both in battle and for cover while hunting.

This wooden shield comes from the Murray River region of south-east Australia, home of the Ngarrindjeri people. They believe that the ancestral being Ngurunderi travelled the area here during the Dreaming, creating the landscape and making the laws by which the tribe still live. Ngurunderi was a major figure in the belief system of the Aboriginals of this area. Legend tells how the ancestor fed off the Ponde – the Murray cod. He began pursuing the cod in New South Wales, and chased it through the landscape on a raft, throwing spears at it. As the cod danced away from its pursuer, it carved a winding path through the country. This became the course of the Murray River.

REGION

Murray River

MEDIUM

Wood

RELATED WORKS

Queensland shield

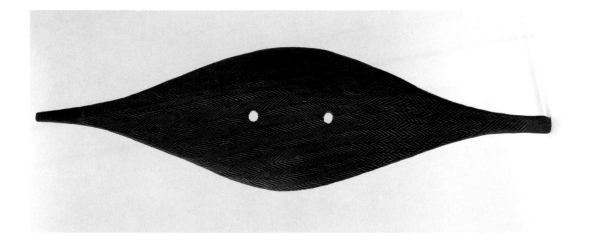

Churinga

Churingas are inscribed stones (or sometimes wooden boards), that were considered sacred by the Aboriginal peoples. They were associated with the Dreamtime journeys of the Ancestors, and represent their continued presence on Earth, and their owner's connection with the otherworld. They linked the people with Alchernera – the world at the beginning of time, and were actually considered to be the spirits of eternal ancestors in visible form. Each churinga spirit was split into two parts. One of these remained with the churinga and the other wandered the world in search of a human child so that it could be re-born.

Churingas were used during ceremonies, and were believed to guarantee the effectiveness of the rituals. When they were not being used, the churingas were usually wrapped carefully in leaves, tied with hair (often human), and hidden away in rocks or tree roots at a point close to the totemic centre, where the spirit would linger. Most people had a personal churinga, but there were also sacred stones that belonged to whole groups or communities. Artists decorated the stones with designs that were associated with the songs and stories of the spirits.

REGION

Unknown

MEDIUM

Carved stone

RELATED WORKS

Aranda churinga

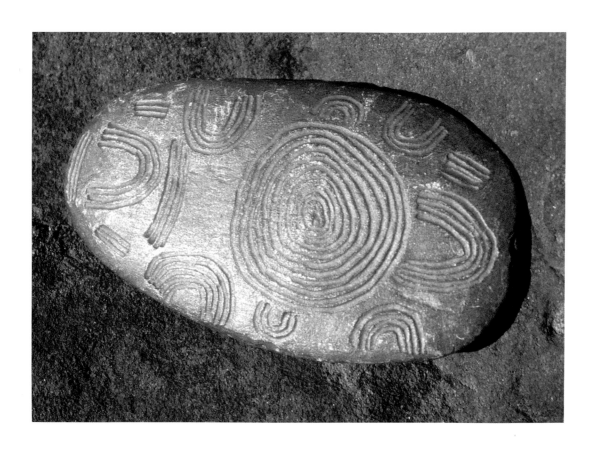

Pubic shield

Pubic shields, or *Yudna*, were worn by boys after circumcision. Boys from all Aboriginal tribes had to go through five initiation stages before they reached manhood. The first stage began at birth. During the second stage, between the ages of 10 and 12, boys were circumcised. They were blindfolded and led away by a group of men, to a place well away from the women and children. There, they would be laid out on the ground and covered with cloaks, after which they were instructed to run away. After a ritual chase, they were captured, and laid on the ground once again. They were covered with dust and put into a trance-like state. The men encircled the boy to be circumcised, and the operation was performed while the boy was supposed to be in a state of enchantment. During the time of recovery he would remain away from the women and eat only vegetables. This pubic shield has been inscribed with several figures familiar in Aboriginal art, including the snake, fish and emu.

REGION

Unknown

MEDIUM

Mother-of-pearl

RELATED WORKS

Western Kimberley pendant

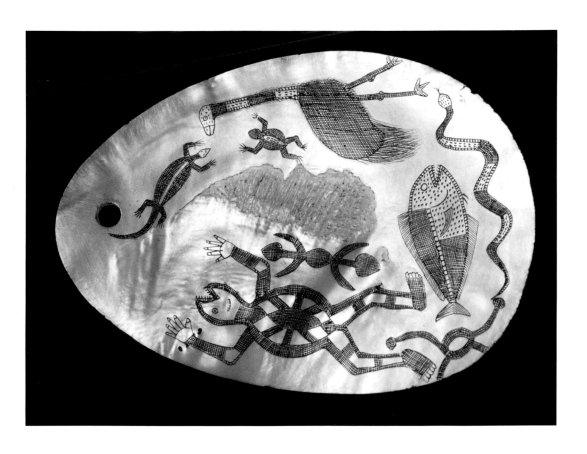

Aranda churinga, c. 1900s

The Aranda people inhabited the desert area of Central Australia, and before the twentieth century they were one of the largest of the Aboriginal tribes. They were decimated by disease and the population is now greatly diminished. This arid region has only a short rainy season and even this is highly irregular – sometimes rain does not fall for two or three years. The hot, dry environment meant that the people were compelled to follow a nomadic lifestyle. They used temporary shelters when moving about searching for food, although larger, more permanent camps for the groups were maintained, where ceremonies and rituals were performed. In common with all Aboriginals, these people used churingas; these were believed to be the spirits of the Ancestors, and were decorated with designs that represented each spirit.

The Aranda people depended on their tracking skills for survival, and their designs reflect this. Representations are depicted as seen from above – for instance, circles represent trees. Traditional designs on churingas included circles and spirals and were not intended as pictures of the spirit, but rather they reflected the pattern of the associated sacred site. It was vital that the artist chanted and talked about his design as he created it. Churingas could only be handled by initiated men.

REGION

Central Australia

MEDIUM

Stone

RELATED WORKS

Churinga

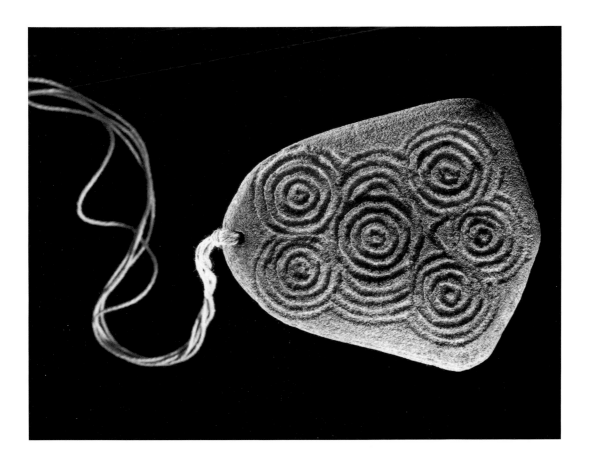

Western Kimberley pendant, c. 1900s

This pendant is attached to a hairstring necklace, indicating that it was used for personal adornment, but pearlshells had a number of uses in Aboriginal tradition. They were used during rainmaking rituals and other ceremonies, and were also important trade goods. The lustre of the pearlshell gave it magical properties, and the shells were highly prized across the continent.

When the pearlshells were decorated, the designs reflected the artwork of the region. This example displays the typical geometric designs of Kimberley. This pendant shows an interlocking key design that probably represents water, tidal movements and clouds, and it is given emphasis by the use of powdered charcoal mixed with fat rubbed into the grooves to resemble inlay. Red ochre was also commonly used. Modern trade in pearls and pearlshells began in Kimberley in the nineteenth century and by 1910, 3,500 people were employed in the industry, including Aboriginal people. The buttons produced from the pearlshells were distributed worldwide, but the advent of the plastic button signalled the end of the industry.

REGION

Western Kimberley

MEDIUM

Mother-of-pearl

RELATED WORKS

Pubic shield

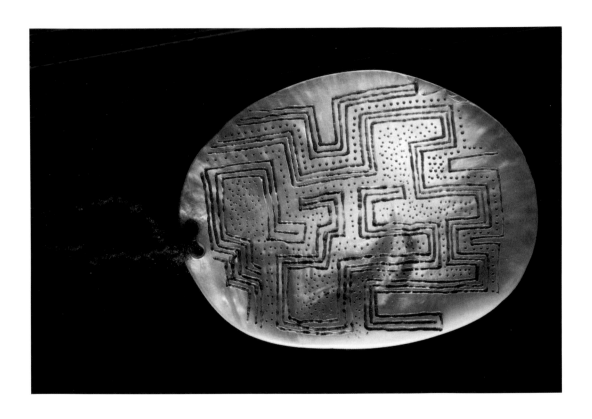

Arnhem Land figure, c. 1900s

This carved wooden figure comes from Arnhem Land, one of the richest areas of Aboriginal art. It represents one of the ancestral beings of the Dreamtime, which is at the centre of Aboriginal culture and religious belief. These spirits travelled the featureless world at the beginning of time, creating all things, and they are thought to exist in sculptures like this.

Arnhem Land is best known for small wood carvings and statuettes, as well as for its carved wooden posts. Aboriginal art fulfils ritual and religious functions, and this figure would have represented a tribal totem spirit, and would have been part of the rite of passage that all young boys went through. The boys go through many stages of initiation before they reach manhood, and some of these are extremely harsh. The first rite is circumcision, performed when the boys are about 12. This sculpture has been decorated with various designs that would have had special meanings known only to the tribe.

REGION

Arnhem Land

MEDIUM

Wood

RELATED WORKS

Kangaroo bark painting, c. 1900s

Mimi spirit bark painting, 1979

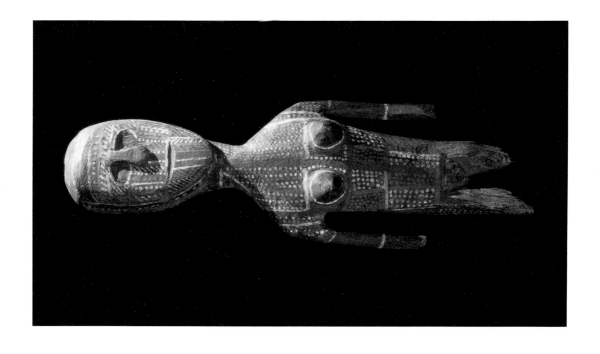

Hair ornament, c. 1900s

This incised wooden hair ornament would have been worn during sacred ritual dances. It is shaped like a feather, and the patterns themselves are featherlike. Both dance and music play a central role in Aboriginal culture, and have done for thousands of years. They are performed for all types of occasion, from weddings and funerals, to solemn sacred rites, celebrating and honouring the Ancestors. Song and dance provide a vital link to the Dreamtime. There are many different types of dance, including *joor-ba* (heritage corroboree), *wangka* (festive corroboree) and *munga munga* (women's corroboree). However, sacred and ritual dances were very different from those used in celebrations and 'secular' affairs, in which all members of the community participated. Creating pieces such as this hair ornament – and indeed any other type of art – was not considered a separate artistic activity by the Aboriginals. Everything was part of the Dreaming, and therefore inextricably linked with everyday life.

REGION

Unknown

MEDIUM

Wood

RELATED WORKS

Lizard and emu bark painting, c. 1900s

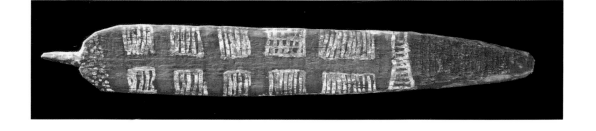

Aranda churinga, c. 1900s

Churingas are some of the earliest forms of artistic communication – the earliest ones may be as old as the Aboriginal culture itself (up to 50,000 years). They represent the oldest form of religion still observed, and churingas are still made by the native Australian peoples – the one pictured here dates from the twentieth century. The Aborigine who made this churinga was from the Aranda region of Central Australia. The people of the central desert region read the patterns on the churinga as a kind of map, and they represent a holistic system of natural phenomena, tied up with the spiritual totem. Women and uninitiated men were not allowed to handle the churingas, and each one had its own song that had to be sung when the sacred stone was being handled. The 'storehouse' in which the churinga was kept was also strictly forbidden – on pain of death – to women, children and uninitiated men. This sacred site could be a hole in the ground, a crevice in a rock, or a hollow tree, but the very placing of the churinga in it made the site of totemic significance.

REGION

Central Australia

MEDIUM

Stone

RELATED WORKS

Churinga

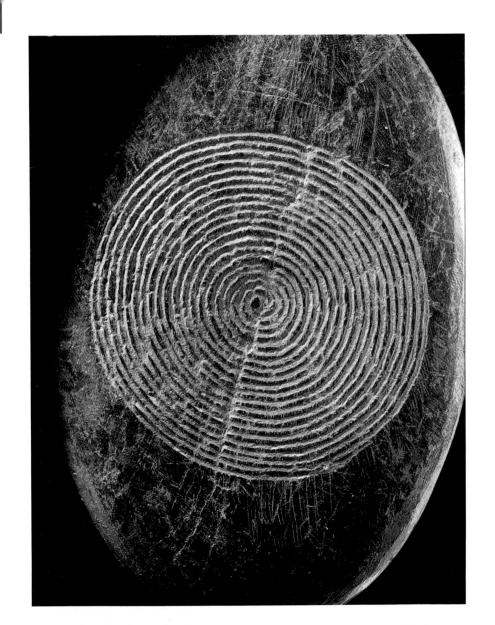

Lizard and emu bark painting, c. 1900s

Unlike the Aboriginal rock paintings that have remained fresh and vibrant for thousands of years, bark painting is perishable, making it difficult to establish the history of the art form. Large bark paintings were observed by the first Europeans to visit Australia, and examples were first recorded in the nineteenth century. The people of the tropical areas collect the bark of the eucalyptus or 'stringybark' trees during the rainy season. The sap is rising at this time, making the bark easy to strip off. The bark is then cured by fire to make it pliable, and flattened out beneath weights until it has dried out. The rough outer side is removed, leaving a thin fibrous sheet, which is smoothed in readiness for the painted design. Traditional colours and pigments are used in this painting: red and yellow ochres, black obtained from charcoal and white obtained from pipeclay or kaolin. These would have been mixed with fixatives such as juice from plant bulbs, egg yolk or beeswax.

REGION

Unknown

MEDIUM

Eucalyptus bark

RELATED WORKS

Journey of the Soul bark painting

Kangaroo bark painting, c. 1900s

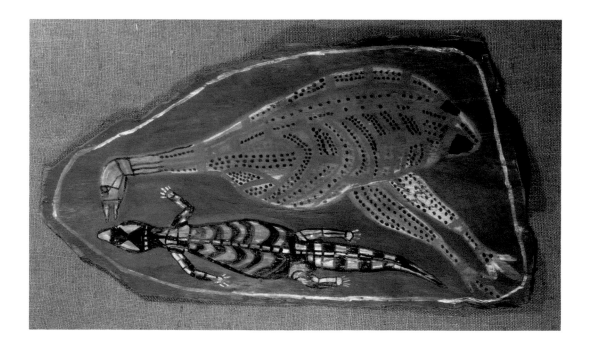

Aboriginal dancing scene, c. 1900s

The ancient bases for Aboriginal portable artwork were prepared from bark, but just as the Native Americans adopted the paper that was introduced by the Europeans as a replacement for animal hide in the nineteenth century, the Australian Aboriginals began to use the white man's materials. William Barak (c. 1824–1903), who painted this piece, was one of the first and best-known Aboriginal artists to make use of these. He was an elder of the Wurundjeri tribe, whose homeland occupied the area that is now Melbourne. They were resettled at Coranderrk, where Barak was commissioned to produce drawings and paintings for the European settlers. He painted many ceremonial pictures like this one, and his works show aspects of Aboriginal' culture and traditions, as well as encounters with the Europeans, by whom he was highly regarded.

The Aboriginals did not dance in the strictest sense. At ceremonies they would make movements that imitated initiation rites or the way animals behaved, and replicate the movements of hunters and men in battle. These ceremonies incorporating 'dance' were called corroborees and there were different types for different occasions.

REGION

Melbourne

MEDIUM

Paper and ink

RELATED WORKS

Snake Dreaming, 1984

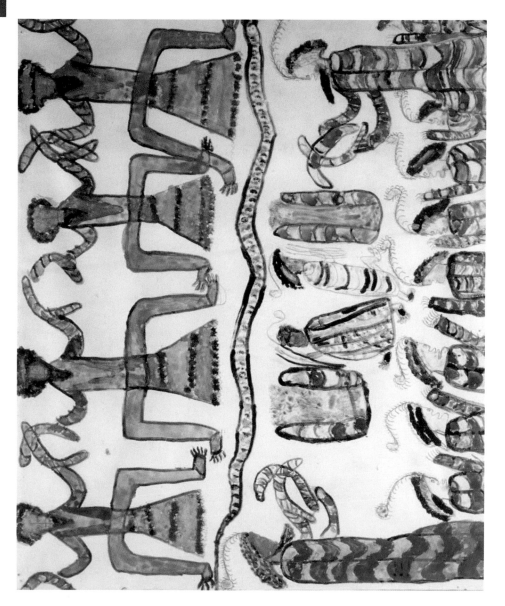

Kangaroo bark painting, c. 1900s

X-Ray pictures can be found among the ancient rock paintings executed more than 4,000 years ago. Many of the finest examples can be found in the hills of Arnhem Land in northern Australia, including those at Ubirri (or Obiri) Rock at Nekakodu. The X-Ray pictures were usually of animals, and bark was a common base for this type of art. The outline was made and sometimes filled in to create a silhouette – generally in white pigment. The interior organs were then painted in, often in divided sections. The oldest X-Ray pictures showed only the bones and some organs, but over time the pictures became far more detailed, and included reproductive organs and even breast milk. After the battles between the Aboriginals and the European settlers, bullets were also sometimes illustrated in X-ray paintings. The tradition of painting X-Ray pictures continues today amongst the Australian Aboriginals. The image of a hunter spearing a kangaroo is typical of the art found in the western region of Arnhem Land.

REGION

Arnhem Land

MEDIUM

Bark

RELATED WORKS

Lizard and emu bark painting, c. 1900s

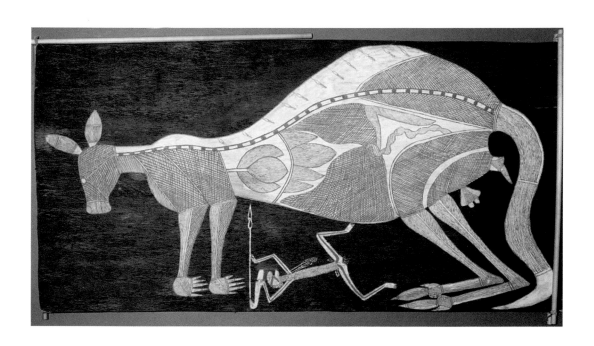

Rock art, c. 1960s

The astonishingly ancient rock art of Australia is c tradition thousands of years old – and one that continues in the modern day. Traditional Aboriginal artists have or enthusiastic market for their more portable work, and the old and ephemeral art of bark painting is flourishing. One of the most famous of the modern exponents of rock art was Najombolmi, and this picture is attributed to him.

Born in 1895, Najombolmi was dubbed 'Bar'amundi Charlie' by the white man. A highly respected hunter and fisherman among his own people, he worked for many years or cattle stations, returning occasionally to his homeland to paint. In 1964, feeling deeply resentful of the white man's treatment of his people and their culture, he returned to Kakadu. Here, on a sandstone outcrop, he painted a traditional Aboriginal Dreamtime representation of Namandjolg and Nammarkun. The latter is also called 'Lightning Man, and he creates lightning and thunder by clashing together the stone axes attached to his knees and elbows. These fearsome spirits were intended to drive the white man from the Aboriginal lands. Najombolmi died in 1967.

REGION

Western Australia

MEDIUM

Pigment on rock

RELATED WORKS

Spirit figures rock art

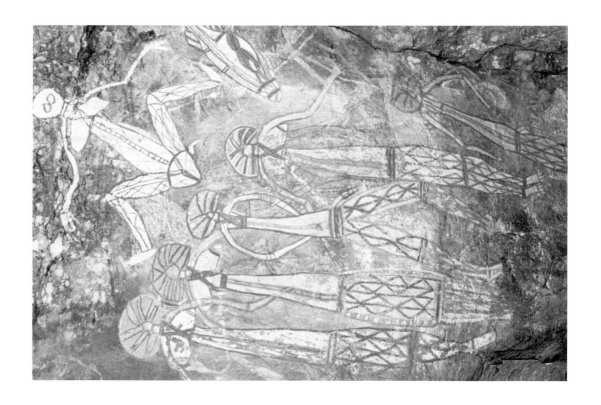

Turtle rock art, c. 1960s

This modern, naturalistic image of a turtle is painted in what is called the 'dynamic style', previously known as the 'Mimi' style after the slender spirit figures that were often represented. These spirits are very small and fragile, and can only hunt in calm weather. When they hear humans approaching, they blow on a rock face, which opens up a crevice in which they can hide. The Aboriginals believe that the Mimi are responsible for making many of the paintings themselves, as well as for teaching the people how to paint.

When the sea encroached upon the sandstone escarpment of Nourlangie, in what is now the Kakadu National Park, the Aboriginals began to include marine fauna in their paintings, and this rock picture of a pig-nosed turtle follows that tradition. It was painted using traditional Aboriginal pigments, keeping alive the ancient practices of the indigenous people's ancestors. The Aboriginal artists of today have a ready market for their work, and demand means that they still favour the use of bark as a base for their pictures. However, increasingly, this ancient material is used in combination with more modern paints and brushes.

REGION

Northern Territory

MEDIUM

Pigment on rock

RELATED WORKS

Spirit figures rock art

Mimi spirit bark painting, 1979

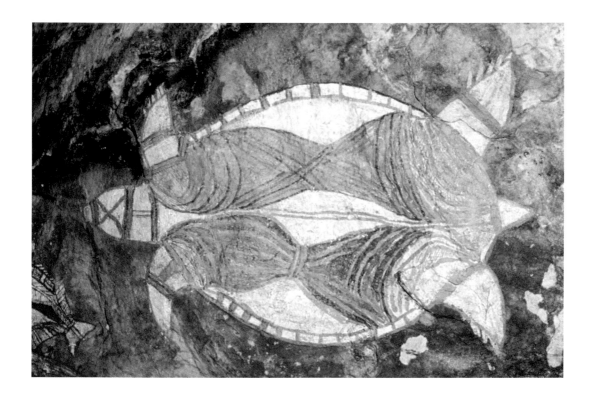

Mimi spirit bark painting, 1979

Wally Mandarrk (1915–87) was a modern Aboriginal artist who frequently painted on rock walls, but he also executed some pieces on bark for the more commercial market, as can be seen in this example. He eschewed modern materials and continued to use the traditional pigments and fixatives used by his ancestors. This picture, painted in 1979, shows the slim form of a Mimi spirit with a wallaby and honey-collecting bags.

There are many ancient rock and bark paintings depicting Mimi spirits, believed to be harmless but mischievous beings. They are often shown as stick-like figures with prominent genitalia on the males and large breasts on the females. The collecting bags in Mandarrk's picture appear to include a dilly bag. This type of bag is woven by women from grasses and used to carry fish and seeds. Both men and women use dilly bags: the women's bags have a long strop-like handle that can be worn around the head, thus freeing the arms for collecting. The men's dilly bags are carried over the shoulder, as shown here.

REGION

Arnhem Land

MEDIUM

Pigment on bark

RELATED WORKS

Bark painting, c. 1960s

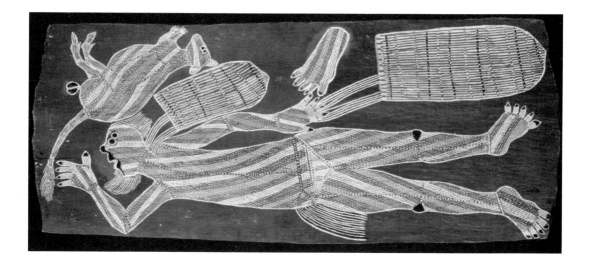

Snake Dreaming, 1984

The Dreaming was the origin of life for the Aboriginal peoples. When the ancestor spirits passed over the featureless world they rested, and where they paused they left the spirits of creatures behind. The creator spirits put humans on the land too, and this links the Aboriginals with every other living creature. Their culture is based on the belief that they are responsible for the care of all animal life and their ceremonies and rituals ensured the continuation of all species. Each person was linked to a particular animal spirit totem and it was forbidden for them to kill or eat this animal.

Turkey Tolson Tjupurrula (b. c. 1938) is an Aboriginal artist who uses modern materials such as acrylic. He is one of the artists of the Pintupi tribe, who have returned to their ancestral homelands of Kintore and Kiwirrkura. They generally paint representational pictures composed of dots, concentric circles and straight lines. Some of Tjupurrula's work is very different from this example – being very stark and composed of many shaded lines in geometric patterns.

REGION

Western Desert

MEDIUM

Acrylic on canvas

RELATED WORKS

Women Playing Manni-Manni by Turkey Tolson Tjupurrula, 1996

Straightening Spears at Ilyingaungau by Turkey Tolson Tjupurrula, 1996

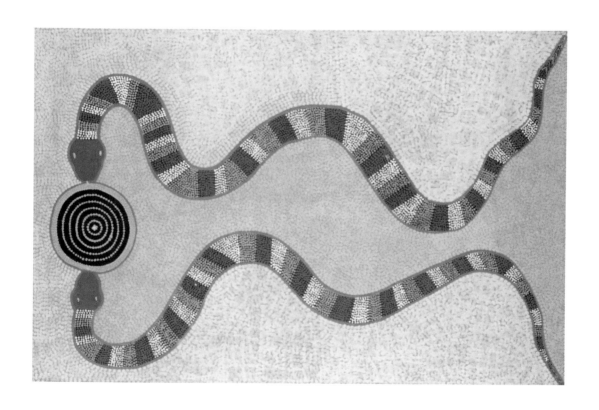

Narriri (Worm) Dreaming, 1987

This is a modern painting using acrylics on canvas, painted by Clifford Possum Tjapaltjarri – an Aboriginal artist of international acclaim. Born in 1960, his is an astonishing story. In 1984, he and a group of family members walked out of the desert and made contact for the first time with Europeans. There was worldwide interest in these people, who were dubbed 'The Lost Tribe'. He was a member of the artistically prolific Pintupi tribe, whose abstract style of painting is much admired. Introduced to the art by his brother Warlimpirrnga, he originally painted in the classical style, producing a series of works associated with his Dreaming. In 1996, he began to develop an altogether different style allied to the abstract designs of other Pintupi artists but using a greater range of iconography for his Dreaming pictures. These are bold and graphic representations of the physical and spiritual world.

REGION

Western Desert

MEDIUM

Acrylic on canvas

RELATED WORKS

Snake Dreaming by Turkey Tolson Tjupurrula, 1984

Witchetty Grub and Snake Dreaming by Goodwin Kingsley Tjapaltjarri, 1989

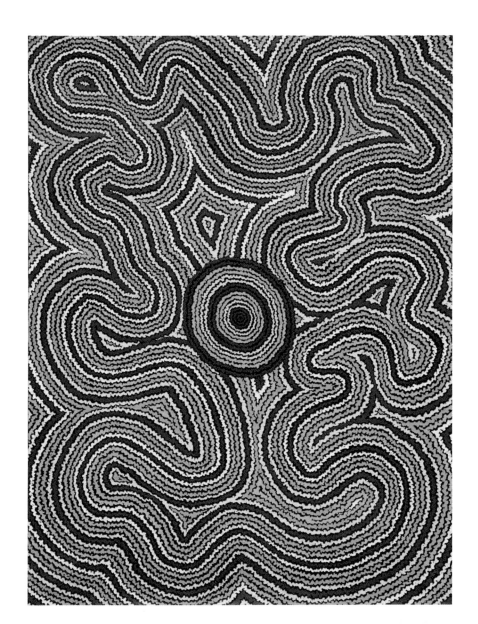

Witchetty Grub and Snake Dreaming, 1989

Goodwin Kingsley Tjapaltjarri is a modern artist, born in 1950 on a reservation settlement north-west of Alice Springs, known as Haasts Bluff. He was raised in the Central Desert and taught the traditional ways of the Aboriginals. He learned to hunt and make spears and boomerangs, and went on to become a stockman. He now lives in the Pintupi territory of south-east Kintore and paints Tingarri dingo and rock-wallaby stories. The Tingarri are the mythical spirit beings of the Dreamtime, who shaped the landscape and created the ancestors. The witchetty grub – the 15-cm (6-in) larva of a moth – is a treat for the Aboriginals. There is a special site of the witchetty grub Dreaming at Undarga, or Emily's Rock, in the Macdonnell Ranges. Here, paintings on the face of the rock show where women of the Dreamtime stood watching the Witchetty Grub men performing a sacred ceremony. Clefts in the rock were storehouses for the sacred Tjurunga, the emblem of the totemic ancestor and the resting place of his spirit. Nearby there are two stones representing the witchetty grub as a chrysalis and at the egg stage.

REGION

Western Desert

MEDIUM

Acrylic, canvas

RELATED WORKS

Snake Dreaming by Turkey Tolson Tjupurrula, 1986

Narriri (Worm) Dreaming by Clifford Possum Tjapaltjarri, 1987

Dingo Dreaming by Clifford Possum Tjapaltjarri, 1990

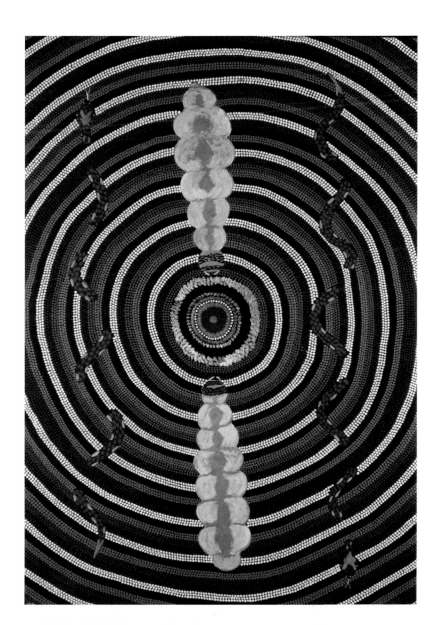

Dingo Dreaming, 1990

This is a typical work representing the Dreaming by Clifford Possum Tjapaltjarri. The dingo is represented in a bold monochrome. Less austere than the work of other Pintupi artists, Tjapaltjarri often uses the Dreaming as a basis for his paintings, which include Narriri (worm) Dreaming stories. Although Dreaming stories depicting one creature are common, Tjapaltjarri assisted his brother Tim Leura on *The Napperby Death Spirit Dreaming*. In one exceptionally beautiful painting, three Dreamings are combined: The Old Man's Dreaming, the Yam Dreaming and the Sun and Moon Dreaming. This spectacular picture is 7 metres (23 feet) long. The dingo appears frequently in Dreamings. Dingos can be trained to hunt most animals, with the exception of kangaroos, and the Aboriginals often take dingo puppies as companion animals.

REGION

Western Desert

MEDIUM

Acrylic on canvas

RELATED WORKS

Snake Dreaming by Turkey Tolson Tjupurrula, 1984

Narriri (Worm) Dreaming by Clifford Possum Tjapaltjarri, 1987

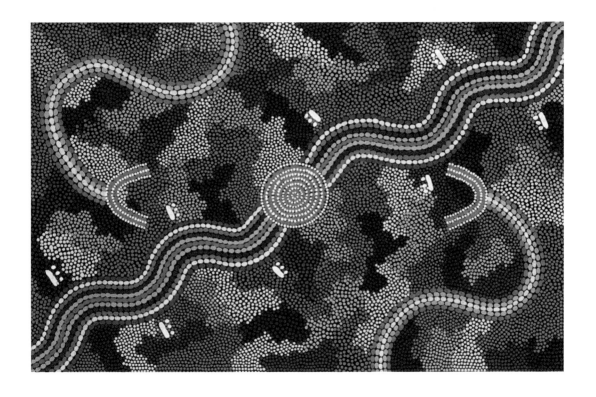

THE GREAT

Folk Art

Pacific Art

Easter Island monolithic statues, c. 1100–1650

Unique to the Pacific Islands are the huge monolithic statues of Easter Island. Called *moai*, they were carved between AD 1100 and 1650 and number over 900. While typical ones were 3.4 to 6 metres (11 to 20 feet) tall, some rose as high as 12 metres (39 feet) and weighed as much as 82 metric tons. The islanders carved them with simple stone hand picks and transported them from the Rano Raraku quarry down to the seashore, where they were erected in groups of four to six on platforms (*ahu*) and topped with a red *pukao* or 'topknot.'

The *moai* were believed to represent clan ancestral chiefs who were descended from gods. While some *moai* faced the sea, the majority faced inland, projecting the *mana* (protective power) of the *aku-aku* (ancestral spirits.) During a bloody civil war, which began in 1680, most of the *moai* were toppled, in most cases breaking their necks. Today a number have been restored to their original positions. *Moai* are characterized by long sloping noses, strong brows, deeply inset eyes and prominent chins. The hatlike cylinder may represent a headdress or elaborate hairstyle.

REGION

Easter Island

MEDIUM

Stone

RELATED WORKS

Hawaiian cluster of god figures, 1970

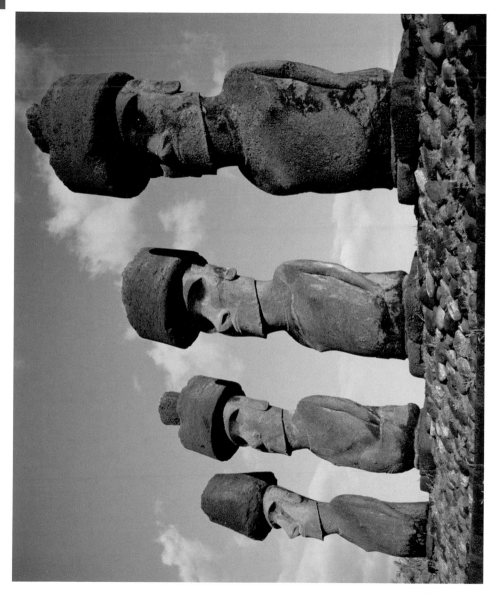

Maori post of rainbow god, c. 1400

This curious carved Maori post (*poupou*) was found in a swamp so placing it in context is difficult. Uenukutuwhata, the rainbow and war god of the Waikato tribes, was said to inhabit this piece when tribal chiefs and priests addressed it during ceremonies. A separate smaller image served to house the god in battles. The four upright prongs may represent the rainbow. While this is c relatively simple design by Maori standards, it shows yet another of the many ways these New Zealand peoples used the wealth of timber in their native lands. Contrast this with the Te Hau-Ki-Turanga meeting house portrait figure, which represents an example of how elaborately housing could be decorated. The Maori had two types of housing: a smaller sleeping house and a more elaborate superior house. Pertaining to the latter, the outside, inside and all posts and lintels, frames and rafters could be covered with intricate spirals, human figures and animals. Some houses might have one lone piece of carved work. The tapu of a superior house was a serious matter.

REGION

New Zealand

MEDIUM

Wood

RELATED WORKS

Te Hau-Ki-Turanga meeting house, 1842

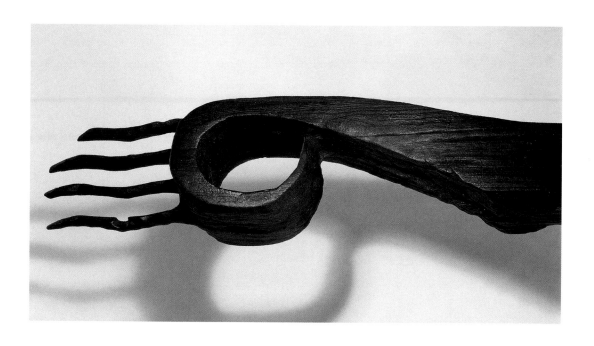

Hawaii feather god

In Hawaiian mythology, the war god Kukailimoku, or Ku, wears a helmet covered in bloody feathers. This fierce-looking example of Hawaiian featherwork is a typical representation of the god, who is shown with an alarming expression of defiance and malevolence. These feather figures are distinctive for their maniacal expressions and gaping mouths that are typical gestures of taunting and defiance of the enemy by warriors. Such images were constructed with a narrow-meshed net drawn over a wickerwork base. Into this were knotted innumerable tiny yellow and red feathers from the mamo, oo and iiwi birds. The feathers were laboriously collected from thousands of tiny forest birds. Typically, the eyes are mother-of-pearl with black wooden buttons as pupils. The mouth of some of these figures contained filed dog's teeth. Heads of Ku were raised as standards in battle, and wooden carved images of him were often placed in semicircular rows within an enclosed temple area (heiau). War was an important aspect of culture in pre-contact Hawaii and throughout Polynesia.

REGION

Hawaii

MEDIUM

Feathers and wickerwork

RELATED WORKS

Hawaiian cluster of god figures, 1970

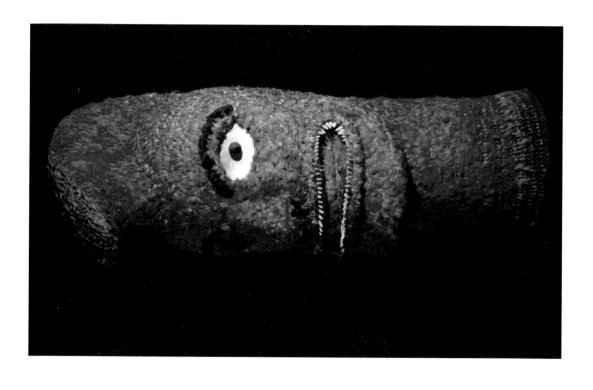

Easter Island command staff

The *ua* or command staff of Easter Island (Rapa Nui) is really a carved wooden mace that would have been carried by warrior chieftains as a sign of rank. Wood was a rare commodity on the island, and art pieces were often cleverly adapted in composition to accommodate the unusual shapes of wood available. *Ua* could be longer than 0.8 metres (3 feet) and were used in ceremony or warfare.

This piece is double-headed and may represent Rau-Hiva-Aringa Erua ;'twin two faces'), a legendary warrior. These enigmatic back-to-back joined heads (*moai aringa*) can be found on hand clubs (*paoa*) as well as staffs. Nearly all Rapa Nui anthropomorphic wooden sculptures share a number of stylistic features: bold crania, prominent brow ridges, artificially extended earlobes and goatee beards. The heads of many exhibit a variety of decorative motifs, ranging from geometric designs to birds, fish and zoomorphic creatures. These decorations may represent tattooing, a rich tradition among the islanders. The earlobes are depicted as artificial extensions with circular ornaments representing islander ear spools, typically made from shark vertebrae.

REGION

Easter Island

MEDIUM

Wood

RELATED WORKS

Easter Island monolithic statues, c. 1100–1650

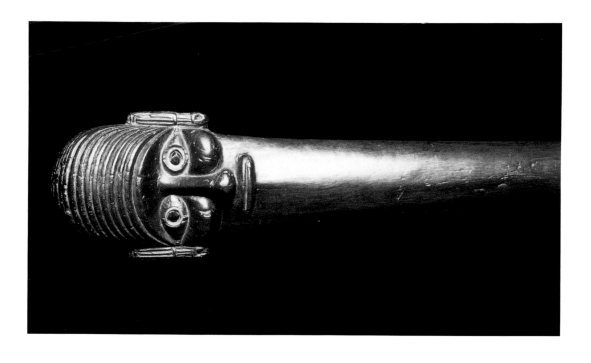

Tahiti double-headed figure

As in many parts of Polynesia, Tahitian art served two primary functions: to communicate with the deities, spirits and ancestors, and to adorn the ruling class and highly ranked warriors. One of the main gods – Oro, the god of war – was represented by club-like images consisting of a wooden core wrapped in layers of woven coconut fibre, on which facial and other anatomical features were lightly delineated. In addition to these more abstract images, the Tahitians produced a variety of more naturalistic renditions of the human form. These most likely represented the gods, spirits or human ancestors called upon to intercede in times of community need. Others served as canoe ornaments or were used in black magic. This double-headed wooden figure was possibly used for sorcery and may represent the dual character of sorcery gods. Male sorcerers worked through a female companion in Hawaii. Double-headed koru figures in Maori art signify a warrior. The image takes its form from the hammerhead shark – a symbol of strength and ferocity that fits a warrior and the attitude required to be successful.

REGION

Tahiti

MEDIUM

Wood

RELATED WORKS

Cook Islands fisherman's god

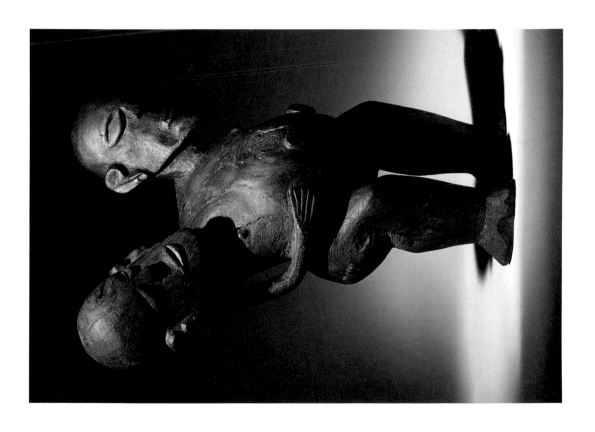

New Caledonia mask

Wooden masks in New Caledonia were traditionally used as part of funerary ceremonies for chiefs. Masks were most often associated with the powerful god Gomawe, and were characterized by a black patina and prominent noses. There are two main types of noses: flatter, broader ones with flaring nostrils and a hook-like curved nose such as exemplified here. This is called the 'beak style'. Protruding noses with large nostrils are regarded as a sign of beauty in women on the islands. The sculptures do an excellent job balancing these probosci with the rest of the composition.

Masks were usually painted black, a colour applied to bodies of the mourners and symbolic of the journey to the land of the dead. Male masks had combs represented on top of the head; female masks had combs at the side. When worn, the mask was adorned with a human hair beard and a headdress surmounted by a mass of human hair trimmed from the heads of the mourners. The art of New Caledonia focused on propagating the status and importance of high-ranked chiefs.

REGION

New Caledonia

MEDIUM

Wood

RELATED WORKS

New Guinea mask

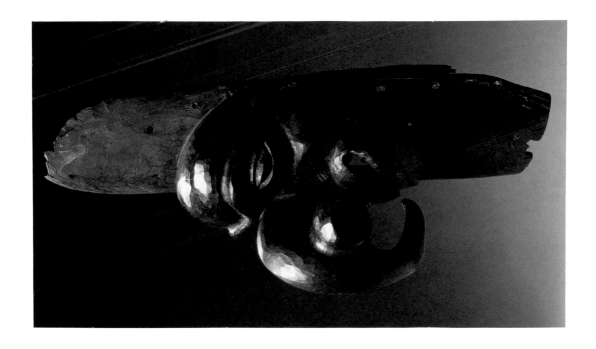

New Guinea mask

The vast island of New Guinea is the most culturally diverse region in the world: over 700 separate languages are spoken, so individual tribes developed quite unique artistic styles. Masks are ubiquitous, but the sizes, shapes, and materials used are staggering in number. Some masks are worn directly on the face, others held aloft, and some are placed as guardians of yam stores or other precious commodities.

This particular mask is similar to a mask worn as part of a towering cane dance framework (*tumbuan*), covered with thousands of feathers densely overlapped in layers of brilliant red, yellow, white and black. It is of oval form, somewhat human in design and expression with pierced eyes, mouth and septum. Only initiated men can work on these masks, which are still made and danced in at the full moon. Each frame is about 5 metres (16 feet) tall and quite narrow, like a bulbous spire. During the ceremony, colourful leaves, flowers, fruits and massive displays of white shell jewellery are added to each costume. A long full grass skirt is tied along the lower edge of the cone to conceal the dancer inside.

REGION

New Guinea

MEDIUM

Wood

RELATED WORKS

Papua New Guinea chest ornaments

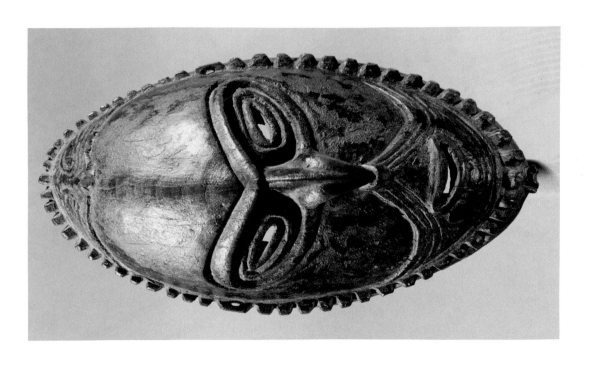

Cook Islands god staff

The Cook Islands are 3,000 km (1,800 miles) north-east of New Zealand and were discovered in 1773 by Captain James Cook. It is thought that an offshoot group of the Cook Islands populace immigrated south to New Zealand, where they were known as the Maori. The islanders carved various kinds of deity figures, including at least three types of staff gods. Some of these images averaged 4 metres (13 feet) in length and were thought to be Oro, son of Tangaroa – the creator and sea god of Polynesia. Others consider it represents Tangaroa himself. The tribal god was believed to enter the object when the shaft was bound with a cord in a certain way and a fringe of red feathers draped round the head as a beard. Although the exact meaning is now lost, the figures suggest procreative symbolism. This particular god staff from Aitutaki has three tiers of deities and the lower portion tapers into stylized human legs. Another example has multiple layers of bark cloth wrapped around its middle. Few of these god staffs survived the 1835 mass destruction of carvings instigated by missionary zealots.

REGION

Cook Islands

MEDIUM

Wood

RELATED WORKS

Cook Islands fisherman's god

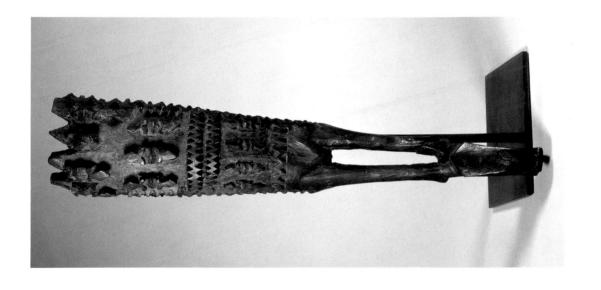

Cook Islands fisherman's god

This fisherman's god from Rarotonga in the Cook Islands is called Taringa-Nui or 'great ears'. Many Polynesian cultures valued extended earlobes with elaborate ear plugs as a sign of beauty. Every fishing canoe in the Cook Islands carried images such as this on their prows. As fishing in ancient Polynesia required good luck and guidance, the natives sacrificed to Taringa-Nui before expeditions to invoke his support for success.

Cook Island carved figures typically displayed a squat figure, with a large navel, protruded tongue, fingers on stomach and an enlarged phallus. They were often painted with tattoo motifs similar to those found formerly on the islands, although they were not always placed on the right parts of the body. This taringa-nui is 31.5 cm (12.4 in) in height and has many stylistic similarities to representations of the god Tiki on other islands. These include large heads placed without necks on to shoulders, with the mouth partially opened and the eyes looking both forwards and sideways. Other wooden carvings by the island craftsmen could be massive in size.

REGION

Cook Islands

MEDIUM

Wood

RELATED WORKS

Cook Islands god staff

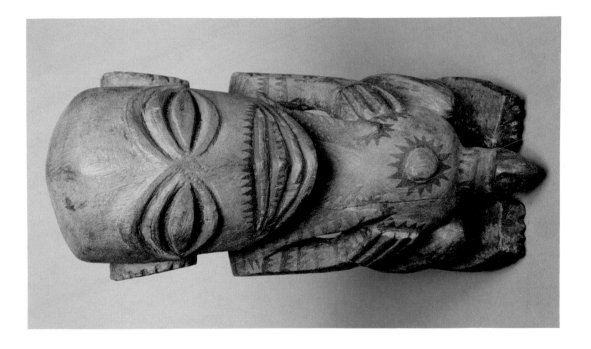

Torres Straits mask

The Torres Straits are located between Australia and New Guinea and are famed for their tortoiseshell masks. These masks were thought to represent the hunting spirits; a man wanted many of these around before he went hunting. To increase his luck, he spit betel juice upon them. They were also used along with wooden mawa masks in various mortuary, initiation, increase ceremonies and other cult practices associated with islander gods.

Generally the masks were produced to represent the human face or animals, but sometimes these two were combined to create hybrid mythological or supernatural beings. By contrast, mawa masks tended to show only the human face. The turtle was an important article of food for the islanders. All initiated men carved masks; the best carvers were recognized as being spiritually more powerful. Other items carved from tortoiseshell include fishhooks and charms to increase tobacco. When Christianity was introduced to the island, the production of traditional tortoiseshell objects was disallowed, resulting in disintegration of the ancestral knowledge and skills.

REGION

Torres Straits Islands

MEDIUM

Tortoiseshell

RELATED WORKS

Torres Straits crocodile mask late 1800s

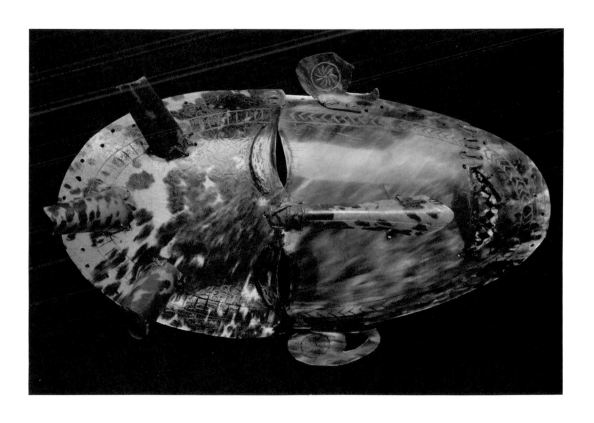

Marquesas Islands ivory tiki

In the Marquesas Islands, in the southern Pacific Ocean, sculpture and statuettes of the god Tiki all appear the same whether they are large or small, in stone or wood. They are stocky figures, with chest contours marked in vigorous lines. The head with no neck is posed massively on shoulders, the mouth partially opened with tongue indicated, and the large, rounded eyes are placed at the side of the head so that they can look both sideways and forwards. These elements combine to give these figures – including this small ivory tiki – an extraordinary expression of force. In this example the eyes have little spirals at the side to represent ears, and the fingers are poised on the abdomen. Tiki's protection was needed urgently in many aspects of life and its symbol was placed on many ordinary life objects: fishhooks, pestles for crushing breadfruit, plates, drums, fans carried over the chief for showing rank, and on the foot-rest of stilts used in competition during sacred games. Over time, some of the three-dimensionality of tiki representations was abbreviated so that he could be indicated by just his eyes.

REGION

Marquesas Islands

MEDIUM

Ivory

RELATED WORKS

Cook Islands fisherman's god

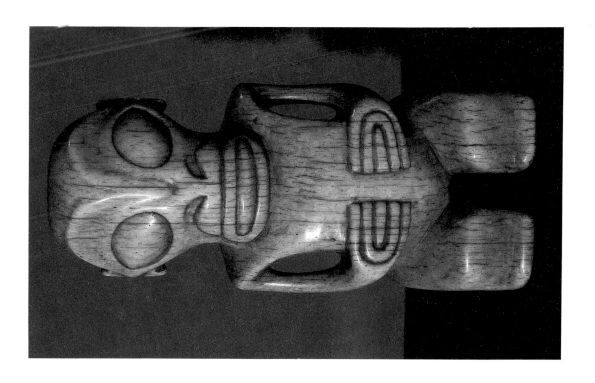

Fiji pillows

These two examples of Fijian *kali*, or headrests, are quite different in style. Made from wood of the sacred vesi tree, the hardness and seeming indestructibility of this material are admired also as human qualities. Fijians believed the head was the location of a chief's *mana* or power, and the *kali* was designed to elevate the head above the body. Headrests of high-ranking people were forbidden to those of lesser rank because they acquired dangerous power. The chief's house was the most decorated in the village, with finely crafted tapa cloth. He and his favourite wife and children used a bed elaborately framed and cushioned, while others slept on the floor. The tear of the headrest was placed at the base of the skull or just below the ear if sleeping on the side. There is speculation that *kali* were first developed to keep the elaborate chiefly hairdos in place during sleep, thus serving vanity as much as repose. Common today is a proverb, roughly translated, 'the headrest here, the headrest there' which means, 'If you have power, so do I'.

REGION

Fiji

MEDIUM

Wood

RELATED WORKS

Fijiula (throwing clubs), c. 1850s

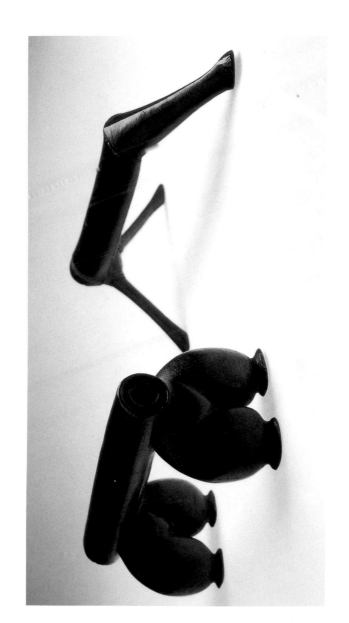

Irian Jaya house door panel

This fascinating item is a house door panel from Siebu Village, Geelvink Bay in Irian Jaya, formerly western New Guinea. The X-ray drawing of a pregnant woman raises many questions about meaning and the belief system behind it. The Minica people of the area produce shields and plates depicting figures with prominent navels. They believe that the spirit of a child enters a woman via her navel and conception then occurs. Minica women stand on the seashore trying to 'catch' the child-spirit from ocean winds. The Asmat believe that birth and death must balance each other and an imbalance can manifest in disease, hunger, misfortune and death caused by unsettled spirits. They also think that the souls of all but children under five and old people who die a natural death roam in limbo, working mischief on the living. The spirits of women who die in childbirth are considered especially dangerous. The Korowai think that the soul of an ancestor is reincarnated into a baby at the moment of its birth. This is an area rife with sorcery and headhunting until quite recently, so it is interesting to conjecture as to the levels of meaning of this particular piece.

REGION

New Guinea

MEDIUM

Wood

RELATED WORKS

Minica shields and plates

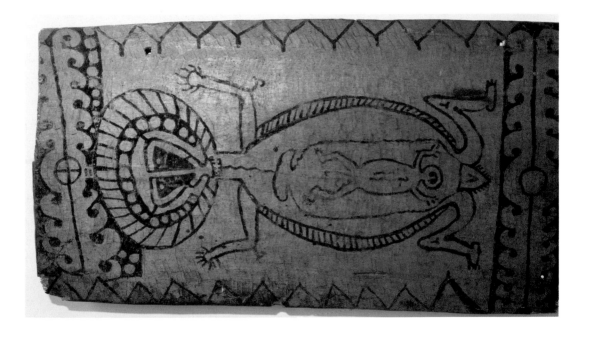

Solomon Islands canoe house figure

Prior to the twentieth century, headhunting was considered an essential part of life on the Solomon Islands. Raids utilized large, plank-built war canoes with crescent-shaped prows and sterns sporting anthropomorphic prow ornaments. Positioned at the water line, these representative mythological spirits warded off danger and ensured smooth seas. The art of this area is characterized by intricate pearlshell inlay designs. *Pirogues* (dug-out tree trunks) with bow and stern ornaments were the pride of every Melanesian. Both war and bonito fishing canoes were docked in decorated canoe sheds that also functioned as the ceremonial houses for men. Herein were contained the ancestor relics and skulls. Wood carved statuettes such as this one usually represented a man seated or standing, with thin arms separated from the body, formless extremities and a face without expression. In addition, the ears were artificially elongated and sometimes the arms held miniature heads. These figures were carved in soft wood, tinted black and enlivened with white paint around the eyelids, eyes and lips. Real hair was frequently stuck on the head.

REGION

Solomon Islands

MEDIUM

Wood

RELATED WORKS

Solomon Islands canoe paddles

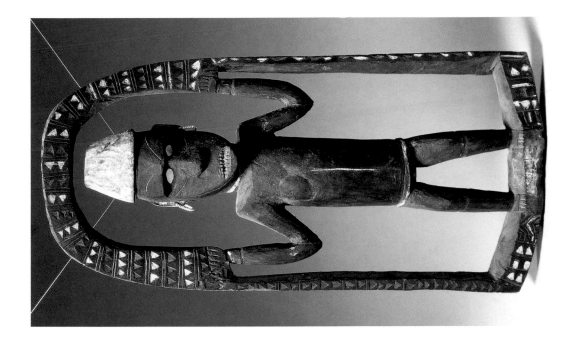

Solomon Islands canoe paddles

Solomon Islanders believed that skulls contain the life force, so headhunting was used to transfer power from victims to the warriors. Headhunting expeditions were dramatic performances. Canoes set cut with streamers of leaves, flowers and feathers tied to the bow and stern. Invading warriors wore feathers, paint and shell ornaments, and were welcomed back ceremonially after a successful hunt with a feast and dancing. War canoes carried 30 or more warriors, with fleets sometimes containing 50–60 canoes. The canoe paddles mirrored the elaborate decoration on the canoes themselves. Paddles were decorated with low-relief anthropomorphic figures known as *kokorra*. These were depicted in a squatting position with raised hands and were believed to have supernatural powers. Finely shaped paddle clubs from the western islands of the regions frequently used straight lines and simple geometric designs. Both plain and highly decorated paddles were produced, including ceremonial paddle-clubs. The items shown here may not have actually have been used in war, since they are in such pristine condition.

REGION

Solomon Islands

MEDIUM

Wood

RELATED WORKS

Solomon Islands canoe-prow figureheads

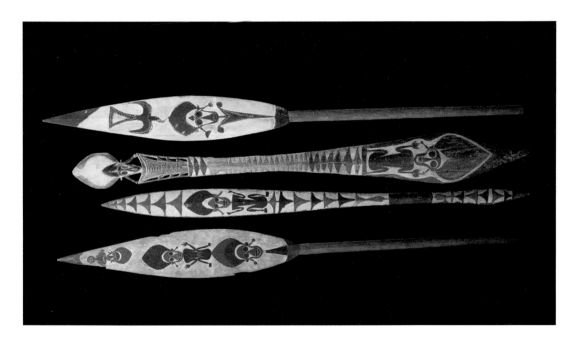

Solomon Islands canoe-prow figureheads

Solomon Island war gods were called *nguzunguzu*. They watched out for enemies, reefs and sand bars, calmed the seas and kept away evil water spirits. Anthropomorphic canoe-prow figureheads representing them typically had a projection from the back of the head for lashing to the bows. These figures were relctively small – 10–25 cm (4–20 in) and were further diminished by the overall decoration on the canoes. Despite some variation, most had many of the features of these two examples: round or pointed heads, curving shell inlay (frequently nautilus shell) patterns on each cheek, running from the bridge of nose around the eyes, from ear to nose and around the edge of the jaw. These mirror similar patterns drawn on men's faces. Some have dog-like features and hands either clasped together or holding a miniature head or a bird. Usually the body is absent.

The figureheads were carved from light wood and then stained black. Eyes were mother-of-pearl, lips were stained red and the ears were sometimes of tortoiseshell. They were often only used as a sign of a successful raiding party to those ashore.

REGION

Solomon Islands

MEDIUM

Wood

RELATED WORKS

Solomon Islands canoe paddles

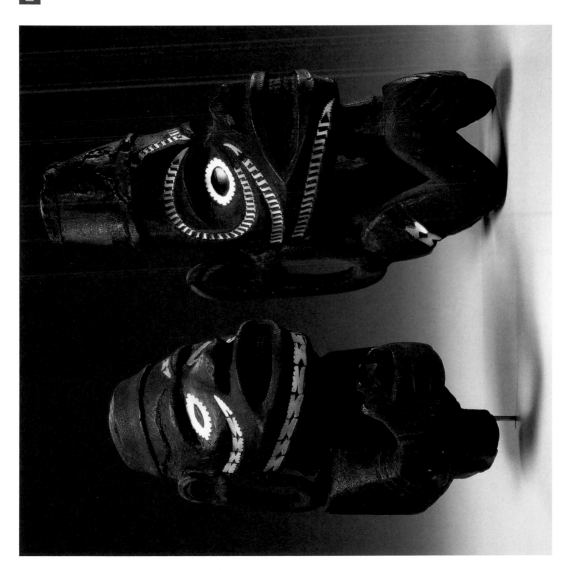

Austral Islands Tangaroa, c. 1600s–1700s

Polynesian sculpture tends to emphasize form over colour. The artists focus on the use of dignified solid forms in space. This unique sculpture from the Austral Islands represents Tangaroa, the creator and sea god of Polynesia. Here he is seen creating the other gods and men, which are shown on the surface of his, face and body. Tangaroa's facial (mouth, nose, eyes and ears) and other physical features are indicated by minute human figures in relief 20 times smaller than the main figure. These 'children' are scattered over the body in absurd positions, giving a surrealistic contrast between their squirming, dynamic poses and the calm, dignified, motionless posture of the god himself, whose concern is with rank and social standing. Further small figures were once held in a lidded, hollow space at the back of the sculpture. The Austral Island craftsmen are famous for their arts – elaborate creative woodcarving and enormous stone tikis. They tended to cover the whole surface of their creations with complicated designs often inspired by the shape of the human body. These islands were originally settled from Tahiti.

REGION

Austral Islands

MEDIUM

Wood

RELATED WORKS

Austral Island stone tikis

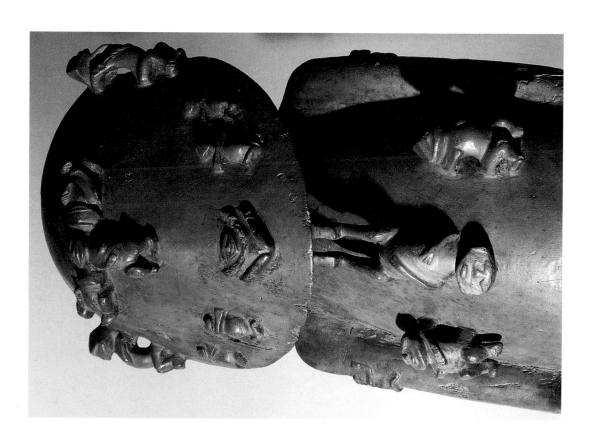

Orokolo mythical ancestor figure

This Papua New Guinea ancestor figure from the Orokolo region represents the mythical god Ukaipi, wife of Ivo. The Orokolo have two types of carved figures: *bioma* and *kakame*. The *bioma* figures are full-figure carvings, around 1 metre (3 feet) tall, with white lime accents. When headhunted skull's were displayed, each skull was straddled by a *bioma*, a smaller flat silhouette figure or a *kakame*. The legs of the figures were inserted into the skull's eye sockets. In front of the skull other small figures called *agiba*, ancestor boards and a row of pig and crocodile skulls were arrayed. *Kakame* figures are more three-dimensional than *biomas* and are sometimes carved from tree branches. Similar figures are used as headrests and stools. These may represent bush spirits called *umu* and are often dressed with a grass skirt. Carvings from the Papua Gulf emphasize the human face – especially the eyes – with black, red and white paint. In 1939 Christian converts burned down the Orokolo big men's house, and the elders stopped carrying out the initiation rites necessary to continue the traditional cultural ways. Public ceremonies and ritual ceased.

REGION

Papua New Guinea

MEDIUM

Wood and grass

RELATED WORKS

Papua New Guinea chest ornaments

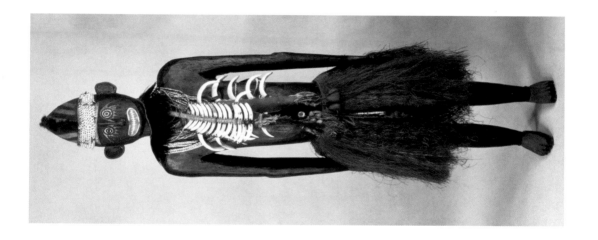

Papua New Guinea chest ornaments

The tribesmen of New Guinea love personal adornment and lose no chance to dress themselves up. In fact, adornment in the highlands of the island is among the most colourful and spectacular in Oceania. This is particularly true during festivals, where it reflects the pride and strength of the various groups. These three examples of chest ornaments from Papua New Guinea are typical and atypical in that each work of this type is a unique creation. With all the varied materials at hand, there are endless possibilities. Some types of shell are considered more valuable than money, and it is the brightness and shininess that draws the eye and creates status. Types of teeth are myriad: dogs, crocodile, porpoise, pigs tusks and human, to name a few. Bird feathers, seeds, bark cloth, bone and natural fibre binding are all knotted together with great care and skill. Sometimes bones of the deceased are used, or a whole bird of paradise. Chest ornaments are often symbols of wealth. Add to this body paint, hair ornaments and wigs, and tattoo or cicatrix scars, and the virtual nakedness of the men goes unnoticed.

REGION

Papua New Guinea

MEDIUM

Various

RELATED WORKS

Orokolo mythical ancestor figure

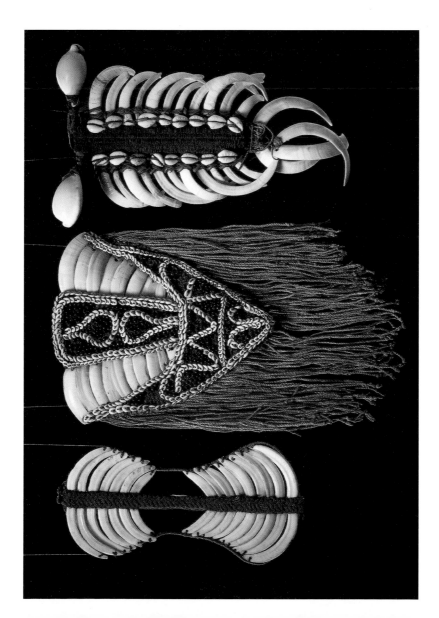

New Britain dance masks

These three masks are from Tolai, New Britain. Masks in this region of Melanesia were made for many different purposes and are of different types. Some included the power to counter black magic (savi); some represented spirits of clan totems. Different points and decorative elements were appropriate to different occasions. Some provoked admiration from the spectators (especially women), and others preserved male well-being from the threat of female pollution. Art in this area was less oriented to things than to performances. The object was not so important as the ritual drama in which it was employed. An object's meaning and value was established and reinforced through the ceremonial occasions in which the spirits were invoked. Sometimes the masks were discarded after the ceremony was over. Another element of the whole ceremony was the spectacular decoration of the human body wearing the mask – sometimes the individual was known, often he was not. Dances were associated with inter-clan exchanges, events, pig-killing ceremonies and warfare.

REGION

New Britain

MEDIUM

Various

RELATED WORKS

New Guinea mask

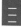

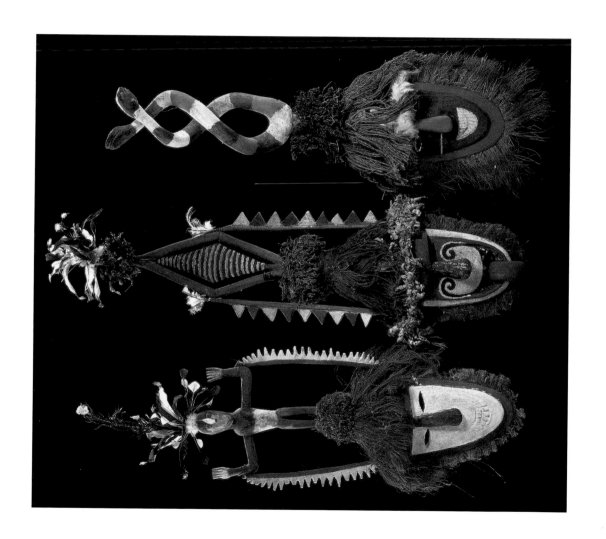

Maori whalebone comb and pendant, c. 1700s

In Maori cosmology, whales were descendants of Tangaroa, the god of the oceans, and they appeared in many tribal migration legends as guides or as signs indicating where to settle. Stylized whale shapes symbolizing the bounty within were often carved on bargeboards or storage houses. Pendants carved from the teeth of sperm whales are highly prized by today's Maori, who still carve beached whalebone into clubs, cloak pins and combs. This comb and pendant from the eighteenth century are examples of *taonga* (sacred objects or treasures), which were handed down through the generations. Without written language, the Maori used such objects to tell the stories of the gods and tribal histories. These objects became a spiritual link between people spanning time and distance, and contain the spirit of all those tribal members who have worn it. Most carvings combine elements from several areas of mythology. These interact to tell a story, thus giving each carving is own special character. Great importance was placed upon each piece; some took years in the making.

REGION

New Zealand

MEDIUM

Whalebone

RELATED WORKS

Maori Hei-Tiki pendant, c. late 1700s

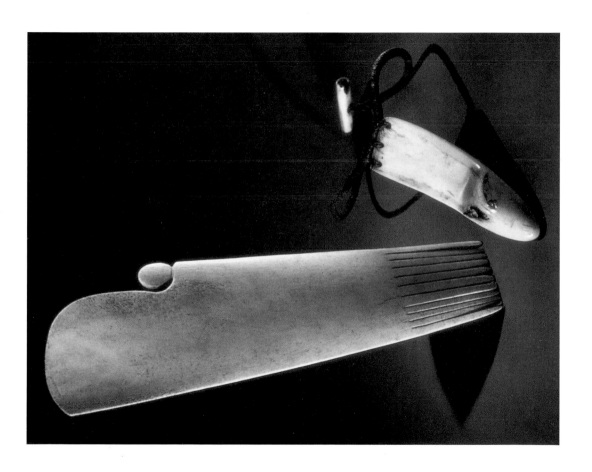

Maori Hei-Tiki Pendant, c. late 1700s

This Maori nephrite pendant is in the form of the god Hei-Tiki ('neck tiki'), who is shown as a small distorted quasi-human figure. Three fingers on a carving connotes that the figure is supernatural. It has some typical tiki design features: the large head, huge round incized eyes and a representative open, grimacing mouth. These pendants were believed to have magical properties and were worn as an amulet. In addition to being regarded as bringing good luck, the tiki is also considered a fertility symbol. It is a very ancient symbol and not clearly understood because of the number of differing legends about it's meaning. Tiki was respected as the teacher of all things. Thus the wearer was believed to possess such Tiki-like qualities as clarity of thought, loyalty, great inner knowledge and strength of character. Tiki was often depicted with webbed feet, suggesting a strong link to sea creatures. According to some Maori myths, he came from the stars and was the first man of the world. Nephrite is a hard green stone found in one small area of the South Island. It was also used for tools and weapons.

REGION

New Zealand

MEDIUM

Nephrite

RELATED WORKS

Maori whalebone comb and pendant, c. 1700s

Caroline Islands statue of Sope, c. 1700s–1800s

The Caroline Islands are technically in Micronesia, but were actually settled by a reverse migration of Polynesians. The islanders produced curious statuettes called *tinos*, which represented their deities. These figures have a powerful abstract quality often regarded as Polynesian in style. Micronesian art in general is streamlined, highly finished and executed with astonishing precision.

This statue is believed to represent the Nukuoro Island god Sope. Two original features of this art style present themselves. First, the head is conventionalized in the form of an egg, with the small end making a chin. Secondly, the arms fall straight and harmoniously, partly stylized and detached from the body. This female figure has an indication of a tattoo at the abdomen, obligatory for women on the island. The chest is also simplified, with a single horizontal raised portion crossing the breast line. At first glance, this could be a Constantin Brancusi sculpture in its elegance and simplicity. The Caroline Islands are also known for their geometric renderings of humans, stars and fish on banana and hibiscus fibres and in their loom-woven works.

REGION

Caroline Islands

MEDIUM

Wood

RELATED WORKS

Caroline Islands fibre art

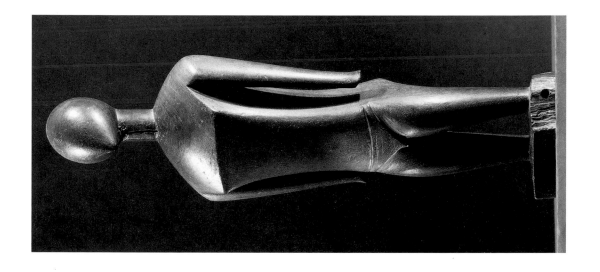

Hawaiian armlets, c. 1700s–1800s

These magnificent boar-tusk armlets (*kupe'e ho'okalakala*) were crafted in the eighteenth or nineteenth century, and would have been worn by hula dancers. Between 19 and 24 full-length tusks, each measuring 10–13 cm (4–5 in) long were pierced in two places and threaded with olona fibre cord.

The hula began as a sacred ritual, which has flourished over time as an art form. At one time there were over 300 distinct hulas in the Hawaiian repertoire, some for ritual use and others for entertaining and gladdening the heart. With the coming of western missionaries, these were suppressed and all but died out. A resurgence during the reign of King David Kalakaua (1874–91) brought back the more secular form, which is still danced today. Both men and women performed the sacred hula, which was a delicate, subtle and artistic form of the dance and which took many long years of apprenticeship to master. Using undulating hips and hand gestures, each movement of the dancer has a specific meaning and can invoke a shark or a palm frond waving in the breeze. With these elements, the dancers told the story of the wondrous legends of the Hawaiian Islands.

REGION

Hawaii

MEDIUM

Boar's tusk

RELATED WORKS

Hawaii feather god

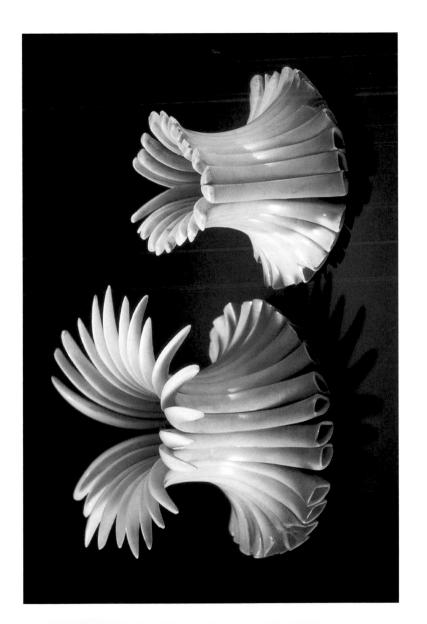

Santa Cruz chest ornament, c. 1800s

This beautiful item is a *tema kapkap* or chest ornament from Ndeni Island, Santa Cruz in the Solomon Islands. Collected before 1890, it was fashioned from tridacna (giant clam) shell, turtle shell, stone and animal teeth, with a vegetable fibre running from the centre to the edge, holding the turtleshell design in place.

Important male dancers wore full-moon style *kapkap* breast ornaments during ceremonies, and eminent warriors displayed them in battle. The lower section of this turtleshell pattern is thought to be a frigate bird, which usually represents spirits of the dead. These birds were important to the Santa Cruz Islanders because their diving showed local fishermen where schools of tuna (*bonito*) could be found. The central section of the turtleshell pattern shows a *bonito*, though some are thought to show sharks. Fish also represent spirits of the dead. Another interpretation of the centre motif is that is signifies the skeleton of an ancestor. A third interpretation is that of a caterpillar that infects banana plants. The frigate-bird design was common on breast ornaments.

REGION

Solomon Islands

MEDIUM

Tridacna shell, turtle shell, stone and animal teeth

RELATED WORKS

Papua New Guinea chest ornaments

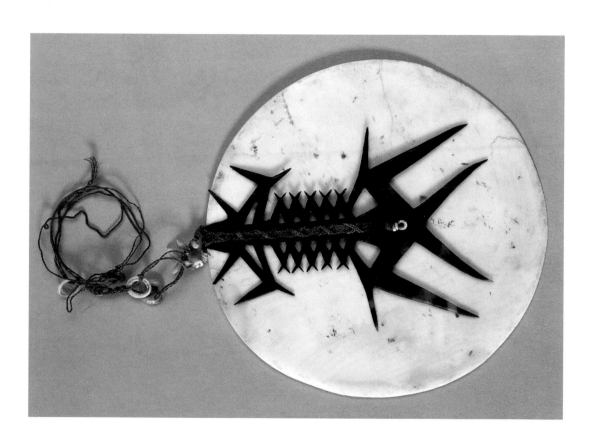

Maori taiaha staff, c. 1800s

The taiaha staff was a weapon carried by Maori warriors. It consisted of a staff with a wooden tongue-shaped blade at the end and typically measured up to 1.5 metres (5 feet) in length. Sticking the tongue out is a traditional sign of Maori defiance before one's enemies. The broad head of the blade allowed room for ornate carvings, while further enhancements of feathers or dog's hair were placed just below. The lower section was flattened into a paddle and used as a striking blade. Sometimes the pointed end was used to initially poke at the opponent, and then when the moment was right, the taiaha was reversed and the paddle used to crack open the opponent's skull. The blade was usually carved with the same design on both sides.

The taiaha was regarded as a status symbol for warriors, and chieftains tended to hold theirs at all times as a sign of rank. All men were trained in the arts of taiaha, with a select few sent to various masters for advanced skill development. This weapon is regarded as one of the most devastating weapons of hand-to-hand combat ever produced.

REGION

New Zealand

MEDIUM

Wood

RELATED WORKS

Maori war cloak, 1836

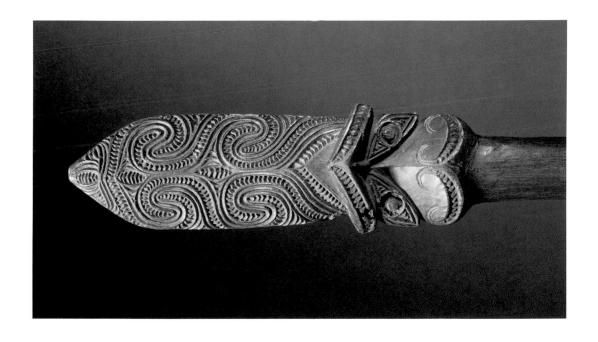

New Ireland mask, c. 1800s

New Ireland is part of the Bismark Archipelago north of New Guinea. Art here is traditionally centred on mortuary ceremonies and feasts to honour the dead. The name for these ceremonies is *malagan* and the same term is also applied to the carved and painted sculptures associated with the ceremonies. Preparation for the fêtes is expensive, requiring a great deal of wealth in the form of pigs and shell money, and can take anywhere from three to four weeks to several years. Performances are organized, feasts are prepared and carvers are commissioned to create complex sculptures that incorporate multiple figures within the design.

The *malagan*'s purpose is to send the souls of the deceased to the land of the dead. It is believed that these souls actually enter the sculptures. At the climax of the ceremony, the *malagan* sculptures are displayed in temporary exhibit shelters and treated with great reverence. Each sculpture honours a specific individual and represents his soul or life force. In south-eastern islands, small limestone chalk figures called *kulap* are broken after the ceremony, thus releasing the souls into the realm of the ancestors.

REGION

Papua New Guinea

MEDIUM

Painted wood

RELATED WORKS

New Britain dance masks

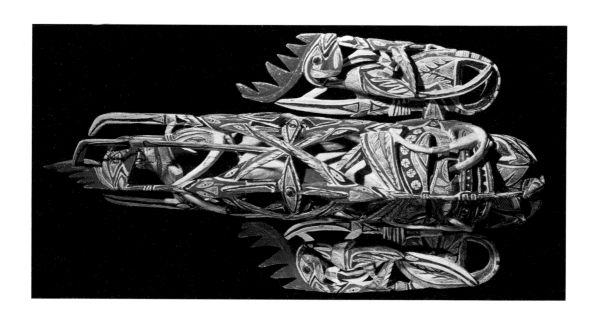

Maori war cloak, 1836

The art of cloak weaving (*whatu kakahu*) is the most prestigious of Maori women's arts. Dog skin or feathers were commonly used to enhance the woven flax. Shown here is *kahu topuni*, a chief's war cloak that was woven with sacred flax and decorated with thin strips of dog fur. It was given as a peace offering in 1836 by the Arawa to the Ngaiterangi tribe to mark the conclusion of a long and bloody war.

Traditionally, cloaks were made of feathers; in the late nineteenth century cloaks with kiwi feathers became the most prestigious of all fine cloaks. From the Maori viewpoint, ornamented treasures (*taonga whakairo*) were not just inanimate objects, but were thought to be living beings imbued with *mana* and having their own genealogy. Such creations were meant to be touched, respected or feared: often in the presence of such objects, one might tremble or weep. Taonga might be approached as mediators between the worlds of the living and the dead and were spoken to as such.

REGION

New Zealand

MEDIUM

Flax and dog-skin

RELATED WORKS

Maori Taiaha staff, c. 1800s

Maori *moko* signature, 1840

This image was used as a signature by Tuhawaika, a chief of the Kai Tahu tribe, on a deed of sale of land on the Catlins coast of South Island in 1840. It was a copy of his *moko* (facial tattoo) pattern and is an example of how intricately this Maori art form was expressed. In Polynesian mythology, Moko is the lizard god. In Hawaii, a Mo'o is a guardian spirit (usually of wetlands or water bodies) that takes the form of a large lizard or human.

The stunning facial spirals not only told a story but also served to make the wearer's facial grimaces more threatening. *Moko* uses the chin as a focus and both positive and negative space is meant to be read. The Maori were adept at reading the stories in the tattoos, which was important for rituals of encounter. Any diversion from the acceptable norm of greeting based on social status was regarded as an insult and could end in fatalities and generations of unresolved feuding. *Moko* was a tool by which hierarchical custom was observed and maintained. While the Maori already had this art form well established before arriving in New Zealand, it became even more dynamic after they settled.

REGION

New Zealand

MEDIUM

Paper

RELATED WORKS

Maori meeting-house figure, 1842

the aforementioned Edward Bath is

fully entitled to hold the afore stated

land, or that any hindrance or let from

Witness—

Henry Hixtoth

John Souraick

Kukawawaira

Souraick
Tongaoho
hy co akiali
Benita

Maori meeting-house figure, 1842

The Maori art of tattooing was known as *ta moko*. It was meant to be read holistically by viewers to give information on the wearer's genealogy, status, occupation and personal history. Each line or group of lines is a component of a larger picture, which can refer to battles attended, chiefs slain or wounds received. A key motif was the *koru* or spiral, which was often not one but two or three parallel lines ending at one point. Another dominant component is *haehoe* lines, which were prominent around the mouth, lips, up the forehead and on the cheek.

Placement of tattoo elements was crucial. For example, *moko* on arms contained a message about the occupational activity of the wearer and might differ from facial design elements. One scroll pattern, *puhoro*, means 'fast to move'; its origin could be the pattern that canoe paddles and the canoe itself leave as a wake in the sea. This figure can be recognized as a portrait of Raharu hi Rukupo, the chief responsible for directing the carving of the Te Hau-Ki-Turanga meeting house built by the Ngati Kaipoho tribe in 1842.

REGION

New Zealand

MEDIUM

Wood

RELATED WORKS

Maori *moko* signature, 1840

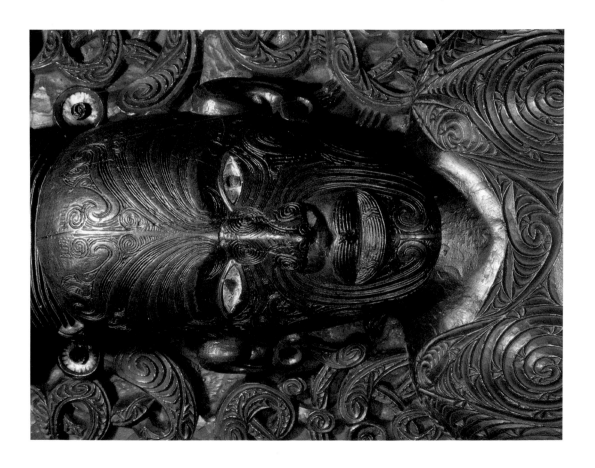

Maori war-canoe head, c. 1846

Maori war canoes were magnificent to behold, with beautifully carved prow and sternposts as well as side panels. They could be up to 21 metres (70 feet) in length and could hold up to 100 fearsomely decorated warriors paddling swiftly. Wars were a constant feature of Maori life. They could be caused by conflicts over land or insults of every description. Because the defeated party had to avenge its humiliation, war was a never-ending proposition. The Maori developed war to a high art, with stockades, dawn raids and elaborate rules of engagement. Wars greatly intensified through the introduction of muskets by the Europeans.

This richly decorated head decorated the war canoe of Rauparaha, a Maori chieftain in the mid-nineteenth century. It exemplifies not only the rich spiral (*koru*) decorative motif commonly used, but also a type of openwork spiral known as *pitau* or *takaranga* that created a lace-like effect. Maori woodcarving could be enhanced with feathers, as in this instance, and with red ochre, the blood of Mother Earth.

REGION

New Zealand

MEDIUM

Lithograph

RELATED WORKS

Solomon Islands canoe-prow figureheads

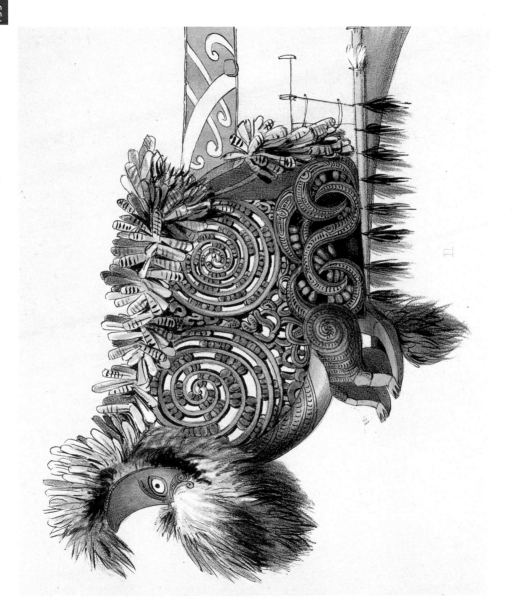

Fijiula (throwing clubs), c. 1850s

The *lula* or chief's throwing club of Fiji was the most deadly Fijian weapon. When the handle struck first, it pierced the flesh. The heavy head then jack-knifed into the victim, dealing a crippling, if not fatal, blow. These clubs had short handles and bulbous heads, and were quite capable of competing with revolvers at close range. Few other peoples such heavy or finely carved clubs. The variety and unusual shapes may derive originally from stone heads or pineapples. During the first half of the nineteenth century, many parts of Fiji were in constant state of warfare. Clubs were used in combat as well as bows and arrows and spears. By the 1870s, the use of clubs hafted with European axe heads superceded traditional ones. Fijian clubs came in other forms. The *bowai*, or pole club, was shaped like a baseball bat and was used for general disabling blows as well as breaking bones. *Waka*, or root clubs, had straight handles with a natural knot of roots at the end that easily crushed skulls. 'Gun stock' clubs resembled rifles (long before real ones appeared) and were designed for cutting and disjointing blows.

REGION

Fiji

MEDIUM

Wood

RELATED WORKS

Fijian *bowai* and *waka* clubs

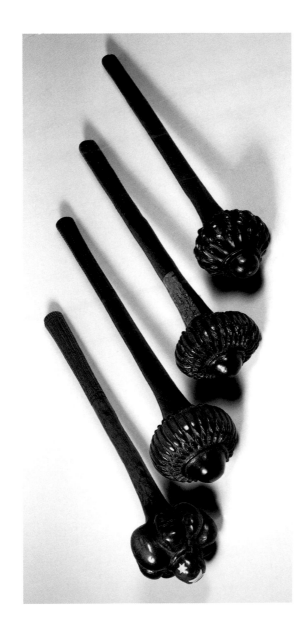

Torres Straits crocodile mask, late 1800s

The Torres Straits mask tradition is estimated to have lasted from before 1606 to about 1900. The Spanish explorer Diego de Prado first recorded the existence of intricate masks and figures fashioned from plates of turtleshell in 1606, a testimony to the antiquity of the tradition. They were used primarily during male initiation and at funerary rituals. The masks represented mythical culture heroes and their associated totemic species. Some masks were human forms; others symbolized birds, fish or reptiles, with many combining human and animal features. Each type of mask had a name related to the purpose of the ceremony for which it was made. It was designed to cover the head or face. While primarily used for rituals to increase garden produce, for hunting success, sorcery and initiation, some masks were also made for children or as effigies on canoes. This crocodile mask from Mabuiag, created in the nineteenth century, is made of turtleshell, pigment, cassowary feathers and seedcase rattles. The crocodile is a prominent totemic design motif, appearing elsewhere as circumcision benches, canoe prows, headdresses and as crocodile-teeth necklaces.

REGION

Torres Strait Islands

MEDIUM

Turtleshell

RELATED WORKS

Torres Straits mask

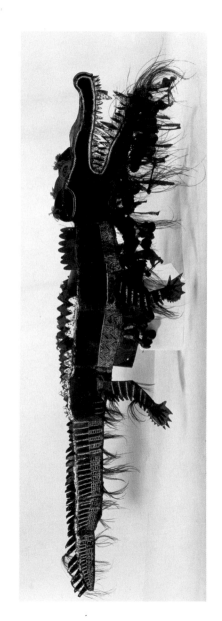

Maori toboggan, late 1800s

Rehia is the Maori word for 'pleasure'. All games and pastimes are referred to as *nga mah a te rehia* ('the arts of pleasure') and are treasured in Maori culture. This delightful child's wooden toboggan from the late nineteenth century was used on a slope made slippery with water. Its 'face' is beautifully carved with *moko* tattooing, perhaps telling its individual story or provenance.

The Maori placed great stress on the desirable effects of physical exercise – especially for boys who were destined to become warriors. They were encouraged to practise games calling for the development of agility and dexterity, and frequent competition upped the ante. Children learned to swim at a very early age and were taught to be absolutely fearless in water. Daily life was rich in games such as jackstones, knucklebones, draughts, stilt walking, and dart throwing. Toys included kites, two types of tops (whip tops and humming tops) and well-carved jumping-jack toys manipulated with strings to make insulting *haka* dance motions. The children also had riddles, puzzles and their own simple fables and stories.

REGION

New Zealand

MEDIUM

Wood

RELATED WORKS

Maori meeting-house figure, 1842

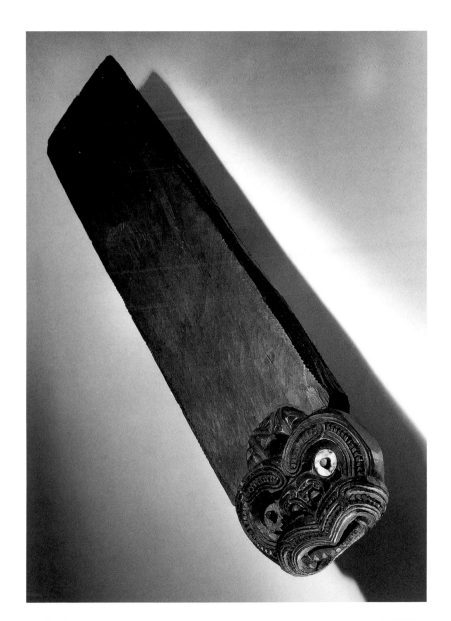

Easter Island ancestral statue, c. 1890–1910

Early nineteenth century Easter Island wood sculpture reached an efflorescence of technical skill because of the introduction of steel tools and supplies of imported wood. They were hallmarked by economical use of wood and great precision and beauty. This ancestral statue, *moai kavakava*, was produced between 1890 and 1910 and is a better-nourished version of the typical emaciated, skeletal figure.

These small wooden and stone images had prominent place in each household, and were the medium through which the family communicated with spirits. Typical characteristics of this artistic genre are heavy brows, prominent nose, nude males standing with knees bent, goatee, pronounced grimace, skeletal 'ribs, carefully delineated vertebrae and two arms hanging straight down. Many of these features resemble those of corpses. The eyes were sometimes hollow sections of bird bone and the pupils were fragments of obsidian.

Ancestor figures were wrapped in bark cloth when in the home. During certain religious feasts, people held them in their arms while singing and dancing. Other Easter Island art forms include bark-cloth images, wooden ornaments, feather work, petroglyphs, 'talking boards', and stone carving.

REGION

Easter Island

MEDIUM

Hardwood

RELATED WORKS

Easter Island monolithic statues, c. 1100–1650

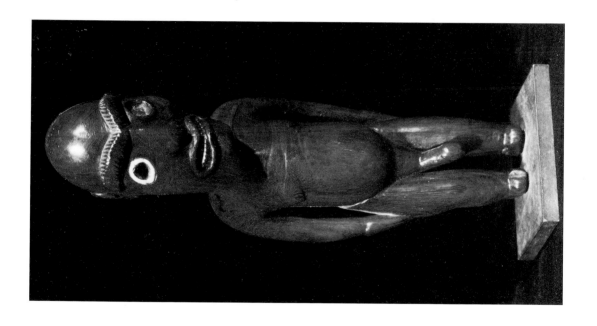

Irian Jaya painted bark cloth, c. 1900s

On the extreme north-east corner of what was formerly western New Guinea, the women of Lake Sentani make highly distinctive bark cloth skirts or loincloths called *maro*. Unmarried women and men remain naked. The cloth is produced from the bark of the paper mulberry, pounded into a felt-like mass and decorated with freehand designs in red, black and brown. The colours are derived from local clays, native plant dyes and charcoal. Because the subsistence economy is based primarily on fishing and sago harvesting, many live in dwellings built on posts over the lake.

This *maro* is decorated to reflect the importance of fish – both in life and as a design element. The motifs are stylized waves, fish and frigate birds. Bark cloth rectangles are used in gifts associated with marriage ceremonies and also worn over the shoulder by women for ceremonial display. Each design has a specific meaning to each clan. Some pieces are abstract, with highly dynamic interlocked curvilinear forms, and others are hybrid fish-like or lizard-like creatures often with human faces. These are still produced today for the collector market.

REGION

New Guinea

MEDIUM

Bark cloth

RELATED WORKS

New Guinea mask

Solomon Islands forehead ornament, c. 1910

In the Solomon Islands, high-status individuals wore *kapkap*, which were pendants or round chest ornaments made from precious materials – turtle or giant clam shell (tridacna shell) – to signify rank and prestige. The shell disk ornament with intricate filigree patterns in turtle shell is typical of the art of these islands and can be quite beautiful. This particular *kapkap* is a forehead ornament from Malaita Island, made around 1910 from turtle shell, stone, shell beads and plant fibre. Sub-nasal pendants were made of mother-of-pearl to a similar shape and design. *Kapkap* were greatly prized because the original wearer must have killed an enemy. They were affixed most often on the forehead or above the temple, although women sometimes borrowed them and wore then as a pendant. Typically, they were crafted by finely working turtle shell with crude implements of stone or hardened bone and then overlaid on to a second disk of polished tridacna shell. The luminous whiteness of the background material brings out the fine workmanship of the *kapkap* itself.

REGION

Solomon Islands

MEDIUM

Turtle shell, shell beads and plant fibre

RELATED WORKS

Papua New Guinea chest ornaments

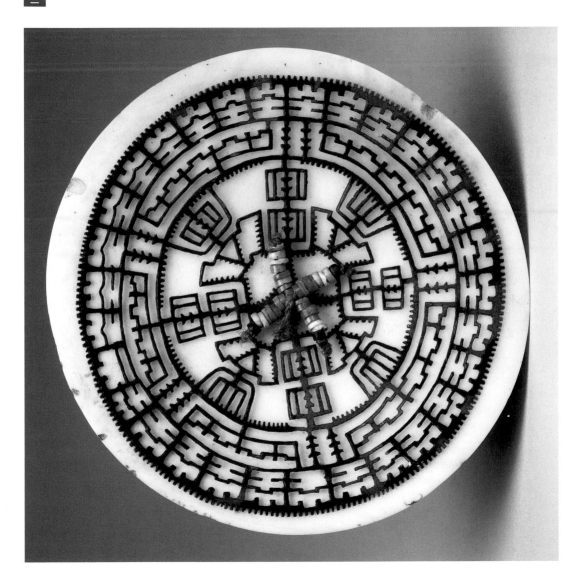

Papua New Guinea ancestor board, c. 1950s

Gopes, or carved ancestor boards, were made from old canoes in Papua New Guinea. There were three types: the most sacred was a large 'named' board owned by a clan. Smaller 'named' boards stood at entrances to clan areas in the long houses. The smallest 'unnamed' boards were owned by boys and young, uninitiated men. These were hung in their sleeping area to help them grow strong. Similar tablets were called *kwoi* and *hohoa*.

Ancestors had the important quality of *imunu*, the power that pervades things, including ritual objects. *Gopes* were used to divine which village to raid and then sent in advance. Carvers were old men who stayed home in the village. The wood was charred before carving with a shark's tooth so the relief design stood out as they worked. The face was emphasized, especially the eyes. Colours included a pink ochre traded from outside, local yellow and red clays, soapstone for grey and powdered white lime. This *gope* shows a geometric design with bilateral symmetry incized into the surfaces. Black, red and white in the recesses accentuates the raised detail.

REGION

Papua New Guinea

MEDIUM

Wood and paint

RELATED WORKS

Papua New Guinea chest ornaments

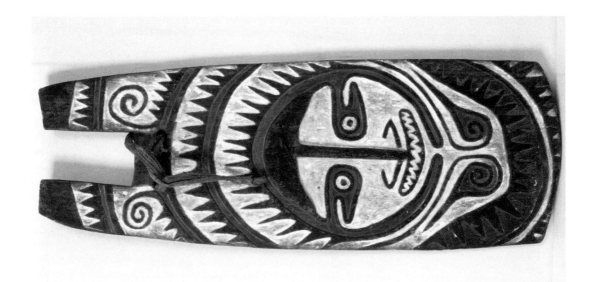

Hawaiian cluster of god figures, 1970

Hawaiian figurative carvings of the eighteenth and nineteenth centuries were some of the most visually compelling yet mysterious works created in Polynesia. Characteristic features of Hawaiian sculptures include elaboration of the head, dislocation of the eyes, protrusion of the jaw, mouth or tongue, faceted surfaces and a 'wrestler's' or 'low-style' dance pose. Buttocks, thighs and calves all have muscular mass with the legs slightly apart and knees flexed or bent. There is often a distinctive horizontal ridgeline crosses the chest. This cluster of tall wooden god figures is located at the Pu'uhonua o Honaunau National Historical Park on the west coast of the big island of Hawaii. The park was established in 1961 on the site of an original place of sanctuary, and the 180 acres of extensively reconstructed grounds include a palace, temple and great wall restored to their probable appearance in the late 1700s. This scene is also recently constructed. The Hawaiians placed their deities, often an image of their war god, Kukailimoku, in semicircular rows within an enclosed temple area (heiau). These figures shared a tendency towards athleticism and defiance.

REGION

Hawaii

MEDIUM

Wood

RELATED WORKS

Easter Island monolithic statues, c. 1100–1650

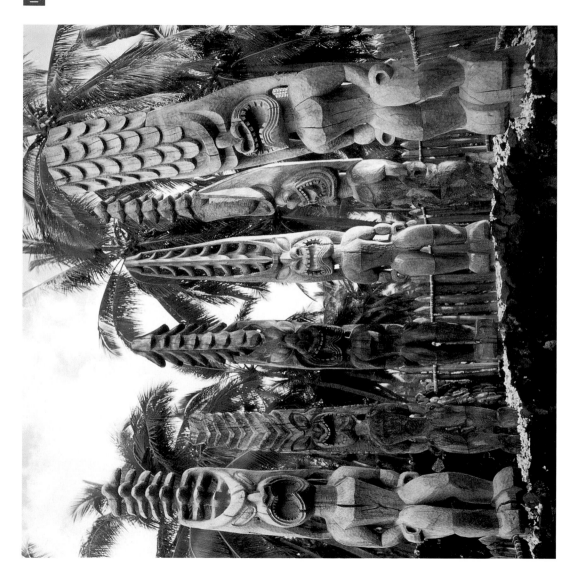

THE GREAT Folk Art

North American Art

Hopewell mica hand, c. 300 BC–AD 500

This mica hand was discovered within one of the Hopewell mound complexes of burials found in the central Ohio River valley. Flourishing from around the second century BC in the Eastern Woodlands area that spread from the east coast of America and Canada and as far south as North Carolina, the Hopewell Indians are thought to be the ancestors of the Choctaw, Creek, Chickasaw and Cherokee tribes. They grew some maize to supplement their hunter-gatherer diet and were responsible for the many small stone sculptures that have been found in this region.

The Hopewell Indians built special mounds for their leaders, and they were focal points for their religious activities. Their elaborate burials used special rites on the heads and hands of the dead, giving this hand particular significance. Mica are minerals found in certain types of rock, and when crystallized, they form flexible sheets. The grave in which this hand was found lies some 480 km (300 miles) from the nearest source of mica and the presence of this artefact is an indication of the status of the leader with which it was buried. Some graves have been discovered that were entirely lined with mica.

REGION

Ohio River Valley

MEDIUM

Mica

RELATED WORKS

Hopewell tribe stone statues

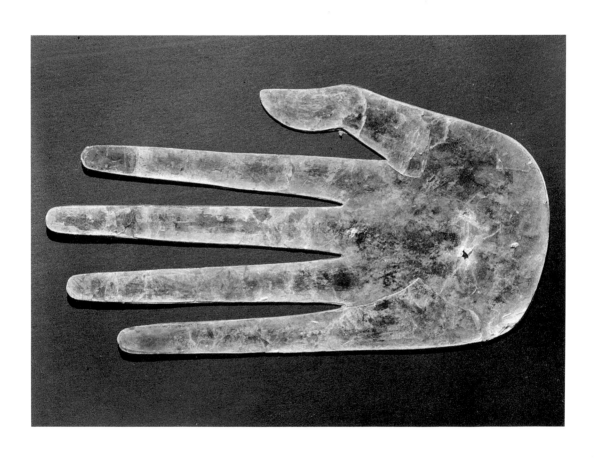

Key Marco cat, c. 1600s

This tribal representation of a kneeling cougar was part of an extraordinary archaeological find on Marco Island in 1896. This area of south-west Florida was originally populated by the Calusa Indians – hunter-gatherers who are known to have been fierce warriors. They fished in the estuaries and have been dubbed 'The Shell People' because of the great mounds of shells that have also been found here. They were scattered and disappeared soon after the Spanish explorers came to the area.

The Calusa were skilled artisans, and more than 1,000 pieces were discovered at the Key Marco site at the northern tip of the island, including masks and weapons, ceramics, bone and shell artefacts, some of which date back to the sixth century. The site was discovered by Captain W. D. Collier and excavated by Frank Hamilton Cushing. Dating from the seventeenth century, the cat is about 15 cm (6 in) high and is in remarkably good condition. It is carved from wood and represents a feline/human figure. The anaerobic properties of the mud had preserved it for centuries, but unfortunately, exposure to the air led to the loss of much of this rich find.

REGION

Florida

MEDIUM

Wood

RELATED WORKS

Calusa masks from Key Marco

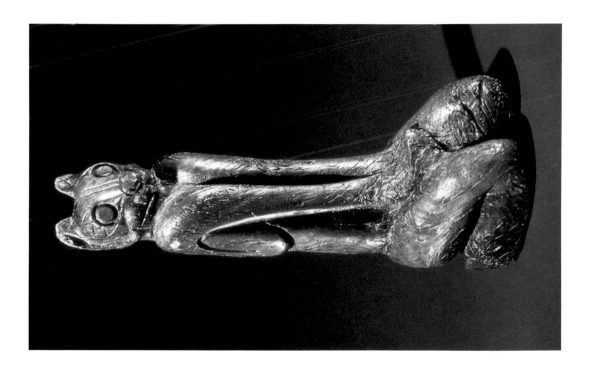

Sioux cradleboards, c. 1700s

Cradleboards or papooses provided security for babies, who would be wrapped in a blanket and bound to the board. Whilst giving the mother some freedom when carrying the child (they could be strapped to the back), the cradleboard could be safely propped up against a surface while she carried out her tasks. Widely used in North America and further afield, the shapes of the cradleboards vary according to the traditions of the tribes, and these cradleboards or papooses are typical styles favoured by the Sioux people. Their purpose is unclear, but other tribes used extensions similar to those on the cradleboard on the right. However, while different tribes usually made these extensions curved, only the Sioux used the straight extension pieces as seen here. Women would fashion these cradleboards as gifts to other women of the tribe. Quillwork was a commonly used form of decoration, carried out only by women using porcupine quills. These were softened by soaking in water before being dyed and then stitched on to leather in distinctive geometric designs.

REGION

Northern Great Plains

MEDIUM

Quillwork and leather

RELATED WORKS

Native American papooses

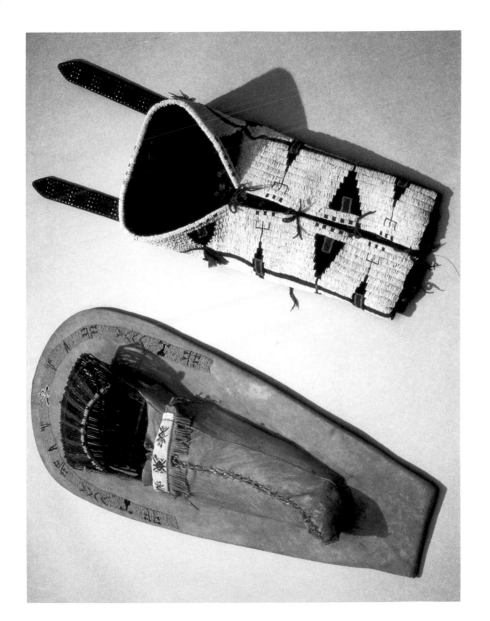

Nootka basket, c. 1700s

This woven Nootka basket shows the traditional motif of hunters harpooning a whale. The Nootka were the only whale-hunters in British Columbia, and the whale was an integral part of the life of the tribe, appearing on many of their woven goods. Only certain men were permitted to hunt the whale and they were chosen from both the chiefs and ordinary tribesmen. There was much preparations before the hunting season began in April, when canoes and harpoons were repaired. The Nootka used detachable pointed harpoons and floats. The whaling canoes were narrow and had a long prow with a squared stern.

Whale-hunting was a dangerous and arduous task that took them great distances from land. There resulted many stories of great bravery, particularly during the 'Death Run', when the harpooned whale would drag the canoe for miles – and sometimes for days – before its death. The hunters ensured that they were well-provisioned for such times. The Nootka carried out only subsistence hunting of whales and believed that the whale permitted its capture and death in order to save the people from starving.

REGION

North-west coast of North America

MEDIUM

Woven fibre

RELATED WORKS

Nootka woven fibre hats

Iroquois pipe, c. 1725

This carved wooden pipe is from northern Illinois and is attributed to the Iroquois, a term used to cover the different tribes of the Eastern Woodlands who had similar lifestyles. These include Mohawk, Oneida and Seneca. The Native American peoples of the south-west made their tobacco pipes entirely of wood but generally, the Eastern Woodland tribes fashioned them completely out of stone, or gave wooden stems to carved stone bowls.

The use of tobacco by the native population was observed by the early European settlers and recorded by Christopher Columbus. The plant was cultivated and grown in the villages of the various Native American tribes, and although used for smoking, had a more important role in ceremonial rituals. Often the tobacco would be ground and thrown on to a fire as an offering. It was also used by shamans as a painkiller for toothache and other ailments. It was also considered a poison. The shamans would draw on these ornate pipes and blow the smoke over their 'patients'.

REGION

Illinois

MEDIUM

Wood

RELATED WORKS

Cherokee Tsalagi pipe tomahawk, c. 1770

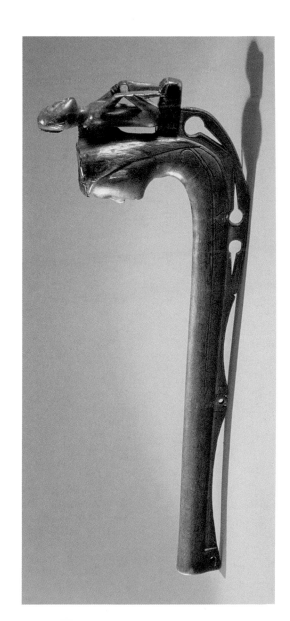

Cherokee Tsalagi pipe tomahawk, c. 1770

This pipe tomahawk, or peace axe, is attributed to the Cherokee Tsalagi people of the south-east – once the largest and most important tribe in the area. The tomahawk was made shortly before they were forced to leave their homelands in Georgia, North and South Carolina, Virginia, Kentucky and Tennessee. The pipe tomahawk is at once a symbol of both aggression and of conciliation, although they were used more as an accessory than a weapon. The name derives from the Algonquian word *Tamalak* or *Tamalakan*, meaning an implement used for cutting. 'Tomahawk' is generally used to describe a lightweight axe, and this example doubles as a pipe. The various adornments used incorporated wood, metals and feathers, and Iroquois men traded furs for such tomahawks. They also became trading goods for European-Americans.

Such pipes had religious importance and were smoked at council meetings. Ornate tomahawk pipes were given as gifts to seal alliances between different groups, and they gave status to their owners. Old photographs show prominent chiefs proudly carrying their tomahawk pipes in a ceremonial manner.

REGION

South-eastern North America

MEDIUM

Wood, steel and lead

RELATED WORKS

Iroquois pipe, c. 1725

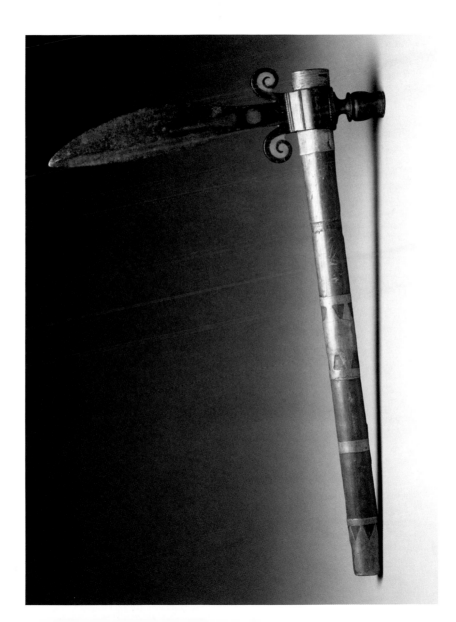

Nootka war club

The Nootka people who fashioned this war club were the first residents of Nootka Sound on the west coast of Vancouver Island. They were renowned for their unique, stylized but realistic carvings, a fine example of which is demonstrated in the eagle head and feathers carved on this war club. Although the eagle is often associated with the Native American sky gods, it also represented the gods of war, and weapons such as this would have been used in the tribal wars.

The Nootka culture was based on whaling and fishing and as such, and the Nootka people believed that salmon were people who had been transformed into fish, and who fulfilled their duty of providing food for the people as part of the cycle of life. The Nootka held special ceremonies to welcome the salmon home each year, and fish are another significant symbol found in the art and artefacts of these people.

REGION

North–West Coast

MEDIUM

Wood, hair, shell and stone

RELATED WORKS

Nootka woven fibre hats

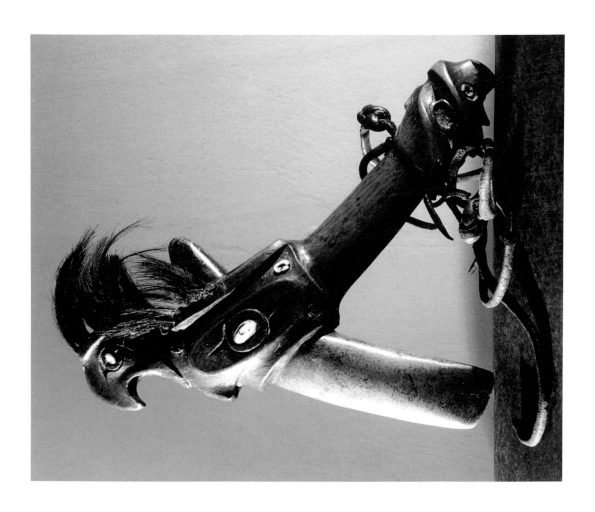

Haida eagle clan totem pole

Totem poles have become inextricably linked to our perception of the Native American peoples. They are an important part of tribal life, serving to remind the people of their history and playing a central role in the great Potlach ceremonies. The carvings on these poles are representations of mythic beings, usually animals, that had helped the tribe and given them power. They were also erected as memorials and mortuaries for the dead.

The Haida eagle clan are traditionally believed to have made the first of these symbolic pieces. There are various stories about the origins of the totem pole, and according to one legend, the outsider husband of a Haida woman saw from his canoe a vision of their village with many intriguing poles beneath the water. Later, with the help of his wife's family, the man raised his first totem pole, made from a cedar log.

This example of a Haida totem pole is surmounted by an eagle, which is the tribal crest, and represents thunder, lightning and rain. Other animals are intricately carved in brightly coloured sections, but the rear side of the totem pole always remains blank.

REGION

British Columbia

MEDIUM

Wood

RELATED WORKS

Haida shields, helmets and weapons

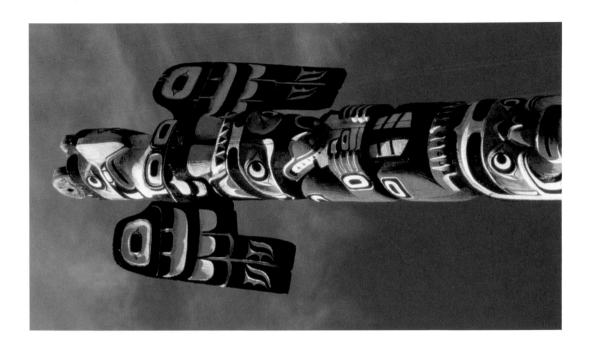

Tlingit soul catcher

This traditional bone soul catcher, decorated with inlaid abalone shell, was used by the Tlingit peoples of the north-west coast of America, and would have been a vital part of a tribal shaman's equipment. It was believed that a soul or spirit could be driven out by witchcraft or during a dream, thus leaving the body vulnerable to disease. The shaman, or medicine man, would locate the spirit and use his soul-catcher to trap it and restore it to the body.

The soul catcher is made of a hollowed-out animal bone with openings at either end, carved to resemble the open mouths of animals. When the shaman had enticed the soul or spirit into the catcher, he would plug the ends with pieces of cedar bark to imprison it within the catcher before returning it to the body. Smaller versions of the shaman's soul catcher were often worn around the neck to ward off illness, and they were also placed in the smoke holes of dwellings to catch any souls that might leave the inhabitants' bodies.

REGION

North-West Coast

MEDIUM

Bone and shell

RELATED WORKS

Tlingit wooden mask

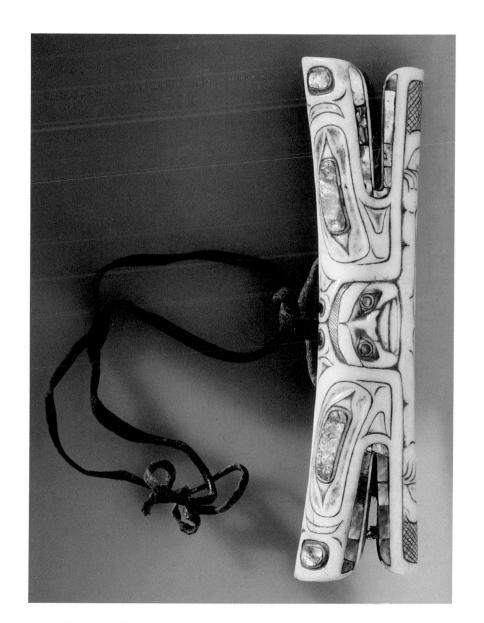

Inuit hunter statue

The semi-nomadic Inuit people of western Canada and Alaska and their forbears, the Tunit peoples, have inhabited the Arctic for around 5,000 years. They were accomplished hunters of the larger sea mammals and are well known for their superb whalebone and soapstone carvings. They mainly hunted seals, walruses and whales on the pack ice and along with fish, these mammals provided the Inuit with most of their meat. They also hunted the polar bear for its hide. Their expertise at hunting gave the Inuit a richer and more prosperous lifestyle than many other native peoples in North America, with the leisure to make carvings like this whalebone hunter.

The carving shows a man wielding a club which would have been used when hunting seals. Cape Dorset, where this piece is from, is a settlement on Baffin Island in Canada, and the area remains the capital of Inuit art today, with hundreds of traditional folk artists creating statues, carvings and other artworks in the typical Inuit style.

REGION

Cape Dorset, Canada

MEDIUM

Whalebone

RELATED WORKS

Contemporary carvings from Cape Dorset

171

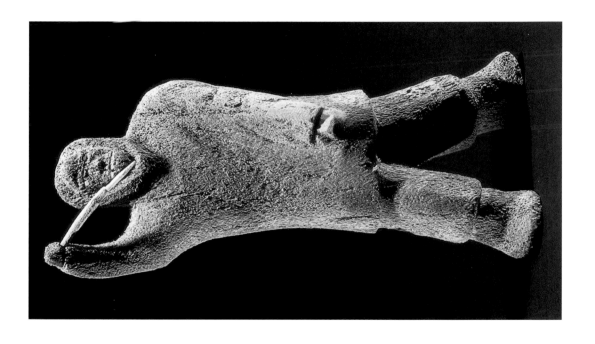

Tlingit wooden mask

The Tlingit peoples are a group of related tribes that originated on the Prince of Wales archipelago, and is divided into two groups – Raven and Eagle (or Wolf). Traditionally, the peoples of one group could only marry members of the other, but since the twentieth century, 'double-raven' or 'double-eagle' marriages have become more common. As might be expected, both the raven and the eagle (and wolf) appear in much Tlingit art.

Like many tribes from the North-West, the Tlingit culture is matrilineal, and women played a more important role than men in many aspects of life. This Tlingit wooden mask depicts an old woman, showing the traditional protuberance of the lower lip that the women displayed from puberty. The eyes and nose are very prominent and the mouth is open, revealing a frog, which was another emblem of the Tlingit people. The frog was a powerful totem of metamorphosis and transformation, and was connected to the magic of both air and water. Its link with water was believed to give the frog lunar energies. The frog was thought to control the weather and its voice could call down the rain. This mask was probably used to encourage rainfall.

REGION

North-West Coast

MEDIUM

Wood

RELATED WORKS

Tlingit soul catcher

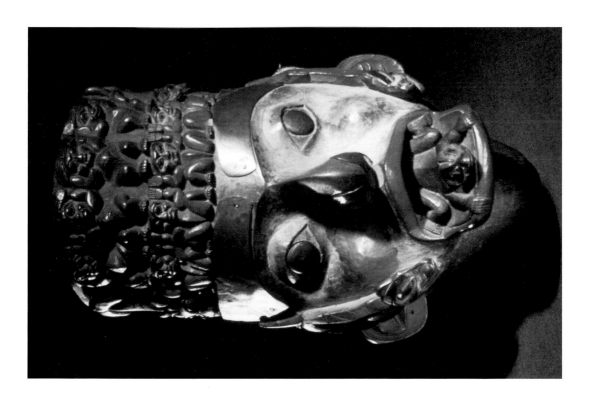

Kwakiutl revelation mask

The Kwakiutl are based around Vancouver Island and the mainland of British Columbia; they are close neighbours with the Nootka. Traditional North American masks fulfilled many functions and there was a great variety of traditional forms for the various ceremonies, based on tribal beliefs, customs and rites. The masks of the Kwakiutl people played a significant part in the ceremonial rites and dances of the tribe. They were often carved from cedar wood (red and yellow) and took elaborate forms. These were often mythological, bird or animals figures, and sometimes – as here – showed dimensions of a human face with other emblems incorporated.

The Kwakiutl were skilled at carving, and their masks were usually quite intricate, with strong curves to highlight eyes, lips and noses. They used bold-coloured paints in strong geometric lines to give them a theatrical appearance and enhance their basic form. The favoured colours were dark red, green, black and white.

REGION

British Columbia

MEDIUM

Painted wood

RELATED WORKS

Bella Coola humanoid mask

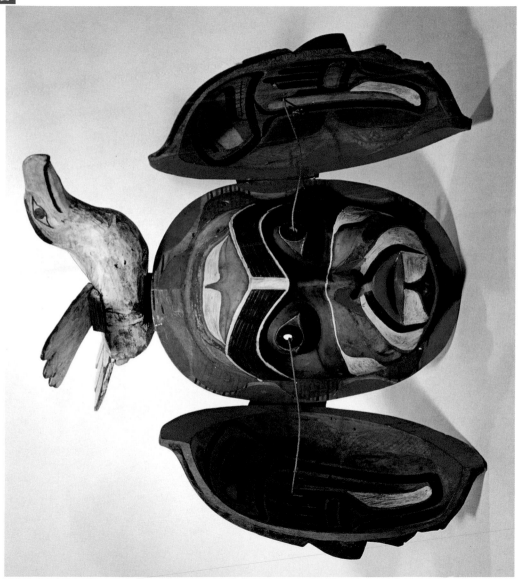

Bella Coola humanoid mask

This mask is an example of the tribal art of the north-west coastal Bella Coola people demonstrating traditional decoration. These Native Americans typically carved curved surfaces as is seen in this stylized form of a human face, which slopes away from the centre all round. On this type of carving the lips are quite prominent and open. Masks were traditionally made of cedar and the imaginative painted design of large blue 'u' or lobe shapes is also typical.

This is probably an 'ancestor' mask, used during ceremonies to honour the tribe's ancestors. The Bella Coola believed that their ancestors were descended from the Creator wearing animal cloaks and masks. The ancestor masks were worn by dancers during special ceremonies performed at certain times of the year. During these dances, the tribe believed the dancer was the actual ancestor. These masks were burned afterwards, so had to be made again for the next ceremony.

REGION

British Columbia

MEDIUM

Painted wood

RELATED WORKS

Kwakiutl revelation mask

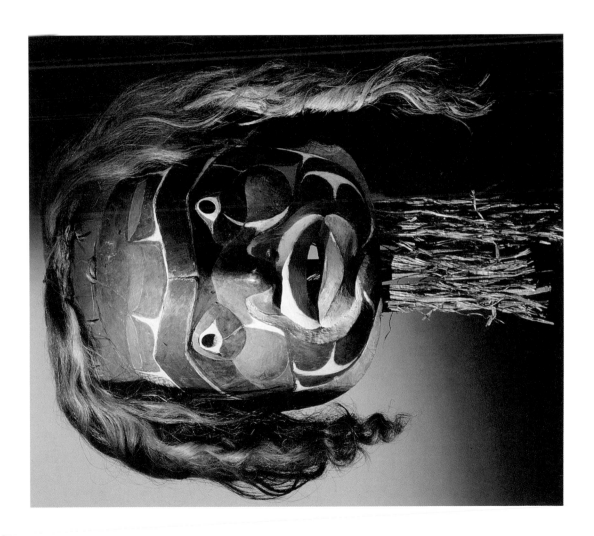

Iroquois mask

The confederacy that made up the Iroquois (including the Mohawk, Oneida and Seneca tribes) was one of the most powerful of all the Native American cultures. The union began before Europeans had ventured this far into Native American territory and made contact with the people, joined by what amounted to a constitution between the various nations, sometime in the fifteenth or sixteenth century.

This is probably what is known as a 'false-face' mask – broadly representing human features, but in exaggerated form. The men who wore these masks belonged to a secret society. New members had to fashion their own masks. Traditionally, they walked through the woods until they came upon a tree whose spirit spoke to them. They communicated with the tree, then stripped a piece of bark before fashioning the mask. They were decorated with hair (usually horsehair) and feathers, and painted in bright colours. They could then accept offerings to perform dances, wearing the mask, that they claimed would drive sickness and disease from a person or from the community as a whole.

REGION

North-East America

MEDIUM

Wood and hair

RELATED WORKS

Iroquois pipe, c. 1725

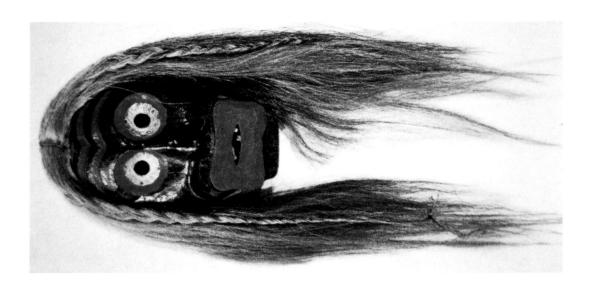

Haida feast dish, c. late 1700s

This ceremonial feast dish, carved in the shape of a dog, would have been used at the great Potlach ceremonies of the Haida. Potlatch means 'to give,' and these ceremonies involved the giving of gifts during feasting that was traditionally based on seal meat and salmon. These feasts served to establish and reinforce the relationships between tribal groups. The hosts would bestow gifts of value to demonstrate their status and guests would reciprocate. This gift-giving became highly competitive, as the different groups vied with each other with increasingly lavish items. These included food, blankets, masks, furs, wampum etc., and would sometimes end with highly valuable goods being burned in a display of extravagance that was supposed to demonstrate hierarchical superiority. There are apocryphal stories of tons of whale oil and mounds of furs and blankets going up in smoke and in the nineteenth century Potlaches were banned because of the perceived wastefulness. The feasts were made legal again later in the century, when their purpose of reinforcing relationships between tribal groups was more fully understood.

REGION

British Columbia

MEDIUM

Carved wood

RELATED WORKS

Haida Eagle Clan totem pole

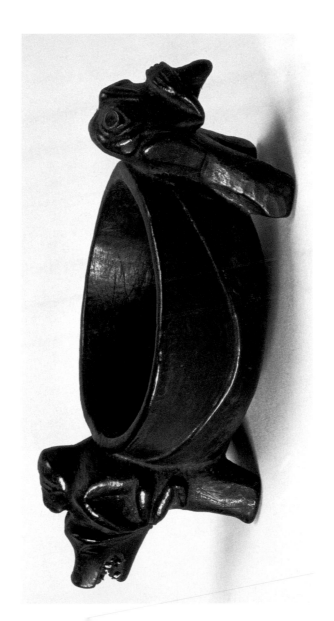

Hopi basket, c. 1800s

The Hopi are a Pueblo people, named for the area they inhabited. They continued the tradition of basketry that reaches back to the ancient peoples of the Pueblo tribes has been discovered here, and these peoples have been dubbed the 'Basket Maker Culture' by archaeologists.

The trade network of the Pueblo was extensive, and the decoration of goods was much influenced by contact with other cultures, including Mexican. Basket-making was exclusively carried out by women, whose wisdom and knowledge of the craft was essential for the making of quality bowls and baskets used and traded by the tribe. They understood the ecology of the surrounding area, and knew where the plants used in the making of the fibres could be found. They made assessments of the value of the materials and prepared them for specific uses. Many plants were used to make the fibres from which the baskets were woven, including roots and grasses. The material chosen depended on the function of the basket – whether it needed to be particularly strong or water retentive. Baskets were used for cooking until superseded by clay pots; the fibres were very tightly woven and any liquid they held would cause the material to swell and so retain it. Hot rocks were then put into the baskets to cook the contents.

REGION

Arizona

MEDIUM

Woven fibre

RELATED WORKS

Nootka basket, c. 1700s

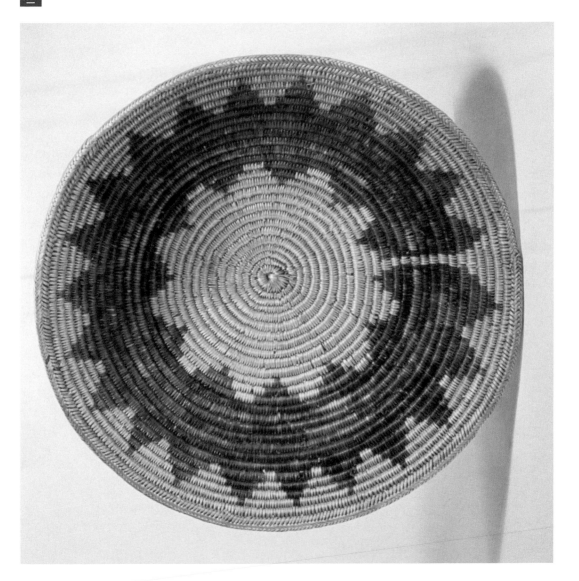

Sioux pouch, c. 1800s

This nineteenth-century Sioux pouch is made of duck skin, and was probably used to hold tobacco and pipes. It is decorated with a symmetrical geometric quillwork design and three representational Thunderbirds. The Thunderbird was a powerful symbol in some Native American mythologies – a gigantic eagle-like bird that caused awe-inspiring thunderstorms by the flapping of its wings, and lightning that flashed from its eyes or beak. It is possible that the story that some Sioux warriors come upon the body of a gigantic and fearsome bird with a bony crest on its head, is based on the discovery of a Pteranodon fossil in the rocks.

The porcupine quills that were traditionally used to make the rectilinear design shown here were sewn on to leather by women who would soften and flatten the quills by drawing them through their teeth. The quills were then dyed. The tassels that they hung from these pouches were generally cut from deer hooves.

REGION

Northern America

MEDIUM

Mixed media

RELATED WORKS

Chilkat blanket

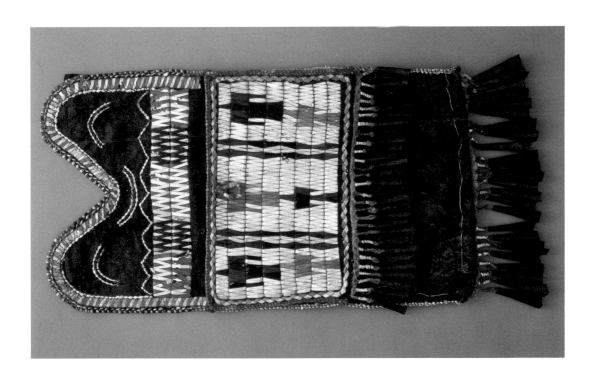

Buffalo hunt pictograph, c. 1800s

This nineteenth-century depiction of a buffalo hunt is painted in the traditional way, using pigments and elk hide. Exclusively executed by Shoshone men, pictographs like this were originally used to make a record of the warriors' bravery in battle, but by this period many recorded their exploits using paper notebooks and ledgers taken or captured from the white man.

A buffalo hunt is depicted here, showing horseback riders driving a herd over a cliff. Before the introduction of the horse in the mid-seventeenth century, the buffalo would be driven by men on foot into corrals placed at the top of ravines, where men hiding nearby would frighten the buffalo into stampeding over the edge. The use of the horse obviated the need for corrals, as the animals could be chased straight over the cliffs. This was probably one of the last depictions of a buffalo hunt before 1869, when the Transcontinental Railway was completed – giving the white man easy access to the vast herds of plains bison. Within 15 years, the buffalo was on the brink of extinction, and the entire way of life of the Native Americans was destroyed. The subsequent wholesale removal of the indigenous peoples to reservations led to a sharp decline in these colourful pictographs.

REGION

Idaho

MEDIUM

Pigment on elk skin

RELATED WORKS

Plains Indian Equipment for the Buffalo Hunt by Kills Two, c. 1900s

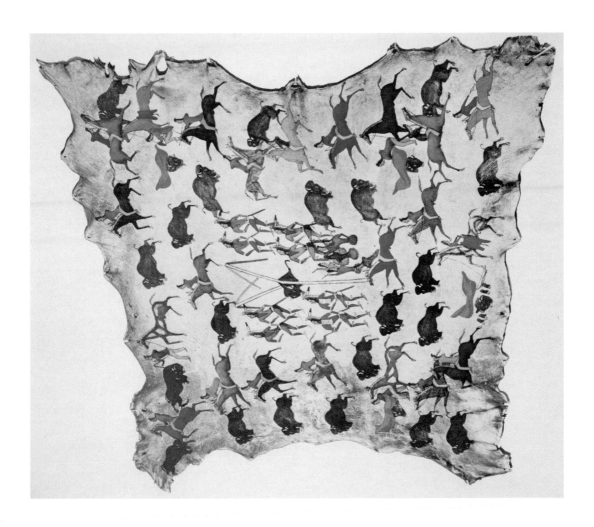

Haida dance rattle, c. 1800s

This dance rattle is a beautiful example of the Raven rattles that were used during ceremonial shamanic dances. It is carved from wood and displays the great artistry and superb carving of the Haida people. The Raven as a culture hero predominates in the myths and legends of this tribe. He is a trickster deity, and is said to have stolen daylight from the heavens and released it on Earth. The Raven holds the box containing daylight in its beak. He is also believed to have discovered the first human, peering out of a clamshell, when scavenging on the beach. He released him by pecking open the clam. Another story tells how the Raven called the Haida tribe out of the Earth.

There are other figures carved on the rattle – a human being reclines on the Raven's back and a frog is positioned above, extending its tongue into the human's mouth. This signifies the relaying of a message. A kingfisher is carved upside down, and on the front of the rattle is a creature combining all the creatures associated with the sea that supported the lives of the tribe.

REGION

British Columbia

MEDIUM

Painted wood

RELATED WORKS

Tlingit shaman's rattle, c. 1800s

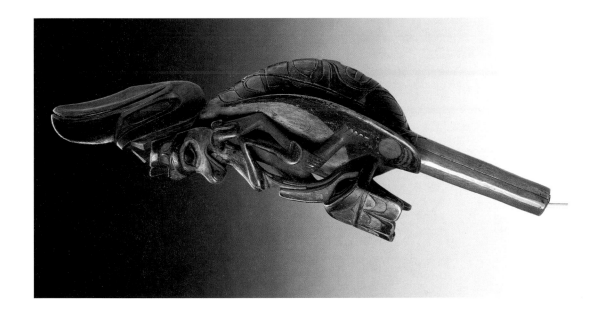

Tlingit shaman's rattle, c. 1800s

Shaman's rattles of the north-west Tlingit were usually ornately carved in the shape of stylized birds and mythical creatures – the Raven rattles being the most numerous. However, they also sometimes took a simpler form known as the globular rattle. This was usually carved into the shape of a human face. This example, dating from the nineteenth century, is of typical Tlingit form – the face is rounded and the eyes are very large. The corners of the mouth are turned down and it represents a spirit. These globular rattles are used by other tribes, and frequently have a face carved on each side (Janus-faced).

The rattles and masks of the shaman possessed powerful magic and were only safe in his hands. When a shaman died, these goods were buried with him to avoid any harm befalling the community. For this reason, a shaman's grave was watched over by carved wooden guardian 'helpers'. The Tlingit believed that spirits of the dead journeyed to a special place in keeping with their life on Earth, before being reincarnated. The shaman, however, would journey to a cave with all his possessions.

REGION

North-West Coast

MEDIUM

Wood

RELATED WORKS

Haida dance rattle, c. 1800s

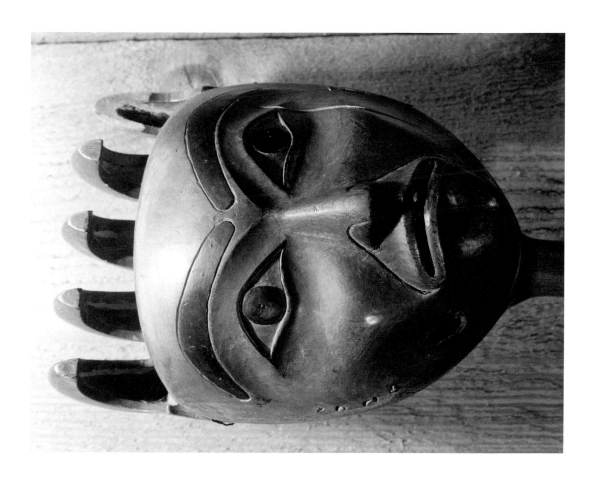

Navajo bracelets, c. 1800s

These fine silver and turquoise bracelets were made by Navajo artisans at the time of the genesis of this kind of jewellery-making. The Navajo had fashioned jewellery out of semi-precious stones and shells for hundreds of years when they were shown the possibilities of silver – a new metal brought out of Mexico. An early Navajo blacksmith began by using silver coins to make jewellery, and early items were cast in clay moulds. These simply made items were decorated by scratching or incizing designs, but soon more elaborate jewellery was made using mounted stones. Some of the first items to be decorated in this way were headstalls for horses. This was followed by bracelets, necklaces and many other beautifully adorned items. The south-west of North America is a significant source of turquoise, and this tribal industry was transformed. A tremendous flowering of this art continued into the twentieth and twenty-first centuries.

REGION

South-West America

MEDIUM

Silver and turquoise

RELATED WORKS

Navajo chief's blanket, c. 1880–90

Crow war-medicine shield, c. 1800s

This nineteenth-century war shield was made by a member of the Crow tribe. The shields used before the Europeans introduced the horse were very large, and could sometimes cover two men. Smaller and more practical shields were used by warriors on horseback, but the protection they offered was not dependent entirely on their physical properties. Protection was also afforded by a personal spirit. In this case, the moon spirit, which was always depicted as a skeletal figure. Before he could be deemed worthy of possessing such a shield, a warrior would spend days fasting and passing into trances. He would be visited by a spirit who would teach him its powers. When the warrior emerged from his trance, he would make his shield and paint it with a representation of the spirit he had seen. The shields were made from animal hide – this one has been made of buffalo skin, and has been decorated with eagle feathers and a crane's head, both of which had magical properties.

REGION

Montana

MEDIUM

Buffalo hide, feathers and pigment

RELATED WORKS

Crow quiver and bowcase, c. 1850–75

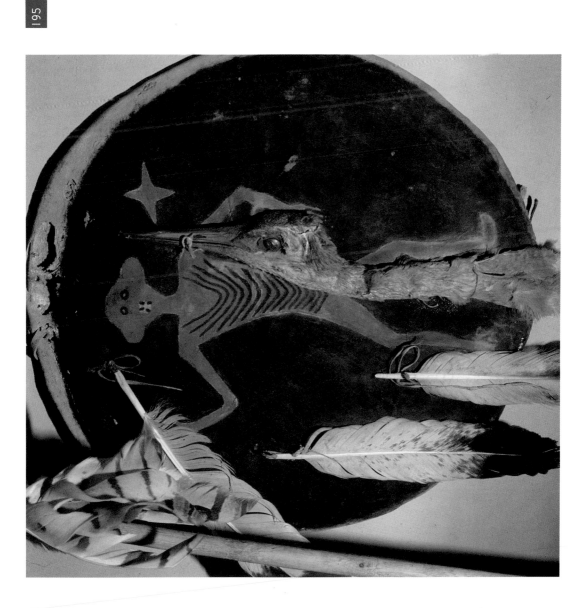

Penobscot powder horn, c. 1815

The Native Americans used horns like this one to carry gunpowder. The horns were taken from a variety of animals, but bison were the most common. The Native Americans put the bison they hunted to many uses – as well as food, their skins were used for clothing and shelters. The horns and bones were used to craft all manner of items, including spoons and cups. To create the powder horns, they were hollowed out, and often carefully decorated with patterns and engravings, and tipped with brass like this one. A circular piece of bone was often attached to the top to cover the opening and prevent the gunpowder from falling out.

Powder horns really only came into common use after the arrival of the Europeans. With the fighting that ensued, most Native American men carried with them a powder horn and shot bag, carried across the shoulders on a wide strap. This powder horn comes from the Penobscot tribe, who lived in the area around Penobscot Bay and the Penobscot River in what is now Maine. They were active in the frontier wars against the new settlers in this part of the country.

REGION

Maine

MEDIUM

Horn, wood, brass and cordage

RELATED WORKS

Creek or Seminole shoulder bag, c. 1820s

Creek or Seminole shoulder bag, c. 1820s

This is an example of an early nineteenth century Creek or Seminole shoulder bag. Intricately decorated with embroidery and glass beads, it has the wide shoulder strap typical of a bandolier or shot bag. The nomadic lives of many Native Americans meant that they needed to carry their possessions with them and various pouches and bags served particular purposes. Some were used for carrying gunpowder, other were used for transporting paints, medicines or tobacco.

Earlier bags and pouches would have been made from animal skins and decorated with beads that had been carved from bones and teeth. Shells and stones were also used, and more rarely, amber or pieces of coral. With the advent of the European settlers, who introduced coloured glass beads, these traditional materials waned in popularity and cloth-based bags were made for trading. The decoration on this bag uses non-traditional glass beads exclusively, but the pattern is typical of the people of the South-Eastern Woodlands.

REGION

South-Eastern Woodlands

MEDIUM

Cloth and glass beads

RELATED WORKS

Penobscot powder horn, c. 1815

Kaigani Haida face mask, c. 1820

This mask represents a noblewoman of the Kaigani Haida tribe. It is recorded in the East India Marine Society Catalogue of 1831, where it is described as 'once being used by a distinguished chieftainess of the Indians of Nootka Sound'. Other records show that the mask came from the Kaigani Haida village of Kasan in the area of modern South-East Alaska and was probably made as a gift or trade item.

Traditionally, masks depicting lower lip piercing had ceremonial use. This lip piercing was carried out when girls reached puberty. It was the custom for the girls' aunts to oversee their upbringing, teaching them respect for the men of the tribe and household duties. When the girls reached puberty, the aunts would ensure that they went into seclusion – during which time they were only permitted to discuss marriage. At this stage, the first lip piercing was carried out using a bone pin. The size of the hole was gradually increased by the use of a slim piece of bone or walrus ivory 'labrets'. Labrets were a sign of social status and were worn only by women of high caste.

REGION

Alaska

MEDIUM

Painted wood

RELATED WORKS

Haida sailor mask, c. 1850s

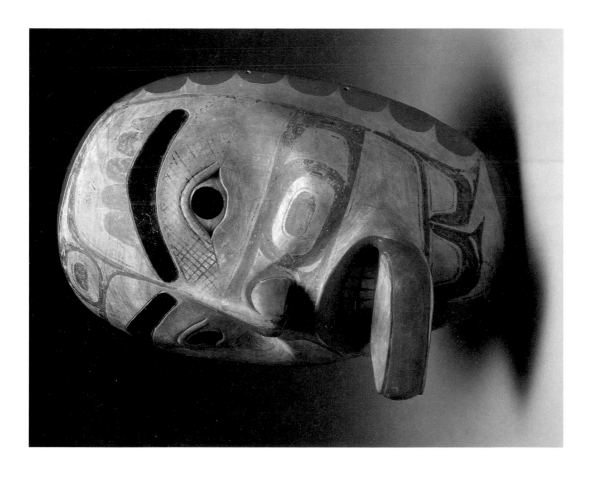

Iroquois false face mask

Masks played an important role in tribal culture, and grotesque Iroquois false face masks are associated with shamans and curing ceremonies. The wearers took on mystic personas and the head of all false face masks was a representation of Shagodyowehgowah, a supreme deity and and head of the False Faces.

The masks worn by members of the False Face Society of the Longhouse religion were cut from living trees and each member would cut his own. He would pick a tree and converse with its spirit before drawing the outline and cutting out his mask. The mask would be fashioned with slits for eyes, a large nose and contorted features, with a raised ridge passing over the forehead. It was then decorated in order to render it as frightening as possible, using pieces of metal such as copper to catch the firelight during the dancing. There were four types of mask: Doorkeeper, Beggar or Thief, Secret and Dancing. Both men and women could belong to the False Face Society, but only the men were permitted to wear the masks.

REGION

North-East America

MEDIUM

Painted wood

RELATED WORKS

Iroquois mask

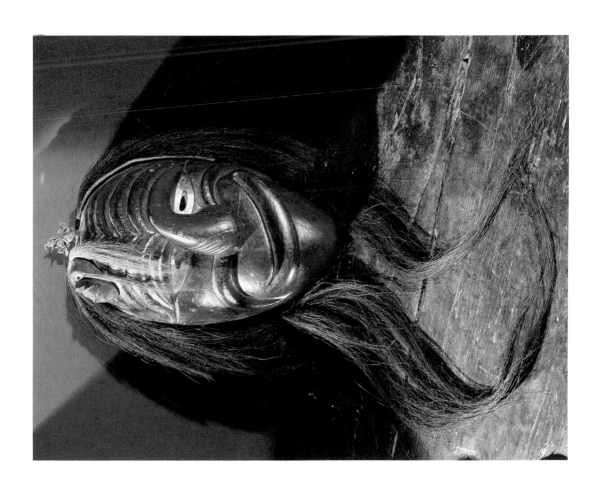

Haida sailor mask, c. 1850s

This Haida mask, depicting a red-haired European sailor, demonstrates a remarkable fusion of ancient Native American traditional culture with the outsiders who came to trade and settle in North America. The Haida had a rich artistic culture, and this is an exquisite example of their work. Probably carved in cedar wood, the hair and beard are realistically rendered and painted, and the freckles are inlaid with glass. The maker may have heard of a story that a Native American girl once saved the life of a red-haired sailor, but the realism of this carving suggests that it was probably based on the artist's own observations of European sailors and traders. Unfortunately, this contact with Europeans had less benign influences: the native population was devastated by smallpox, influenza and other diseases previously unknown to them. After 1774, when they experienced the first contact with Europeans, 95 per cent of the Haida population was wiped out by epidemics, and by 1915 the population comprised just 558 individuals.

REGION

North-East Coast

MEDIUM

Wood and glass

RELATED WORKS

Kaigani Haida face mask, c. 1820

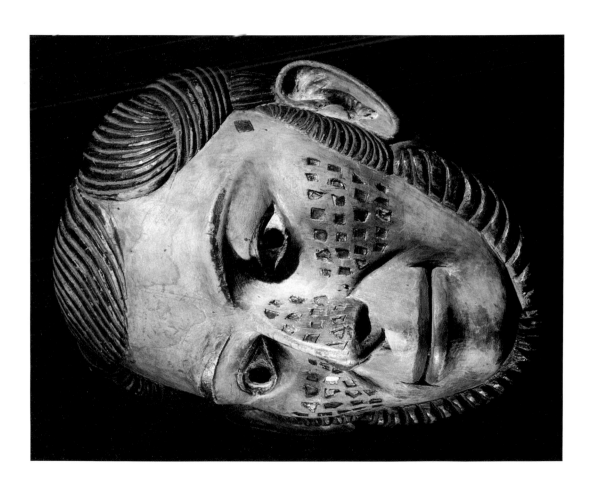

Crow quiver and bowcase, c. 1850-75

The real name of the Crow tribe who crafted this bowcase and quiver is Apsaarooke, or Absarooke, and they were a small tribe of Montana hunters whose lives centred upon the great herds of buffalo. They were an independent and warlike people, who distanced themselves from neighbouring tribes. They took great pride in their reputation as fine hunters, and likened themselves to a great pack of mountain wolves who would sweep down upon their enemies. They used animal hides for clothing and their lifestyle meant that their artistic and creative expression manifested itself in decoration of clothing and various carrying pouches such as this quiver and bowcase. Fine, soft leather and fur such as otter skin was ideal for all kinds of pouches. The women of the tribe would work beautiful designs on to all their menfolk's accoutrements, using glass beads in brilliant colours. There was great competition to make their husbands the most splendidly clad.

REGION

Montana

MEDIUM

Cloth, glass beads and fur

RELATED WORKS

Crow war medicine shield c. 1800s

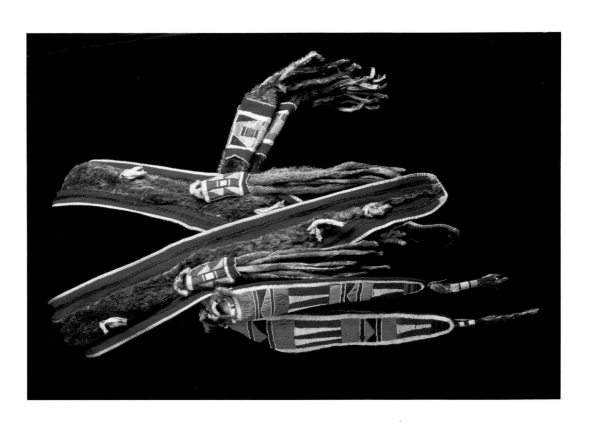

Inuit shaman's mask, c. 1850–80

The shamans of the Canadian Eskimo or Inuit people who made this mask were called Angalok. They were able to cure disease in individuals by exorcising demons known as Gahadoka gagosa, who were believed to inflict sickness on individuals. They could also repulse any evil spirits who might be causing perceived group misfortune. The shamans, or medicine men, were responsible for conducting the tribal public rituals and worked with personal spiritual helpers called Yeks, who assisted them when making contact with the supernatural world, for instance, when they were speaking with a deceased relative of a patient.

Spirit masks were an essential part of the shaman's kit and some were fashioned to allow healing smoke or ashes to be blown through the mouth over specific parts of the sick person's body. This painted wooden mask of a Tunghak spirit demonstrates the medicine man's power to see into the bodies of the sick and to pass through the hole at the centre, into the spirit world.

REGION

Lower Kuskokwim River, Alaska

MEDIUM

Painted wood

RELATED WORKS

Tlingit shaman's rattle, c. 1800s

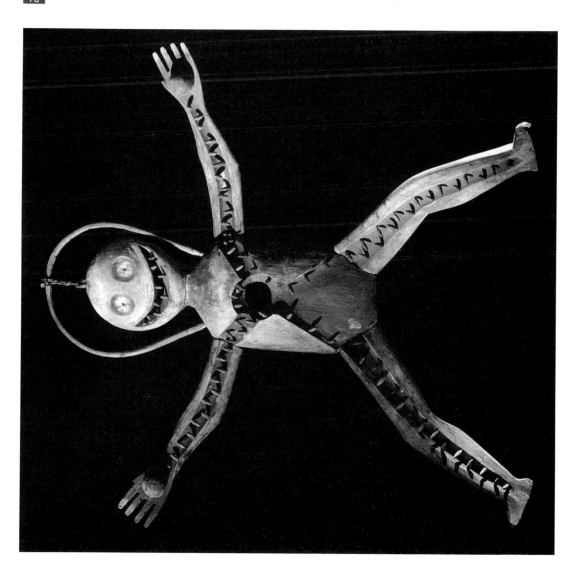

Potowatami spoon, c. 1870

This wooden spoon was made by the Potowatami, who lived in north-eastern America. Even after the arrival of the new materials introduced by the Europeans, wood remained the favoured material for eating bowls and spoons or ladles. Nomadic people needed lightweight utensils, and families would treasure their stock of bowls and spoons. In earlier times, bowls for everyday use and for feasting, as well as spoons, were hollowed out of a burr of wood by burning with hot cinders and then scraping away the charred wood. Spoons and ladles usually had animals carved on their handles, as does this example, which dates from around 1870. This spoon was probably not shaped by the charring method, but by the use of an adapted European blacksmith's knife. It was reported by a contemporary observer that those men who were less skilled at hunting deers for trading, carved tulipwood bowls in order to exchange them with the hunters. In this way they obtained their skins. At the time that this spoon was fashioned, many Native Americans had become famously skilled artisans.

REGION

North-East America

MEDIUM

Wood

RELATED WORKS

Haida feast dish, c. late 1700s

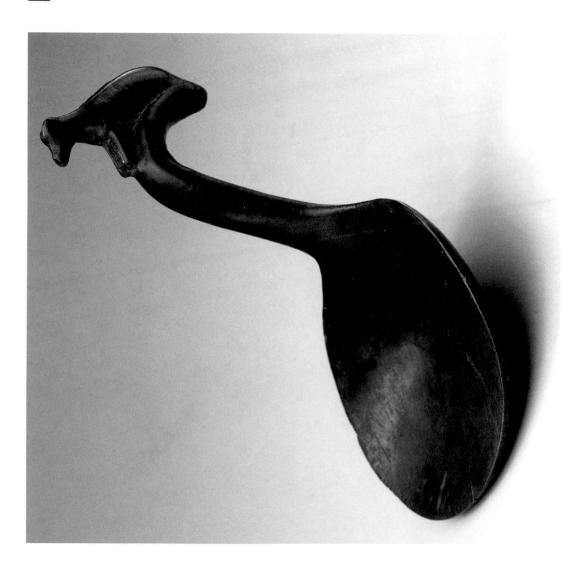

Sioux pipe bowl, c. 1880

This is the bowl of a tobacco pipe made by Eastern Sioux natives. It is carved from the red catlinite traditionally used to make bowls of wooden stemmed pipes. Catlinite is a soft, easily carved stone that ranges in colour from light to deep red. It was used by the Sioux for ritual and ceremonial pipes, and was regarded as sacred. Legend says that the Great Spirit stood upon a wall of rock in the form of a bird and the tribe gathered to him. The Great Spirit bird took a piece of clay from the rock and fashioned a pipe. As he smoked it, he blew the smoke over the people. He told them that they had been made from the red stone and they must offer smoke to him through it. He forbade the use of the stone for anything but pipes. The Sioux used pipe smoke at every ceremony. Before beginning to smoke, the pipe-holder would cradle the bowl in his palm, with the stem pointing outwards. He would then sprinkle a little tobacco on the ground, giving back to Mother Earth what they had taken.

REGION

Great Plains

MEDIUM

Catlinite, lead and glass

RELATED WORKS

Iroquois pipe, c. 1725

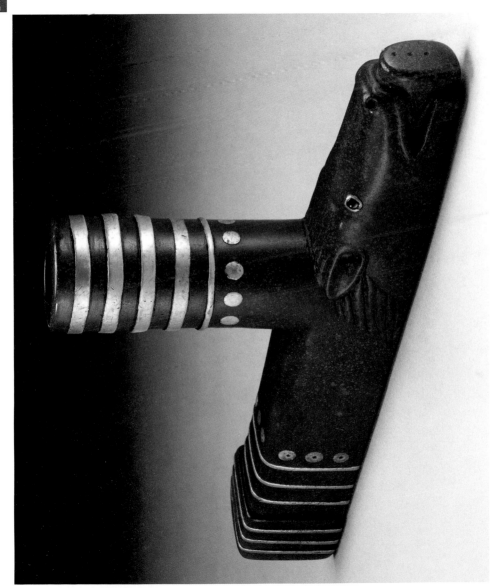

Navajo chief's blanket, c. 1880–90

Amongst the Navajo, weaving has traditionally been done by women. It is regarded as a sacred art; the universe was created by a mythical ancestress known as Spider Woman, who wove the universe on a great loom. However, the woven textiles and designs of the Navajo have no sacred significance. Early blankets were made using cotton and the wool of the Chinno sheep, using traditional upright looms. A Navajo would carry out all the processes of producing blankets, from shearing the sheep and spinning the wool, to dying and weaving. Many women kept large flocks of sheep. As with many other traditional crafters, the Navajo weavers were quick to use the innovations introduced by European settlers, specifically, the 'Germantown' commercially produced yarns. These yarns, named after the town where they were produced, were extremely fine and superior to the native yarns. The chemically produced dyes prompted a great change in the colours and patterns of the Navajo; the early, simply striped blankets of the first phase were superseded by exciting new designs in brilliant colours, known as 'Eye Dazzlers'.

REGION

South-West America

MEDIUM

Wool

RELATED WORKS

Creek or Seminole shoulder bag, c. 1820s

Chippewa awl, c.1890

The handle of this nineteenth-century awl was carved from deer antler by the Chippewa or Ojibwa, tribe of the Great Lakes area. Generally, the Chippewa people of the Great Lakes region decorated their carved pieces with stylized animal representations, rarely using anthropomorphic designs. However, the human hand shape of this handle was also common amongst this tribe. It can be seen on some of the many 'crooked' knives that were used. These utilized the European blacksmith's knife – used for shoeing horses – which was bent to make a useful curved blade. These were widely adopted to carve out bowls and spoons. Previously, a lengthy and painstaking process was involved in carving out concave shapes: a burr of wood would be burnt with hot cinders and the charred wood scraped away by the use of beaver incisors set into a handle of wood or antler. Other knives and tools, such as planers and this awl – an instrument for making holes in materials like wood or leather – greatly improved the efficiency of tribal handiwork.

REGION

Great Lakes

MEDIUM

Deer antler

RELATED WORKS

Potowatomi spoon, c.1870

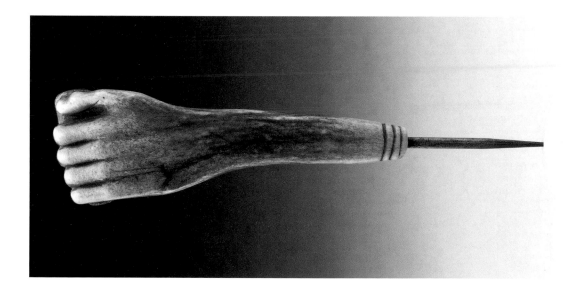

Arapaho war bonnet, c. 1900

This splendid eagle-feather war bonnet belonged to the last great chief of the Arapaho, Chief Yellow Calf, who died in 1935. War bonnets like this one served a ceremonial purpose only, and were usually made up of a cap or band, with a long trail characterized by these erect feathers. The two colours of eagle feathers signify light and dark, daylight and night, summer and winter. The large feathers represent men and the small ones women – and they are greatly treasured.

The eagle is a sacred bird in many Native American belief systems. He is the messenger of the Creator, and legend tells how eagle feathers come to be used by the Native Americans. A solitary warrior was visited by seven great eagles, who showed him how to make eagle-feather war bonnets that would bring his tribe victories. Since that time, the eagle has been a symbol of honour and feathers are given as prized gifts. It is considered a sign of good fortune to find an eagle feather and the possessor of an eagle feather will always treat it with respect, giving it a place of prominence in the home. The feathers must never be mishandled or destroyed.

REGION

Great Plains

MEDIUM

Eagle feathers

RELATED WORKS

Tlingit robe

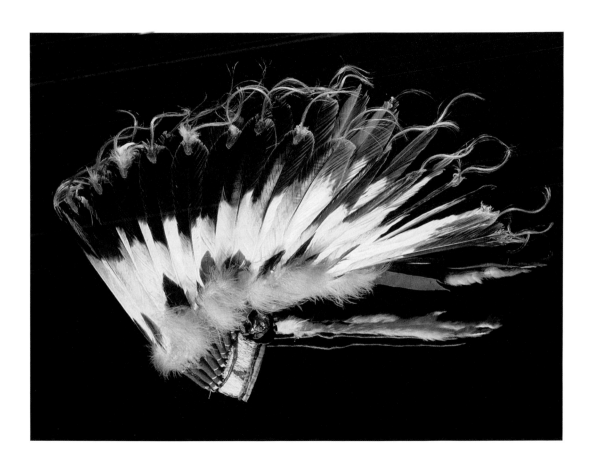

Chilkat blanket

The Tlingit word for these traditional Chilkat blankets is *Naxein*, meaning 'fringe about the body'. They were made by the women of the tribe from mountain-goat wool, to designs painted by the men on to planks of cedar wood. The formline designs are divided into two groups: one representing animals and the other the human face. This is an example of the second group, showing a large face at the centre of the blanket. The three separate sections of the design are set out very precisely; the height at the centre is half of the width and the black-and-yellow striped border is one-twelfth of the total width. The divisions of the fields are clearly marked, and the side sections are symmetrical. There is, however, generally some variation in the curve of the lower border.

Items like this blanket were traded extensively and were highly prized for the Chief Dances at Potlaches, when the chiefs of the southern tribes would wear them. This type of blanket weaving was once carried out over a wide area, but disease decimated many people and the art died with them. The Chilkat women alone carry on this tradition.

REGION

British Columbia

MEDIUM

Goat wool

RELATED WORKS

Sioux pouch, c. 1800s

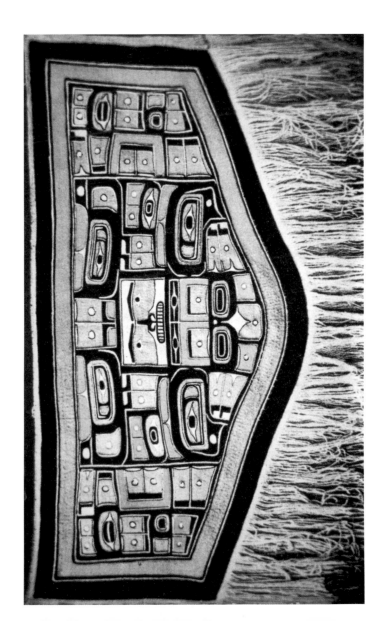

Wampum belt

This wampum belt was made by the Lenni Lenape, or 'Delaware' Native Americans who inhabited Pennsylvania and other mid-Atlantic areas, including New Jersey, Delaware and parts of New York. Wampum is the American Indian word for the white and purple beads that they carved from shells; the purple beads were made from clam shells and the white from whelks. The native peoples used these beads for decoration and the colours had meanings. White stood for peace, health and good fortune; purple 'represented sorrow and sympathy. These belts, which were woven with thousands of beads, were used by the Native Americans as pledges to validate treaties when they were handed to Grand Council Chiefs. The beaded belts were also used to record important events or as memory aids by the arrangement of the patterns woven into them. The European fur traders obtained the belts to exchange for furs from inland natives, and some Dutch and English colonists used wampum as currency until the mid-seventeenth century, when metal coins became readily available.

REGION

Pennsylvania

MEDIUM

Beads

RELATED WORKS

Creek or Seminole shoulder bag, c. 1820s

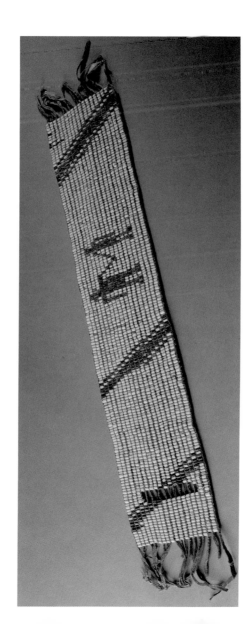

Arapaho Ghost-Dance dress

The Ghost Dance religious cult surfaced briefly in the nineteenth century as a direct response by the indigenous peoples of North America to the incursions of the white man, the resultant decimation of many native peoples, and the impact on tribal tradition and culture. The Ghost Dance dress was made entirely of traditional materials, thus demonstrating a rejection of the incomers' goods. This beautiful garment is made of deerskin, which was essential in Arapaho lore, and is painted with Arapaho directional symbols as well as celestial symbols of the moon and stars, eagles, magpies and dragonflies. These creatures symbolize the realm of the sky. Incongruously, this garment also seems to represent the American flag. It was believed that the new Ghost Dances and songs would cause the disappearance of the white man and the misfortunes that he had brought, and there would be a return to the old days. Each tribe developed its own Ghost Dances according to its own culture and some even incorporated the Christian idea of a Messiah.

REGION
Great Plains

MEDIUM
Deerskin

RELATED WORKS
Tlingit robe

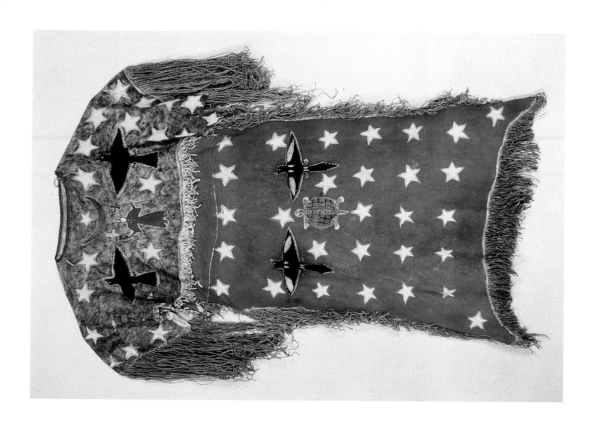

Tlingit robe

This Tlingit robe, made of goat's wool and embellished with otter fur, would have been worn by high-ranking men at their great feasts, or Potlatches. As with the blankets that they made, the Tlingit women created the robes following designs painted by the men on planks hewn from cedar wood. These designs were very similar to those on the blankets, and this robe is decorated with representations of the bear. The mythical Bear Mother of the North-West and Canada gave birth to a child who could change into a bear. The brown bear was the totem of the Tlingit peoples, who believed that many animals were once humans who were so alarmed by the daylight released from a box by the mischievous Raven, that they took refuge in the woods. These animals could transform themselves back into humans, and the ability of the bear to walk on its hind legs gave substance to this belief. Tlingit legend tells of a woman who married a bear. The bear instructed her in the correct and respectful ways of killing him and the woman took these rituals back to her people.

REGION

North-West Coast

MEDIUM

Goat wool and otter fur

SIMILAR WORK

Tlingit blanket

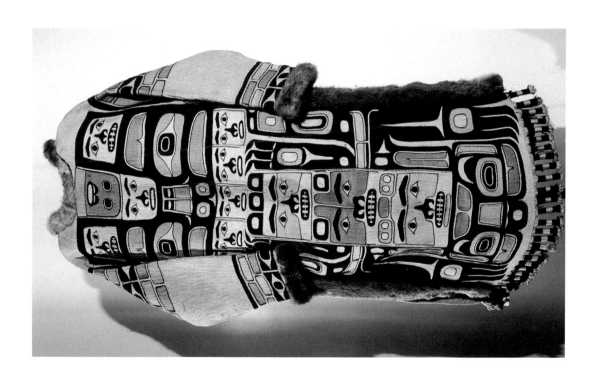

Haida bowl, c. 1900

Haida bowls were generally made from easily sourced wood such as alder or maple, and were often carved from a single block. They were carved out using beaver incisors or later, adapted metal knives, introduced by the Europeans, and were generally carved at the ends. Serving dishes were carved most heavily and frequently took the shape of the body of the creature depicted. Bowls were used for holding seal oil as well as food, and as the oils soaked into the wood, there was no necessity for a preservative. Another material used in bowlmaking was sheep's horn. This was made malleable by steaming and was then shaped over a wooden form.

This Haida bowl takes the shape of a dragon. There are many dragons, or dragon-like serpent creatures, in Native American myth and lore, many of which were believed to dwell in rivers, lakes and the ocean. Generally these were not seen as good deities, but rather powerful and dangerous ones. Some were believed to have control over natural forces like the weather.

REGION

Canada

MEDIUM

Wood

RELATED WORKS

Haida feast dish, c. late 1700s

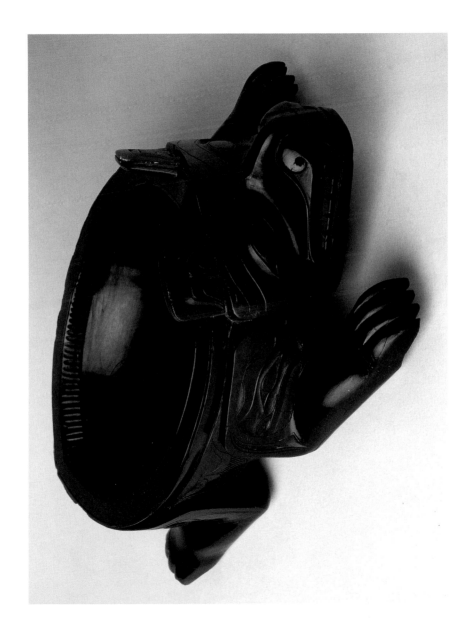

Plains Indians Equipment for Buffalo Hunt, c. 1900s

This nineteenth-century painting by the Native American artist Kills Two (Nupa Kte, b. 1869) is worked on canvas and shows a Plains Indian pursuing a buffalo. The ancient ways of killing the buffalo involved hunting on foot, and various methods were used. The animals were sometimes driven over cliffs or into ravines or rivers where they could be speared or shot with arrows. Hunting parties would also cover themselves with buffalo hide or wolfskins and stalk the herds, targeting a particular animal. With the arrival of the horse, the Indians quickly became skilled riders and this changed the hunting methods radically.

The people of the plains believed in reciprocity; the giving of something in return for what has been taken, and a shaman would accompany the hunt and offer up prayers to the spirit of the slaughtered animal before it was butchered. Every part of the buffalo was utilized. The buffalo provided clothing, shelter, knives and tools, bowstrings, paint, soap and fuel. Even the skull was used during ceremonies. The meat was distributed amongst the tribe according to each family's needs. Nobody went hungry.

REGION

Unknown

MEDIUM

Pigment on canvas

RELATED WORKS

Buffalo hunt pictograph, c. 1800s

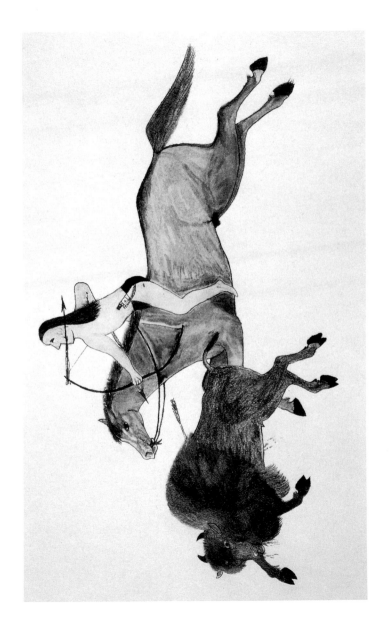

Crow Mother Kachina doll, 1925–33

The Kachinas are ancestral spirits who bring blessings to the Native American people and are elemental to their religious beliefs. They enter the souls of dancers during rituals and ceremonies, bringing rain and fertility to the land. It was believed that people joined the Kachinas when they died. There are many different Kachinas belonging to different tribes and Kachina ceremonies are vital rituals for the tribe. They usually involve dances by masked men who are believed to embody Kachinos. The Crow Mother – mother of all Kachinos – is particularly well known, and comes into the community during the Bean Dance Ceremony, called Powamuya. She is often dressed as a bride. Kachina dolls are made to be given to children and women at important ceremonies, and Crow Mother dolls are particularly significant for children. The Bean Dance Ceremony is highly important in the initiation of children into the lore of the Kachina. A masked dancer representing the Crow Mother will appear and teach them.

REGION

New Mexico

MEDIUM

Wood, wool yarn, paint and string

RELATED WORKS

Pueblo kachina dolls, 1933

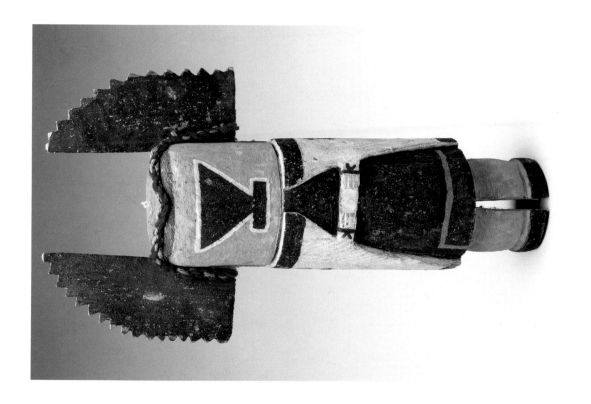

Pueblo Kachina dolls, 1933

This group of Kachina dolls was painted by Waldo Mootzka (1903–38). Born in Arizona, Mootzka had no formal training, although he would go to the Oraibi Day School and watch the Native American Fred Kabotie at work. It was probably here that he learned the skills of watercolour painting. He worked in various mediums, including gouache, and later in his life turned to silversmithing.

Here, the artist has depicted a group of Kachina dolls. The Kachina were the ancestor spirits of the Pueblo Indians. Although they were not worshipped as gods, Kachinas were accorded great reverence, as they were believed to have the power to bring rain to water the crops in the springtime. The Kachina were actually impersonated by groups of dancers who would visit Pueblo villages in the first half of the year, and perform particular ceremonies. The dolls were originally created in the form of the dancers, and were intended to educate the children of the tribe about the Kachina spirits. However, the dolls have become a form of art in themselves, and are now considered to be collector's items.

REGION

Arizona

MEDIUM

Tempera over pencil on buff wove paper

RELATED WORKS

Crow Mother kachina doll, 1925–33

Ojibway Headdress, 1975

Native North American painter and graphic artist Norval Morrisseau hails from the Ojibwa tribe and has made this the focus of his art. Awareness of Native American traditions blossomed during the 1960s, as a by-product of the Civil Rights movement, and Morrisseau belonged to the generation that spearheaded this revival. He held his first one-man exhibition at the Pollock Gallery, Toronto, in 1962, and the success of this show established him as the leader of a new school. This has been variously described as the Woodlands or Algonquian school of legend painting.

Morrisseau took his basic subject-matter from Ojibwa folk traditions, many of these had been preserved as pictographs on birchbark scrolls. Traditionally, non-Native Americans were not permitted to see these images, but Morrisseau broke this taboo. He has combined the legends with more universal Native American symbolism and European forms. Much of his work has a strong spiritual basis, dealing with such themes as soul travel and self-transformation. It reached its widest audience in Montreal, when Morrisseau and Carl Ray designed the Indian Pavilion for Expo 67.

REGION

Great Lakes

MEDIUM

Paint on paper

SIMILAR WORKS

Chippewa owl, c. 1890s

THE GREAT

Folk Art

Central & South American Art

Olmec colossal head, c. 1200 BC–200 BC

One of the earliest of the many distinctive Central American cultures was the Olmec civilization. Dating from around 1200 BC–200 BC, it flourished in the southern gulf coast of Mexico. Best known for its gigantic 'baby-headed' sculptures such as the one depicted here, Olmec art is distinctive in that it is more monumental in scale and plainer in design than later Mexican styles, which emphasized ornate costumes and complex arrangements of figures. The Olmec believed that a woman united with a jaguar, producing a race with both features. Much of the figurative art reflects these hybrid beings. The head here may represent that of a ceremonial ballgame player or a ruler. The helmet is a curious feature. The colossal stone heads can be 1.5 metres (5 feet) tall and weigh more than 20 tonnes; the largest found is 2.4 meters (9 feet) and weighs 14 tonnes. How these were transported over long distances along rivers is not clearly understood but an impressive feat nonetheless. In addition to the heads, other sculptural styles include rock-cut reliefs, altars, giant stone slabs called stelae, and clay or jade figurines.

REGION

Mexico

MEDIUM

Basalt

RELATED WORKS

Totonac relief from ball court, c. AD 500–900

Paracas textile (detail), c. 600–200 BC

The Paracas culture of ancient Peru (600–200 BC) was renowned for its ornate burial textiles. Bodies of the dead were wrapped in many yards of cloth and provided with food and ceremonial objects. Burials in the Paracas peninsula provide the richest expression of Chavin art and culture. The bodies were eviscerated and dried before being draped with finely woven squares of decorated cloth. These were often 5 x 3 metres (15 x 10 feet) in size and plainly woven with cloth dyed a dark, rich red, green, brown or black. Then finely, brightly coloured cotton thread was embroidered across the entire surface in complex designs of gods, demons and animals. These huge pieces of embroidered cloth, covered with endless repetitions of divine figures, are testimonies to a sophisticated theological system as well as the great wealth and social importance of the deceased. A number of women would have taken many months to cover some 20 square metres (200 square feet) of cloth with complex squares. This detail of a complex Paracas 'linear style' texture shows a mythical figure (the Oculate Being) with elaborate headdress, protruding snake-like tongue and cat-like whiskers.

REGION

Peru

MEDIUM

Alpaca wool

RELATED WORKS

Mochica vessel (detail), c. AD 100–600

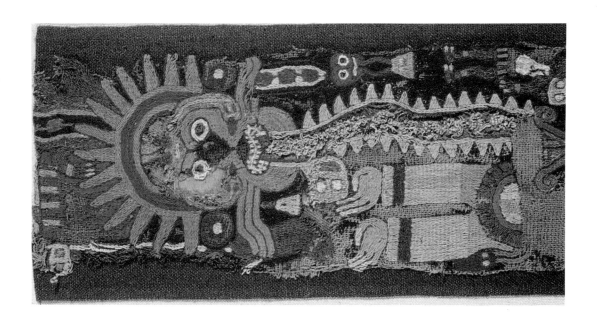

Jalisco hollow-ware figures, c. 250 BC–AD 400

Between 200 BC and AD 500, the inhabitants of the Pacific coast state of Jalisco, Mexico constructed elaborate underground shaft and chamber tombs peopled with large, hollow ceramic figures. Jewellery, weapons, ceramics and other objects were also placed with the dead. Similar tombs in the states of Nayarit, Colima and Michoacan yielded similar items. These artifacts give us a window into many aspects of everyday life during the time of the deceased. The largest figures measured approximately 1.2 metres (4 feet) in height whereas the smallest could be just 10 cm (4 in). They were normally dark brown, red or cream and could also be solid. Common representations include warriors with weapons, men and women in standing or sitting positions, figures holding vessels, pregnant women, women with children and couples. Some may have belonged to a grouping showing a particular scene. Sadly, many of the figures are available as a result of tomb looting so much of the context has been lost. This group of four seated black ceramic hollow-ware figures is from Ameca, Jalisco, and dates to the Proto-Classic period around 250 BC–AD 400.

REGION

Mexico

MEDIUM

Earthenware and black pigment

RELATED WORKS

Totonac Lord of the Dead figure

Nasca vase, c. 200 BC–AD 600

An artisan of the Nasca culture in Peru created this very modern vase sometime between 200 BC and AD 600. It could easily be a product of today. Nasca ceramics run the full gamut of life-and-death imagery. Beautifully made on turntables with extremely thin walls, they represent the apex of creativity in clay in the central Andes. Their vibrant slip decoration displayed more colours (up to 13) than anywhere else in the Americas, and their complex wraparound compositions are brilliantly executed. This red ware vase combines two bands of simple geometric motifs framing a band of human faces. The representation of human heads is common in Nasca art – some show trophy heads with their eyes and mouth stitched shut with thorns. Graves have yielded up such heads. The potters had great mastery in slip work, creating pots so finely burnished that the smooth surfaces reflect light. This culture was also responsible for the Nasca Lines – including the enormous hummingbird – that can be appreciated only from an aeroplane or satellite.

REGION

Peru

MEDIUM

Earthenware

RELATED WORKS

Mochica zoomorphic jar, c. AD 100–600

Mochica square stirrup-spouted vessel, c. AD 0–700

The Mochica culture flourished on the north coast of Peru from AD 0–700 and is famous for the richness of variety, pictorial quality and quantity of its ceramic tradition. One private collector is said to own 40,000 pieces. Mankind is shown in almost every possible contemporary activity, from love-making to burial. Many animated scenes depict people involved in ceremony or war. This richness of detail helps us glimpse everyday life in aboriginal America. Most vessels, such as this square stirrup-spouted vessel were pressed to shape in moulds that could be used for several pieces. A warrior figure is shown here in full battle regalia with battle-axe, headdress, spear-thrower and mace. His long ear pendants are a sign of status and he carries a bag which may contain lima beans or coca. Although the vessel itself was a technical challenge to create, with its closed body and complex spouts, the stirrup spout was a practical combination of handle and tube for drinking liquids such as corn beer. It was especially well-adapted to the dry environment because the small top opening allowed only minimal evaporation.

REGION

Peru

MEDIUM

Ceramic

RELATED WORKS

Mochica stirrup-spouted portrait jar, c. AD 0–700

Mochica stirrup-spouted portrait jar, c. AD 0–700

Mochica artists modeled many funerary vessels that appear to be naturalistic portraits of important persons. The individuals are detectable by their idiosyncratic features such as scars, areas of fat, deformities or surgeries. Expressions range from regal to mirthful, and each wears distinctive large earspools and a decorated headdress. Some male heads show marks of war and disease: a few females show tattooing across the chin. One head shows a single-eyed man; several show missing areas of the eyelid, lower nose and upper lips, a sign of Leishmaniasis, a parasitic disease that destroys these tissues. Portraiture is not normally a characteristic of New World art. Motifs are generally painted in red on a white or cream background with flesh tones rendered in beige or tan pigment. In the Andean region, a drinking vessel denoted a person's status. Peasants drank from gourd bowls while the well-to-do drank from pottery containers or even gold and silver vessels. The stirrup-spouted portrait jar shown here depicts one of these real people with details of his clothing and the left hand intriguingly pointing to a cup held in the right.

REGION

Peru

MEDIUM

Ceramic

RELATED WORKS

Mochica square stirrup-spouted vessel, c. AD 0–700

Mochica zoomorphic jar, c. AD 100–600

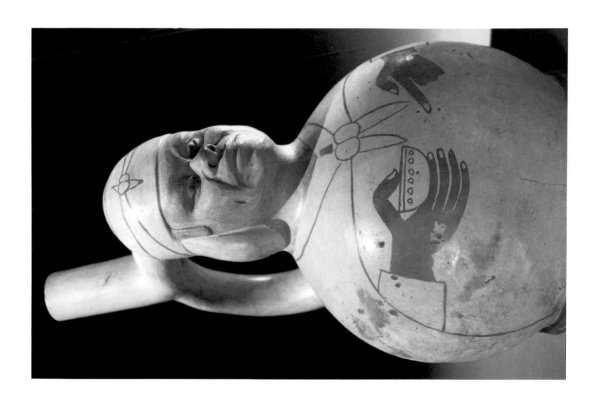

Mochica zoomorphic jar, c. AD 100–600

Animals played an important part in everyday and in religious aspects of Andean life. Mochica vessels depicted the animals that were important to their culture – foxes, owls, hummingbirds, jaguars, eagles and the domesticated llama and alpaca. The jaguar was one of the most powerful symbols in Meso- and South America, admired for its strength, ferocity, cunning and hunting ability. This magnificent great cat was worshipped and feared along with the snake. Often the ceramic artist mixed the forms of several animals in one work, creating a type of mythical beast that corresponds to the European concept of a dragon. This Mochica stirrup-spouted zoomorphic jar shows a composite animal combining a feline fanged deer head with a serpent body. An animal's fecundity was also important, particularly the camelids (llama, vicuna, alpaca), which were sources of Andean food fuel, fibre and transportation of goods. One delightful vessel shows a mother llama tenderly nuzzling her offspring. Some of these zoomorphic jars may have represented the totemic animal of a priest or shaman.

REGION

Peru

MEDIUM

Ceramic

RELATED WORKS

Mochica stirrup-spouted portrait jar, c. AD 0–700

Mochica vessel (detail), c. AD 100–600

The desert-like conditions of some areas of Peru have allowed a wealth of exquisitely woven textiles from ancient graves to survive. All women practised spinning and weaving – for family needs and to contribute woven goods for tribute and taxes to the rulers. Alpaca and llama wool were used in the Andean region; cotton on the coast. The backstrap loom was the most common loom throughout the Americas and is still used today. It consists of two loom bars (poles holding the warp) hooked to a support such as a pole or tree at one end and pulled taut by a belt around the weaver's back at the other end. Threads of the weft are lifted up to alter the pattern and introduce more colours using heddle sticks and a shed rod. Women kept sewing and weaving tools in intricately woven and decorated fibre baskets. Spindle whorls and needlecases were also decorated, all these items were buried with a woman so she could continue weaving in the afterlife. This detail of a painted design from a Mochica vessel shows two weavers using these looms, a sewing case, drinking vessel (kero) and a stirrup-spouted pot.

REGION

Peru

MEDIUM

Ceramic

RELATED WORKS

Mochica square stirrup-spouted vessel, c. AD 0–700

Mochica zoomorphic jar, c. AD 100–600

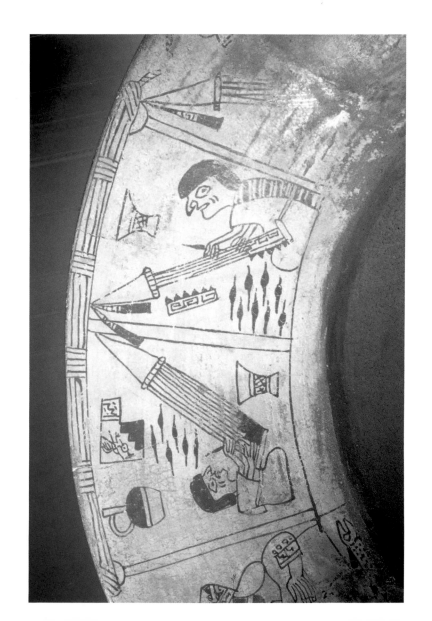

Mochica sacrificer god, c. AD 100–600

The breathtaking graves at Sipan, Peru give us a wealth of information and reveal new aesthetic achievements in Mochica metalwork. Gold, silver and copper, together with their alloys, were the chief metals used. Metal tools and weapons became progressively more common and complex in type. Outstanding are the gold breastplates and head ornaments, as well as portrait heads and decorative masks of hammered metal. Smaller articles included rings, necklaces, nose pendants and ear ornaments of superb workmanship and style.

The Mochica made great technical advances in combining metals, gilding copper and inlay work. This copper appliqué figural banner shows the 'Decapitator' or 'sacrificer god' holding a sacrificial knife in one hand and the severed head of his victim in the other. His eyes and snarling mouth are of shell or bone. The Warrior Priest was buried with several sumptuous items displaying this gruesome image, thus showing him to be a "ormidable warrior. Historical accounts suggest a greater use of metal than indicated by recorded archeological finds.

REGION

Peru

MEDIUM

Copper or tumbaga

RELATED WORKS

Mochica square stirrup-spouted vessel, c. AD 0–700

Mochica zoomorphic jar, c. AD 100–600

Tepantitla wall painting,
c. AD 100–700

The great city Teotihuacan dominated much of Mexico from AD 100–700. The remains of this complex city-state are still quite spectacular to visit, and the relatively well-preserved wall murals are a rich primary source of social and religious information about life during these ancient times.

The murals were applied to a thin sheet of fresh plaster and painted predominantly with reds as well as blues, yellows and greens. The style is flat and linear. While a wide range of images exist, the chief emphasis was centred on the Great Goddess and Tlaloc, the god of rain and agricultural fertility. He is typically depicted, as shown in this partly reconstructed mural, with his distinctive face mask in profile and left hand holding a lightning bolt. Animals such as coyotes, owls and jaguars are also prominent on the murals as well as abbreviated versions of various deities. Many frescoes show scenes from Tlalocan, the paradise of Tlaloc, peopled by many small human figures. It was believed that Tlaloc could send down many different types of rain, including devastating hurricanes, to help crops either grow or be destroyed at his whim.

REGION

Mexico

MEDIUM

Polychrome on plaster

RELATED WORKS

Totonac relief from ball court, c. AD 500–900

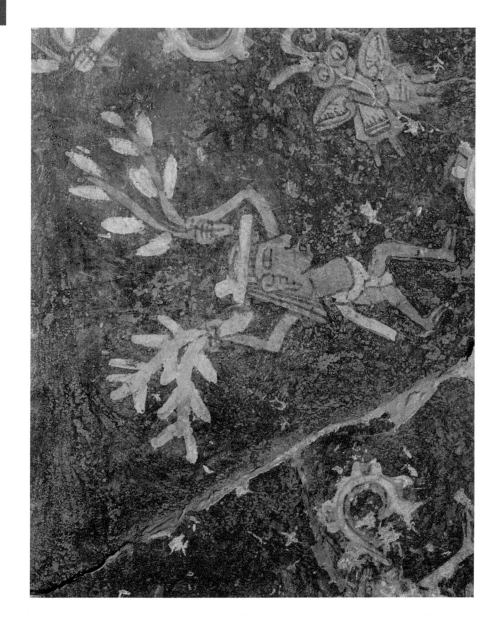

Totonac stele, c. AD 400–1000

The Totonac empire was a rival city state to the Aztecs and was conquered by them 25 years before Hernán Cortez landed in 1516. It numbered about 100,000 people at that time. This upper section of a stele is from Veracruz, Mexico and dates from AD 400–1000. It shows Quetzalcoatl ('Feathered Serpent') wearing a necklace, earrings, the wind jewel on his chest and his traditional cone-shaped hat. A jewel through his nose shows Toltec influence.

Quetzalcoatl is one of the major deities of the Aztec, Toltec and other Central American peoples. He was the creator sky god and a wise legislator; he was the god of the wind as well as the water god and fertility god. As the bringer of culture, he introduced agriculture (maize) and the calendar. Quetzalcoatl was the patron of the arts and crafts. He was the son of the virgin goddess, Coatlicue, and was described as light-skinned and bearded. When Cortez appeared in 1516, the Aztec king, Montezuma II, was convinced Cortez was the returning god.

REGION

Mexico

MEDIUM

Stone

RELATED WORKS

Totonac Lord of the Dead figure

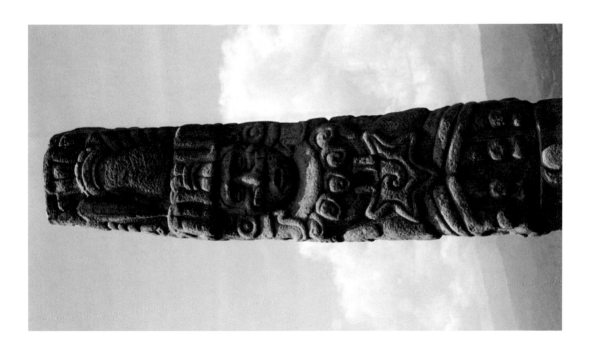

Guangala fish earrings, c. AD 500

Precious metals were crafted as far back as 3,500 years ago in the Andes. Gold, silver and platinum had uses as objects of ritual, as trinkets and as jewellery. Wearing gold jewellery, as in many cultures historically and today, was a sign of a person's wealth and power. Wealthy and distinguished persons were buried with their precious objects. After 500 BC, seven or eight differing cultures became active in Ecuador all using gold and casting copper and various types of bronze. Gold work first appeared as flat sheets, but rapidly assumed three-dimensional forms. On figurines we can see what people wore – men sometimes wearing a loincloth and women donning skirts to the ankle. Jewellery was worn on legs, arms, nose, neck and ears. Some lines marking bodies may have represented paint or tattoo. Golden animal figurines and small golden masks are fairly common from this time. A few figurines of this period actually wear earrings and nose-moons of gold. These gold earrings with bits of turquoise in the form of fish come from the Guangala culture, around AD 500.

REGION

Ecuador

MEDIUM

Gold

RELATED WORKS

Huari discs, c. AD 500–1000

Tiahuanaco silver diadem, c. AD 500–800

The famous ruins of Tiahuanaco (AD 500–900) on the Bolivian side of Lake Titicaca are at an elevation of 3,810 metres (12,500 feet). This site is considered a ceremonial centre, since it was too far above the tree line for an important economy to develop. Abandoned before the Spanish Conquest, it is best known for its monumental architecture, which surpassed Incan masonry in precision – enormous stepped pyramids, standing statues, and large monolithic art.

Viracocha, the sun god, ruled over this complex. He was described as a bearded man with white skin and beautiful emerald eyes, who originally created all things and restored civilization after the Flood. As the sky and thunder god, he was generally depicted as having staves in both hands and an aureole around his head. This two-pronged silver diadem was originally part of an elaborate headdress. The central face with radiating lines and surrounding feline heads is similar to the Viracocha figure on the 'Gateway of the Sun' monolith at Tiahuanaco.

REGION

Bolivia/Peru

MEDIUM

Silver

RELATED WORKS

Sinu spiral breast ornament, c. 1000–1500

Totonac relief from ball court, c. AD 500–900

The ceremonial ball game was ubiquitous in pre-Hispanic Mexico and Central America. It dates back at least to Olmec times and varied according to where and when it was played. The stakes were high as the game was highly symbolic of many beliefs. Violent competition was a symbol of the battle between darkness (night) and light (day) and re-enacted the death and rebirth of the Sun. The exact rules are not known, but the game involved an I-shaped ball court and a solid rubber ball. Players could only use their hips to propel the ball through small rings set high on the walls. The losing team was often sacrificed – along with many of the spectators. Sacrifice was an important source of blood necessary to keep the sun, rain and earth gods appeased. The victim was stretched over a sacrificial stone to collect his blood and heart.

This elaborate relief carving from the south ball court at El Tajin in Veracruz (Totonac classic period AD 500–900) shows a ball player being sacrificed. Details from such reliefs show much costume detail such as helmets, gloves, padded knee and hip protectors made of hide, and horseshoe-shaped yokes worn around the waist.

REGION

Mexico

MEDIUM

Stone

RELATED WORKS

Tepantitla wall painting c. AD 100–700

Totonac stele, c. AD 400–1000

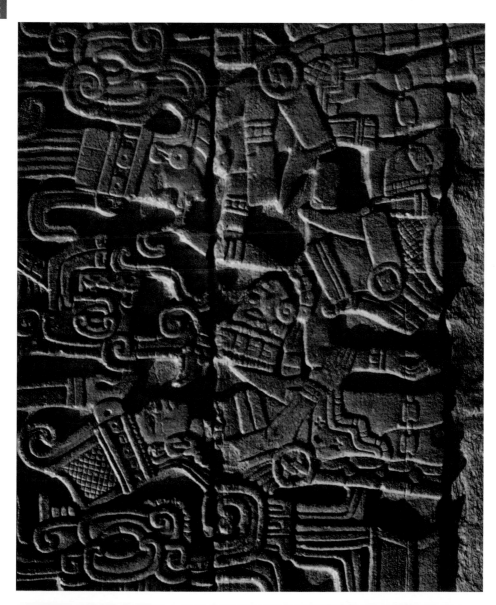

Maya cylindrical vessel, c. AD 500–900

Fine Mayan polychrome ceramics come from the tombs of high ranking persons from the classic period AD 250–850. The vessels have a wide range of shapes and styles; the most common are cylindrical vases between 12 and 30 cm high and large plates with supports and lids between 20 and 30 cm in diameter. The painted decoration on these objects is set against a white or cream stucco layer or an orange background. Black lines or incisions are used for sketching detail. Some of the most ancient vessels featured modelled decorations in red and black on an orange background. The best known of these featured human figures in various situations with hieroglyphs explaining the scene. Religious and political ceremonies were the most common themes. This cylindrical vessel is decorated with date glyphs and a Mayan ball player wearing block body paint, quite sumptuous regalia and heavy padding. A great yoke protects his vital organs which explains the meaning of stone yokes found by archaeologists. Scenes like these are invaluable sources of information about the life and activities of the person buried in the tomb.

REGION

Mexico

MEDIUM

Polychromed ceramic

RELATED WORKS

Nasca vase, c. 200 BC–AD 600

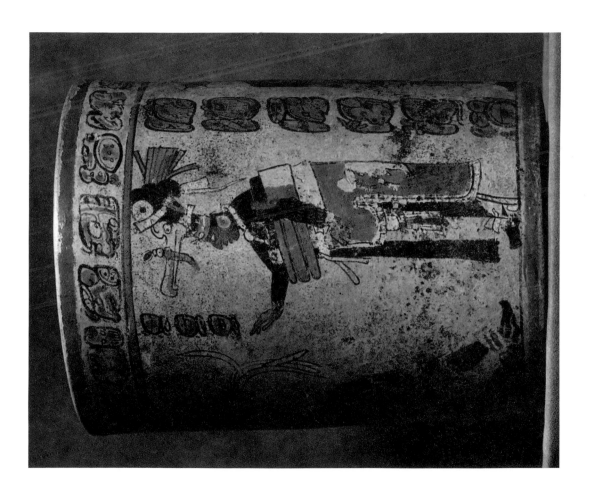

Huari discs, c. AD 500–1000

The Huari of Tiahuanaco, northern Bolivia/Peru were ancestors of the Incas, and their population was estimated to be 10,000–70,000 in the period AD 500–1000. Huari craftsmen excelled in the creation of colourful stone and shell mosaic-decorated works. They incorporated such materials as conch and spondylus shell, mother-of-pearl, serpentine, lapis lazuli, pyrite, gold and silver into their mosaics. Not only did the Huari produce jewellery such as pendants and ear spools but they also decorated cups, conch shells and wood lime containers with these mosaic elements.

The two discs shown here are of turquoise and shell, and possibly jet and lapis set into thick shell. They were probably used as ear spools or worn on clothing. While these two pieces are quite modern in their geometric symmetry, small, simplified feline heads are more ubiquitous in Huari adornment. The characteristics of stealth, ferocity and power of jaguars and pumas found their way into shorthand symbols for these much-admired qualities. The inlaid shell technique has also been discovered on one freestanding figurine and on mirrors.

REGION

Bolivia/Peru

MEDIUM

Turquoise and shell

RELATED WORKS

Guangala fish earrings, c. AD 500

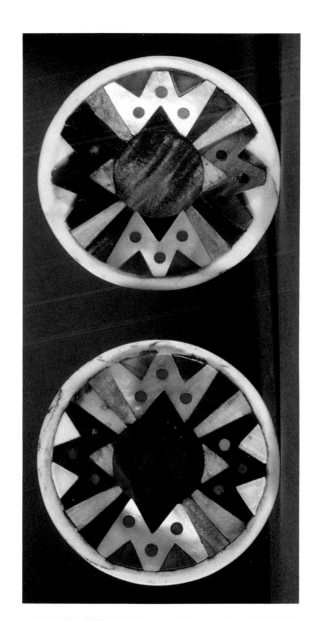

Totonac Lord of the Dead figure

The Totonac peoples of Veracruz, Mexico, distinguished themselves with fine clay modelling. The Remojadas style in the southern portion of Vera Cruz specialized in hollow figurines with thin walls. The Totonac seemed to respect physical beauty and emphasized quality of skin and form. Even figures of old people, such as the famous statue of the fire god, show a quality of realistic musculature observed from nature and a beauty of surface despite the skeletal limbs. This Totonac pottery figure of the Lord of the Dead, Mictlantecuhtli, is a gruesome if delightful achievement. It was believed that those who died a natural death went to his realm, Mictlan, where they had to dance with other living skeletons until it was time to be reborn. On their way to his underworld the dead were reduced to skeletons by a wind of knives. Typically this god of death is shown as a blood-spattered skeleton or a person with a toothy skull. Mictlantecuhtli's headdress is decorated with owl feathers, and he wears a necklace of human eyeballs. He is associated with the spider, owl and bat.

REGION

Mexico

MEDIUM

Clay

RELATED WORKS

Totonac stele, c. AD 400–1000

Totonac relief from ball court, c. AD 500–900

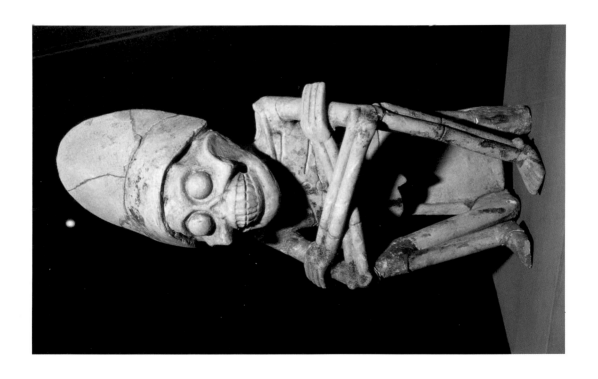

Cocle plate, c. AD 500–1300

The Cocle style of polychrome pottery from central Panama dates from the period AD 500–1300 and is highly prized for its bright colours and quality of line. One characteristic is that it seems to be a happy art, for the beasts and figures appear good-humoured, dancing and smiling. The dominating motif is the crocodile or crocodile god, but birds of various types, turtles, deer, monkeys, bats, crabs, lobsters, sharks and stingrays also appear. Rarely are the creatures fashioned realistically. Usually elements of several are combined – two-headed snakes have legs; birds have crocodile scales, with jaws replacing beaks. Another common characteristic is the bewildering variety of scrollwork and other geometric motifs used to fill space. This filler is cleverly adapted to eccentric shapes in balancing the major decoration. Shown here is a representative polychrome plate depicting a dancing crocodile, jaguar, a supernatural creature or possibly a masked shaman. The central figure is surrounded with elaborately and sinuously designed birds and a snake.

REGION

Panama

MEDIUM

Ceramic

RELATED WORKS

Michoacan lacquered tray, c. 1600s

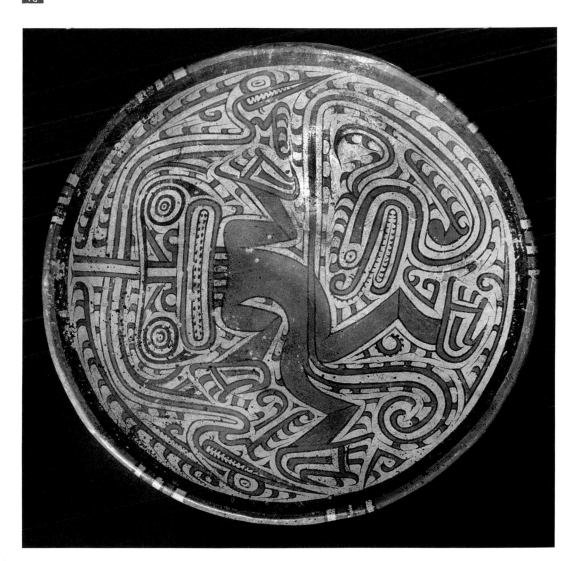

Aztec incense burner

Every Aztec had an incense burner, either singly owned or shared on communal staircases. By AD 450 Teotihuacan was mass-producing these items for local use and trade. Rich iconography was stamped on, using a variety of symbolic images. For example, this incense burner has two symbols of Tezcatlipoca – the smoking mirror (this nickname) painted on top of the handle and the turkey-claw shape of the handle itself. Tezcatlipoca was the god of night, darkness and deception, the patron of evil and sorcerers, and ruler of divination (especially black mirrors). Incense burners were also placed whole in graves as funerary offerings or broken and scattered around the body of the deceased. Tree resins, used as incense throughout Mesoamerica were known as *copal* and made of diverse plant sources. Copal was considered the 'blood of trees', a primary food for deities just as maize was food for humans. Some natives of Guatemala today drip sacrificial blood on copal that is then used to cense maize seeds before planting. Other tribes use it to drive out deer spirits from the carcass before eating it.

REGION

Mexico

MEDIUM

Painted metal

RELATED WORKS

Aztec mask of Xipe Totec, c. 1200–1500

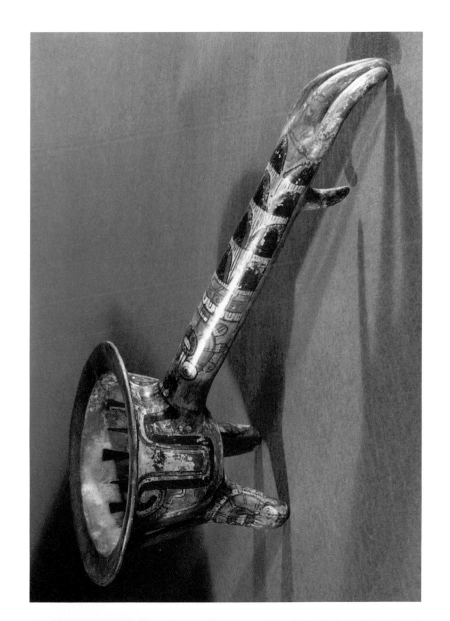

Aztec statue of earth goddess

The figure shown here is the awe-inspiring Aztec earth goddess, Coatlicue, 'Serpent Skirt'. She was the mother of gods and mortals, creator and destroyer of earth. She had several guises: Chuacoatl (snake woman), the fearsome goddess of childbirth; and Tlazolteotl, goddess of sexual impurity and wrongful behaviour. Shown here in her most gruesome form, she is depicted as a flesh-eating goddess of sacrifice. Typically she was draped with a necklace of skulls, severed hands and human hearts, her skirt of writhing snakes and had huge clawed fingers and feet.

This sculpture was found in 1819 in front of the main plaza at Teotihuacan on the *omphalos* (stone of splendour) slab that marked the centre of the Earth. Her face consists of two fanged serpents, her skirt is of interwoven snakes, and where her head is severed, blood pours forth in the form of serpents also – all symbolizing fertility). She feeds on corpses just as the Earth consumes all that dies, in the process facilitating new growth. She shows the power of Nature to punish as well as nourish.

REGION

Mexico

MEDIUM

Stone

RELATED WORKS

Aztec solar disk, c. 1500

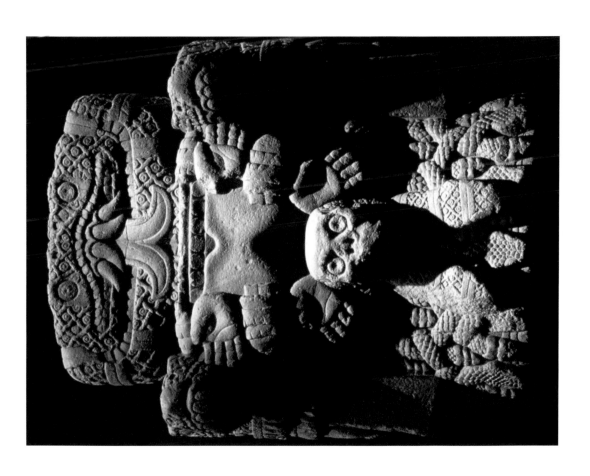

Mayan relief panel, c. AD 702–64

The Maya in Central America produced intricate relief carvings that either adorned buildings or stood alone as stelae (inscribed stone slabs and pillars). These were used to depict rulers and information about the significant events and dates during their reign. Over 40 stelae and 30 accompanying altars were found at the Mayan site of Tikal in Guatemala. Eighteen of these featured royal portraits and historical texts, and were used to reconstruct the 30-plus dynastic rulers of Tikal starting with Yax Ch'aktel Xok ('First Scaffold Shark') in the first century AD and ending with Hasaw Chan K'awil II ('Heavenly Standard Bearer').

The basic format on the stelae remained constant. It depicted a handsomely outfitted lordly figure on a wide side of a stone shaft; the sides and back were covered with long hieroglyphic inscriptions about his reign. Over time the accoutrement, headgear and garments became more grandiose and visually complex. The stela shown here is from the eighth century AD, and shows a seated male carved on a relief panel with traces of paint.

REGION

Mexico

MEDIUM

Limestone

RELATED WORKS

Totonac relief from ball court, c. AD 500–900

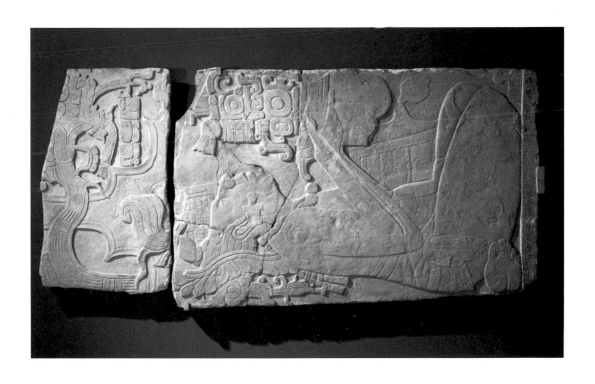

Toltec mosaic disc, c. AD 900–1200

The Toltec empire in Mexico lasted from AD 900–1200 and was the first state to integrate people of Mexico and Central American into one cultural system. Its most concentrated population was at Tula, 80 km (50 miles) north of Mexico City. The Toltecs had a complex trading network that stretched over much of Mesoamerica and they were influential over art in the broader empire. Strong archaeological evidence indicates that not only the upper class obtained fine jewellery, pottery, artifacts and feathers, but the common people did as well. Stonework (including mosaic) was highly developed and the raw materials came from the far-flung regions – turquoise from New Mexico and Arizona; jade and serpentine from Guatemala; onyx from Puebla; and marine shells from the Pacific and Gulf coasts. One mosaic disc contained over 2,000 turquoise fragments; an elaborate ceremonial breast plate consisted of 1,200 carved spondylus shell plaques. This beautiful and delicately wrought mosaic disc of turquoise, shell and flint may have been part of a warfare costume consisting of a mosaic headdress, butterfly pectoral and spear thrower.

REGION

Mexico

MEDIUM

Turquoise, shell and flint

RELATED WORKS

Huari discs, c. AD 500–1000

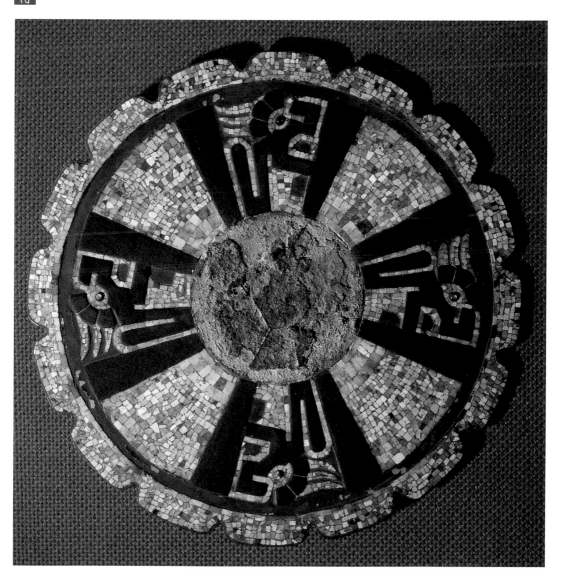

Sinu spiral breast ornament, c. 1000–1500

In the great river valleys of Columbia a number of smallish tribes produced some of the richest gold work of the Americas. Gold metalwork was the major Colombian art and their artifacts were traded widely. Gold was plentiful and easily collected from the rivers. The chiefs of these groups lived in great state and wore items such as this gold spiral breast ornament as appliqués sewn on the chest area of ceremonial garments. The nobility also wore these items without clothes, as nakedness was a testimony to social importance. They displayed their beauty openly with necklets, head ornaments and bangles on arms and legs.

The Sinu culture (1000–1500) has left many enigmatic gold pectorals of this type, some with mushroom-like representations. This would imply the existence of a cult using intoxicating fungi, a species of which occur in the area. Many pectorals have wing-like structures, possibly signifying magic flight – a frequent characteristic of the hallucinogenic experience. The Sinu metallurgists used the lost wax method and were especially good at filigree work. This spiral breast ornament is from Santa Merta, Columbia, and is thought to depict an owl's face.

REGION

Columbia

MEDIUM

Gold

RELATED WORKS

Tiahuanaco silver diadem, c. AD 500–800

Aztec mask of Xipe Totec, c. 1200–1500

Xipe Totec ('Our Flayed Lord') was the Aztec god of springtime and vegetation, fertility, flowers and life. He was also the patron of metalworkers and the bringer of skin diseases and eye problems. Victims were sacrificed in his honour during agricultural festivities. Afterwards, priests wore their flayed skin to symbolize the annual spring renewal of vegetation and renewal of the Earth's 'skin'. Wearing the skin represented new plants covering the ground in springtime.

Gods were arbitrary in Aztec cosmology and needed to be acknowledged and propitiated regularly. Aztecs often wore masks to participate in their many sacred rituals; the priests wore black robes stained with blood during the ceremonies they conducted. Religious dress served the function of adornment and communicated the role of the individual. Masks were also placed over mummy bundles to protect the deceased from the dangers of the afterlife. This stone mask of Xipe Totec dates from the Aztec period 1200–1500. Note the ear spools, which were a popular Mesoamerican item of adornment.

REGION

Mexico

MEDIUM

Stone

RELATED WORKS

Aztec statue of earth goddess

Mixtec page from Codex Cospi, c. 1350–1500

The history of the Mixtec people (1350–1500) in Mexico is known in some detail because of eight existing written documents or codices. The Mayans and Aztecs had similar manuscripts, which recorded their history, genealogy and administrative affairs with beautiful multicoloured hieroglyph symbols. The 'paper' was carefully prepared from pounded tree bark, animal skin or cloth made from maguey plant fibres, covered with a chalky paste (gesso) and fan folded. The 7-metre (23-foot) long Madrid Codex has been partially deciphered and found to detail rotations of Venus and its planetary influence on human affairs. This page from the Codex Cospi shows offerings being made by the sun god (Aztec Huitzilopochtli) at the top and the god of darkness (Aztec Tezcatlipoca) below. The former stands before a temple in which his symbol, the eagle, is enthroned while the latter's temple is inhabited by the rational owl, a symbol of utter destruction. Other codex pages show domestic scenes, such as a chief offering a vase of cocoa to his wife or the struggles of the Mixtecs to defeat the Zapotecs including lists of towns and their chiefs.

REGION

Mexico

MEDIUM

Deerskin

RELATED WORKS

Aztec codices

Inca jaguar head, c. 1440–1532

The jaguar played an important role in pre-Columbian culture. The largest of the big cats in America, it became a symbol of authority and prowess in hunting and in battle. Many gods have jaguar attributes throughout Central and South America; hunters and warriors frequently adorned themselves with jaguar pelts, teeth or claws. The jaguar's reputation as a fearless predator was adopted in various ways as an authoritative and martial symbol. Shamans considered the jaguar as a spirit companion (or *nagual*) that protected the shaman from evil beings during his journey to the spirit world. The jaguar was often chosen as a nagual because of its strength and ability to move easily between the separate worlds of trees, solid ground and water. It could hunt at night and in the daytime, and had the habit of sleeping in caves, places associated with deceased ancestors. In Inca society, sorcerers held high positions as protectors from spirits, and had the parallel ability to move about between worlds, those of the living and of the spirits.

REGION

Peru

MEDIUM

Painted wood

RELATED WORKS

Inca kero, c. 1500s

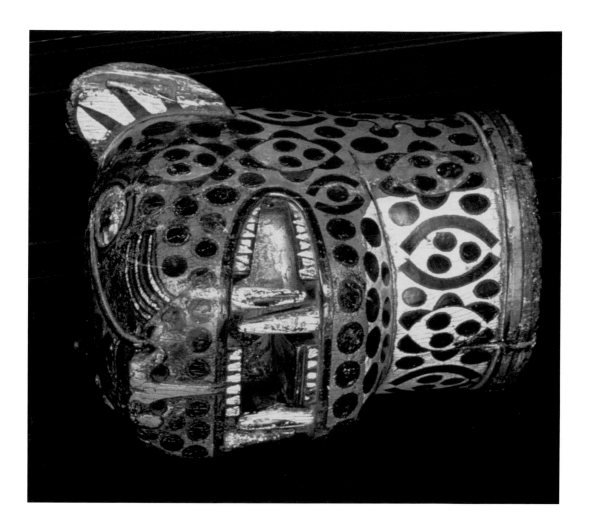

Aztec pot, c. 1469–81

In 1978, electricity workers unearthed an entire archaeological complex lying beneath the streets of Mexico City that revealed the Main Temple (Templo Mayor) – the site where the Aztecs received their prophetic vision concerning where to build their capital. An eagle was seen perched upon a prickly pear cactus devouring a snake, and construction began in 1390 of this massive complex that can be visited today. Over 6,000 artifacts were excavated from the site in the first five years. This fired clay pot with painted images of the gods Tlaloc and Chicomecoatl was found in Chamber III, part of building stage IV of the Temple Mayor around 1469–81.

Tlaloc, the god of rain and fertility, was greatly feared by the Aztecs who sacrificed children to appease him. Responsible for floods and droughts, his underworld was inhabited by those killed by lightning, drowning or disease. Chicomecoatl was one of three separate goddesses associated with maize. Her bailiwick was mature maize – this was the best seed corn of the harvest stored for sowing. There was another goddess of tender maize and a third the personification of the maize plant.

REGION

Mexico

MEDIUM

Fired clay and paint

RELATED WORKS

Aztec incense burner

Aztec mask of Xipe Totec, c. 1200–1500

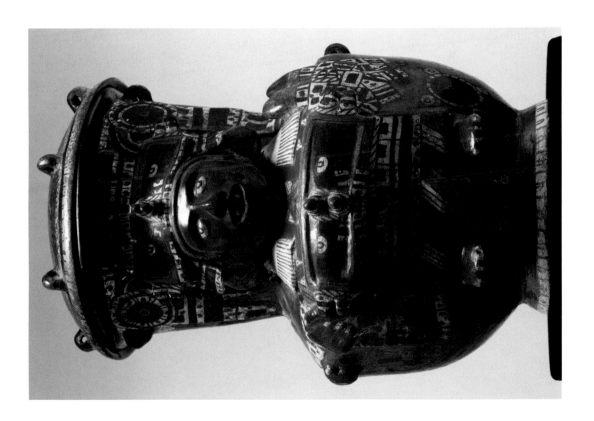

Aztec solar disk, c. 1500

The best-known solar disk is the Aztec calendar stone, which is perhaps the most famous symbol of Mexico. The original, intricately carved basalt disk is 4 metres (12 feet) in diameter and weighs more than 24 tons. The solar year was the basis for the civil calendar that determined the myriad ceremonies and rituals linked to the agricultural cycles. The calendar is made up of 18 months lasting 20 days, with five empty days at the end. Solar stones had mythological as well as astronomical significance.

This bas relief of another solar disk shows two main characters in the Aztec pantheon: Huitzilopochtli ('Hummingbird on the Left') and Tezcatlipoca ('Smoking Mirror'). Note the richness of carving and numerous subject detail. Each element of the gods' costume and paraphernalia had symbolic meaning (often multi-layered) that related to his and his various alter egos' functions and mythology. For example, Huitzilopochtli, the sun god and sometimes the god of war, could be depicted as a hummingbird or a warrior with armour and a helmet made of hummingbird feathers. His animal disguise was the eagle.

REGION

Mexico

MEDIUM

Stone

RELATED WORKS

Aztec statue of earth goddess

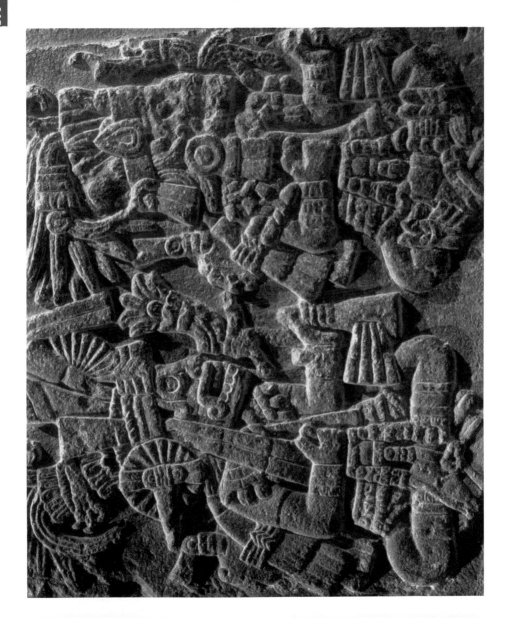

Aztec mosaic serpent, c. 1500s

The serpent was a potent symbol in Mesoamerican religious beliefs and art. The word for serpent in the Aztec language, Nahuatl, is *coatl*. This played a part in many Aztec god names, such as Quetzalcoatl (the Feathered Serpent), Xiucoatl (the Fire Serpent) and Coatlicue (She of the Serpent Skirt). The serpent was a synonym for strength, skill and ingenuity, since it could walk on earth without 'feet and swim without fins. Besides dogs and turkeys, snakes were one of the animals domesticated in ancient Mexico because they caught rats and protected the household. Snakes were rife in all the cosmology of the region. One myth told that the sea surrounding the world is the largest serpent – it has two heads and the sun has to pass through its open jaws when day turns to night. This mosaic of a double-headed serpent is Aztec/Mixtec from around the sixteenth century. Carved in wood and inlaid with turquoise, iron pyrites and red and white shell, it was probably worn as a pectoral (a brooch or chest ornament) by a priest on ceremonial occasions.

REGION

Mexico

MEDIUM

Wood and turquoise

RELATED WORKS

Huari discs, c. AD 500–1000

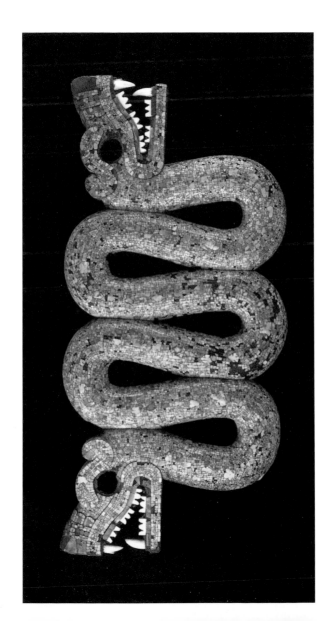

Inca kero, c. 1500s

Wooden beakers known as keros were found throughout the Andean region in cemeteries buried with other objects. They are a flaring-topped tumbler and were traditionally made in pairs for the ritual exchange of *chicha*, a beer made from maize. After 1570, decoration on keros became more 'acceptable' to the Spanish compared to the previous 'pagan' motifs. This sixteenth-century kero portrays Francisco Pizarro, the Conquistador who conquered the Incan empire. The Inca were easily overpowered in 1532 because the ruler, Huayna Capac, had heard that strange bearded men were arriving on the coast, an event foretold by Inca legend. The Spanish tried to impose Christianity, forced the people to abandon their irrigated lands and instead mine precious metals. The Inca were told that the Spanish suffered from a disease which only gold could cure. Much cruelty, overwork, European diseases, and lack of food killed off a huge percentage of the population. In spite of all this, the Incas continued many of their old practices of religion and crafts, and continued making these keros well into the nineteenth century.

REGION

Peru

MEDIUM

Wood

RELATED WORKS

Nasca vase, c. 200 BC–AD 600

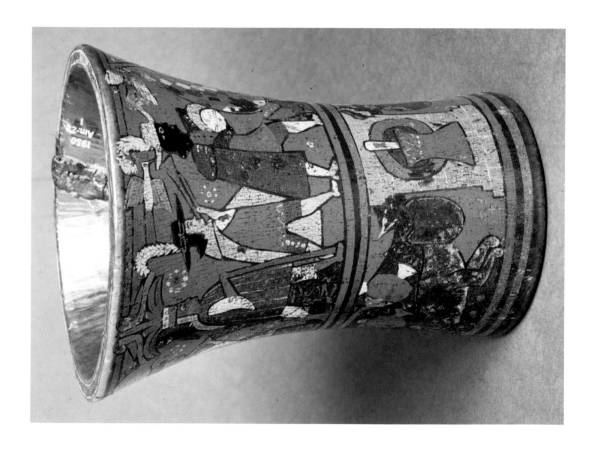

Michoacan lacquered tray, c. 1600s

After the establishment of the lacquer guilds in the sixteenth century, the Patzcuaro area of Michoacan in Mexico became noted for the production of large trays (bateas) made from the fat of the aje insect (a cousin of the insect that produces cochineal red dye). After the aje is boiled, ground, filtered and dried to extract fat, the result is combined with oil from chia seeds. This batea dates from the seventeenth century and has a sophisticated geometric theme. Designs from Uruapan have a geometric border. Many more recent trays depict flowers, trailing vines and fruits of the region. The Rayado-style lacquer of this area is a collaborative effort. The women build up the lacquer layers on cedar wood while the male artists work out the design with a thorn. The women then add more pigment and polish the surface. The design is cut through to reveal the underlying colour, followed by more powder polishing. The raised surface appears as a matte finish against the original lacquered background. Two colours are common but some trays may have three or four. Painted lacquered boxes, lacquered gourd bowls and black lacquer are further variations.

REGION

Mexico

MEDIUM

Lacquered wood

RELATED WORKS

Mochica vessel (detail), c. AD 100–600

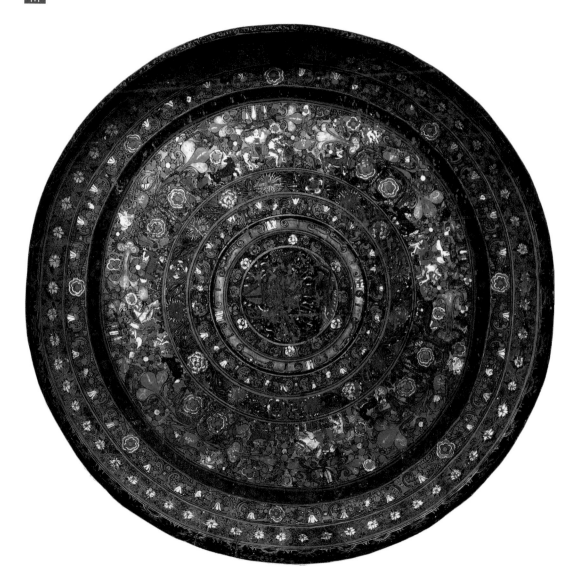

Huaro church mural, 1802

This detail of a mural comes from the Church of S. Juan Bautista in Huaro, Peru, and is the work of Tadeo Escalante, the 'last great painter of Cusco'. Painted in 1802, the church is on the World Monuments Fund field project as an endangered site. This terrifying painting of Hell on the right-hand wall of the church contrasts beautifully with the more serene ceiling – covered with floral and animal motifs with native Peruvian species figuring prominently. Other scenes show the Tree of Life and depictions of pleasure, death and dying, reflecting the duality of these two ideas in colonial Hispanic cosmology. The topic of final judgment was frequent in the colonial world. This particular fragment shows sinners jumping over one another and experiencing severe tortures before passing by the boiling pot. An important element is the Christian devil-beast devouring the sinners, a reworking of an Inca puma into a more acceptable form of non-pagan worship. Other aspects of the mural are a skeleton in whose bones lies the soul and the three symbols of earthly vanity: the mitre, tiara and crown.

REGION

Peru

MEDIUM

Pigment on stone

RELATED WORKS

Tepantitla wall painting c. AD 100–700

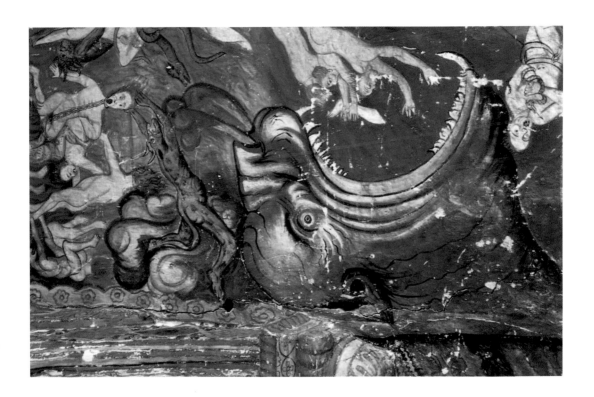

San Blas Cuna painted bark-cloth costumes, c. 1830

The Cuna Indians of Panama retreated from the mainland to the islands of the San Blas Archipelago in the seventeenth century at the time of the Spanish invasion. There they continued their traditional cultural ways of fishing and agriculture in isolation until quite recently, and today they still retain their tribal identity. The Cuna subscribe to an elaborate system of body painting. The women take great delight in applying pigment on every part of the body, especially the face. Themes include figures of birds, animals, trees and men. Trees are an integral part of Cuna life – they protect both the people and their crops, provide medicine and produce fruit. The Cuna personalize every element of nature, treating it with conciliation and flattery as if it were human.

These elaborate painted bark cloth costumes date to around 1830 and represent forest spirits. For unknown reasons, there is a high rate of albinism among the Cuna men. These 'children of the moon' are considered sacred and are traditionally assigned women's duties with full respect and acceptance. The right-hand costume probably represents an albino.

REGION

Panama

MEDIUM

Bark-cloth and paint

RELATED WORKS

Mexican Day of the Dead costume (detail), c. 1900s

Oaxaco Day of the Dead mariachi, c. 1900s

The Mexican *Dia de los Muertos*, or 'Day of the Dead', represents a unique reworking of New World ancestor worship rituals dating back over 3,000 years. It is still joyously celebrated today by folk of Mexican descent. The concept of Danse Macabre was imported from Europe and fused with pre-Hispanic customs and attitudes to result in a uniquely Mexican festival day especially prevalent in Oaxaca, a town south of Mexico City. It reflects the Mexican belief in the duality of life and death and is a chance to stick one's tongue out at death. Oaxaca shops are filled with candy skulls and *calveros* (skeletons) made of wood, papier mache, clay, wax and sugar. These figures are dressed as every conceivable profession from doctor and judge to tennis player and prostitute. They are shown engaging in all kinds of activities — e.g., dancing, drinking, hair styling. Skeletons are viewed by Mexicans as funny and friendly rather than spooky and scary and are even made into sugar treats for children. The three *calveros* shown grouped here are *mariachi* (a traditional Mexican band) players with their instruments.

REGION

Mexico

MEDIUM

Papier mache

RELATED WORKS

Mexican Day of the Dead costume (detail), c. 1900s

Mexcian Day of the Dead costume (detail), c. 1900s

The Mexican Day of the Dead is a chance for families to honour their dead relatives in style and an atmosphere of fun. The exact day (around 1 November) and manner of celebration varies throughout Mexico and other parts of Latin America. It often takes on a Mardi-Gras like atmosphere in large cities, with people wearing skull and devil masks dancing and drinking in the streets. This is often accompanied by satirical verses that poke fun at local important people. Some towns parade an open coffin with a smiling person in it. The family usually sets up a household altar, some beautifully decorated with three distinct tiers, upon which they lay candles and offerings (*offrendas*) to the dead. Graves are decorated with flowers and more offerings. The soul of the deceased is believed to visit on this day so items are collected that they would enjoy – toys for the children or bottles of alcohol and special foods for adults. This textile is a detail from a traditional Día de los Muertos costume that gives a hint of the colour and pageantry involved in this unique festival.

REGION

Mexico

MEDIUM

Textile

RELATED WORKS

Oaxaca Day of the Dead mariachi, c. 1900s

THE GREAT

Folk Art

Comparative Art

Algerian rock painting, c. 4000–2000 BC

In central Sahara of Southern Algeria, a vast massif towers over the sand dunes. Covering an area greater than France, Tassili Ajjer has a population of less than 40,000, but the proliferation of rock art that can be found here is an indication that the environment was different in earlier times. Thousands of these vivid pictures remain as a testament to a lush landscape, where great herds of animals were hunted by Neolithic man. The pictures recount hunting exploits and reveal an animistic belief system. They also record details of invasions that probably include the incoming of the Garamantes. There is little currently known about these people, who were here between 500 BC and AD 500. They founded a kingdom in an area that is now part of modern-day Libya, and it is known that they built an elaborate underground irrigation system to source the fossil water beneath the desert. The rock art here pre-dates these people, and some of the paintings over 8,000 years old. The artists made use of the local pigments, mixing the ochres with sap from acacia trees and with goat's milk.

REGION

Algeria

MEDIUM

Pigment on rock

RELATED WORKS

Spirit figures rock art

Scandinavian rock painting, c. 3000 BC

The most impressive display of rock carvings in Scandinavia is to be found at Vitlycke in western Sweden. This is the largest single site of Bronze Age art, and the variation in subject matter is breathtaking in its diversity. The lives of the people who carved these pictures are vividly portrayed. Pigments are used to colour the patterns etched into the rock face. Many meanings have been attributed to the various patterns and positions of figures. Snakes, for example, can represent a prayer for rain rather than the interpretation as the God of thunder that is found in many cultures and mythologies. Several of the pictures in this region are devoted to male exploits and women appear rarely. These two warrior figures are quite different in style, and would seem to represent members of opposing tribes. Although the meaning of some of these carvings is unclear to modern eyes, the onlooker can readily decide upon a personal interpretation, linking him or her to these early peoples.

REGION

Sweden

MEDIUM

Pigment on rock

RELATED WORKS

Spirit figures rock art

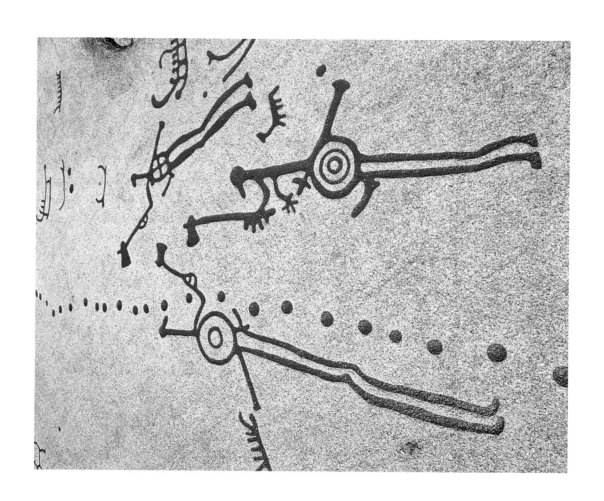

Sumerian hair ornaments, c. 2500 BC

The Sumerian civilization was based in southern Mesopotamia, in what is now Iraq. The origins of the Sumerian people are unknown, but they were certainly one of the earliest peoples, and by around 3000 BC, there was a flourishing civilization in this region. Archaeological excavations have revealed that the Sumerians were technologically advanced, and skilled in many crafts. Among the artefacts uncovered are pots, jewellery and weapons that demonstrate great skill in working with materials available to them, especially copper, gold and silver.

Many headdresses, necklaces and earrings made from gold and silver have been found in Sumerian tombs of the third and second millennia BC. This elaborate headdress is made from gold, lapis lazuli and carnelian, and was discovered in the burial pits excavated by the English archaeologist Sir Leonard Woolley (1880–1960). As well as the headdress are earrings and necklaces. Jewellery of this type is known to have been worn by the female attendants of Queen Pu-Abi, of the Third Dynasty of Ur.

REGION

Middle East

MEDIUM

Gold, lapis lazuli and carnelian

RELATED WORKS

Hair ornament, c. 1900s

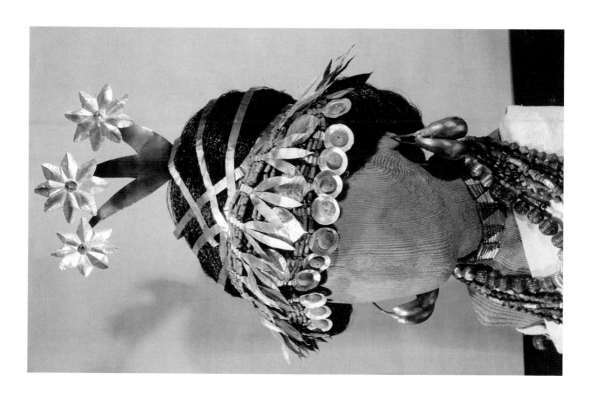

Athenian amphora, c. 580–530 BC

This carefully decorated and graceful amphora was possibly made as an offering to the gods – or to contain offerings – rather than for any utilitarian purpose. The functional ceramic vessels used in the daily lives of the Greeks were used for almost all purposes, including storage and for drinking, and were not generally highly decorated.

This particular amphora from Athens dates from the Archaic period, which began between 600 and 700 BC. The designs of this period had evolved from the previous abstract and geometric designs that had their roots in the Egyptian style. The figures were based on the geometric anatomical ideal of the Kouros statues that echo the statues of Egypt. The decorative Archaic period figures, such as those seen here, were more naturalistic in form and were usually nude, with much attention given to anatomical detail. Although the figures looked static and stiff, they represented a physical ideal. The Archaic period was superseded in about 480 BC by the even more naturalistic style of the Classical period.

REGION

Greece

MEDIUM

Ceramic

RELATED WORKS

Nasca vase, c. 200 BC–AD 600

Phoenician glass pendant, c. 500–300 BC

This coloured glass pendant would appear to be a representation of a high-ranking Phoenician man. Phoenicians of this class wore their hair and beards in a very particular style – the hair emerged in large rounded curls from beneath a wreath or diadem-style band, and the beards were either arranged in one or two rows of curls extending around the cheeks from beneath the ears, or arranged as one row of longer ringlets, as seen here.

The Phoenicians inhabited the area of what is now coastal Lebanon, and they colonized the city of ancient Carthage in Tunisia, where this pendant was discovered. The Egyptians found out how to make glass, but the Phoenicians are credited with discovering how to make transparent glass and with inventing the glass-blowing technique. They mass-produced glass for trade, and the Egyptians took much of this for use in decoration. Phoenician glass artefacts have been discovered by archaeologists as far afield as the Celtic sites of Britain.

REGION

Tunisia

MEDIUM

Glass

RELATED WORKS

Maori Hei-Tiki pendant, c. late 1700s

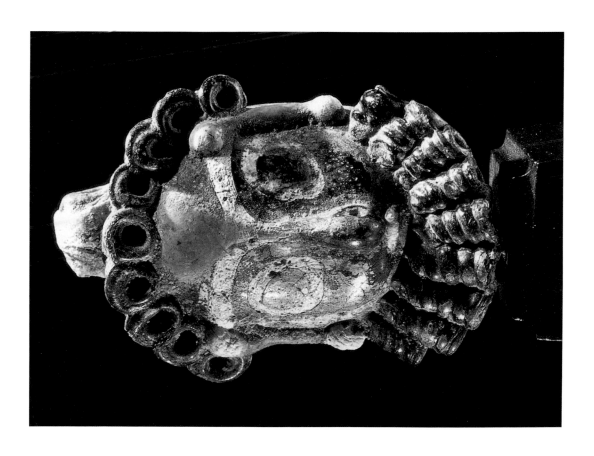

Korean lacquered baskets, c. 330 BC–AD 300

These baskets were discovered in a tomb in Lelang in north Korea. Some exceptionally fine examples of Chinese lacquerware have been found in the tombs of this area, which was once colonized by the Chinese. The baskets date from the Han dynasty, (206 BC–AD 220). Specialized craftsmen were dedicated to each stage of the production of the Han dynasty lacquered pieces. The first stage – involving the preparation of the base of hemp cloth, bamboo basketwork or wood – was carried out by the Su-Kung. This was then primed and coated with many thin layers of lacquer, by others known as Hsiu-Kung. The Shang-Kung prepared this final surface, polishing it to a high gloss for the artists who carried out the decoration, known as the Hua-Kung. Others added worked inlay or engravings into the lacquer, including gilding for inscriptions. These baskets have been decorated with figures representing model sons, and the script is taken from the *Hiao-king*, where Confucius declares that 'Filial Piety 's the root of all virtue'.

REGION

Korea

MEDIUM

Lacquered basketwork

RELATED WORKS

Hopi basket, c. 1800s

Roman Neptune mosaic, c. AD 0

This perfectly preserved Roman mosaic of Neptune was discovered in Algeria. The Romans came to North Africa during the period of expansionism after Julius Caesar and they named the indigenous peoples of present-day Algeria Barbars (which meant 'foreigner'). They established a base at Carthage and in the first century AD they occupied the city of Cuicol, now called Djemila. This was an area surrounded by fertile agricultural land, and the Romans built two forums and an amphitheatre here. Archaeologists excavating the ancient Roman remains of the city have found many mosaic pictures like this alongside the baths, steam rooms and houses. Many of them, including this one, show typical aspects of Roman mythology.

Neptune was the Roman god of water, and wa slater identified with the character of Poseidon in Greek mythology. It is thought that the origins of this deity lie in an ancient indigenous fertility god, but like so many gods of the Greek and later Roman pantheons, his evolution from earlier belief systems cannot be exactly ascertained.

REGION

Algeria

MEDIUM

Mosaic

RELATED WORKS

Tepantitla wall painting, c. AD 100–700

Celtic bronze fitting, c. AD 0

This bronze fitting represents a horse's head, and is typical of the Celtic bronze art of the British Isles. The earliest distinctive style of Celtic art has been found in Germany and parts of France, and these designs gradually disseminated, with the peoples, throughout Europe and to Britain. Celtic pieces are often highly ornamented and elaborate, with stylized plant and animal forms and/or strong geometric patterns. The Celts decorated all manner of objects – from pieces used in sacred rituals, through shields and weapons, to everyday domestic items. The pieces wre often finely wrought in metals such and gold and bronze.

Among the remains of Celtic art across Britain are amazing stone High Crosses (ubiquitous across Ireland), hanging bowls and chalices, including the famous Ardagh Chalice – a large silver cup decorated with gold and inset with panels showing animals and birds. Celtic jewellery is also particularly fine, and items such as the Tara Brooch are a testimony to the skill and imagination of these early metalworkers.

REGION

Britain

MEDIUM

Bronze

RELATED WORKS

Sinu spiral breast ornament, c. 1000–1500

Sarmatian diadem, c. AD 0

Sarmatia is an ancient region in eastern Europe, situated between the Vistula River and the Caspian Sea, occupied by the Sarmatian people from the fourth century BC. This magnificently ornate diadem was discovered in a burial mound at Khokloch, and is believed to date from around the first century AD. Diadems like this would have been worn by high-ranking members of the society or priestesses. Its richness is evidenced by the number of precious gems used in its creation – turquoise, coral, garnet, pearl and amethyst, all set in gold.

The influence of Greek art is clear in this piece – the similarity with Greek calathoses, which were wrought from gold and worn by priestesses serving the Greek gods, is clear. Here, a ritual scene is also depicted, in which sacred animals gather beneath the Tree of Life.

REGION

Holland

MEDIUM

Gold, turquoise, coral, garnet, pearl, glass and amethyst

RELATED WORKS

Tiahuanaco silver diadem, c. AD 500–800

Roman mosaic pavement, c. AD 100s

After the death of Julius Caesar in 44 BC, the Roman Empire enjoyed a long period of success and expansion. By the first century AD, the Romans ruled large parts of the globe, including North Africa – where the remained until their withdrawal at the beginning of the fifth century. Roman art and artefacts have been found across the world, in areas where the indigenous peoples did not share their belief system. In Tunisia, where this mosaic was found, they left a legacy of what is probably the largest collection of Roman mosaics in the world. These colourful scenes were created by placing together thousands of tiny pieces of stone or tile to form an image.

The Roman nobility lived lavish lifestyles and the plethora of mosaic floors that have been found are a demonstration of their efforts to outdo and impress their friends and neighbours with shows of wealth. This particular mosaic pavement was discovered in a Roman villa at El Alia. It shows a figure fishing in a large lake, abounding with fish. On the bank of the lake stands an African hut, and, to show the Roman influence, the ruins of pieces of Classical architecture.

REGION

Tunisia

MEDIUM

Mosaic

RELATED WORKS

Roman Neptune mosaic, c. AD 0

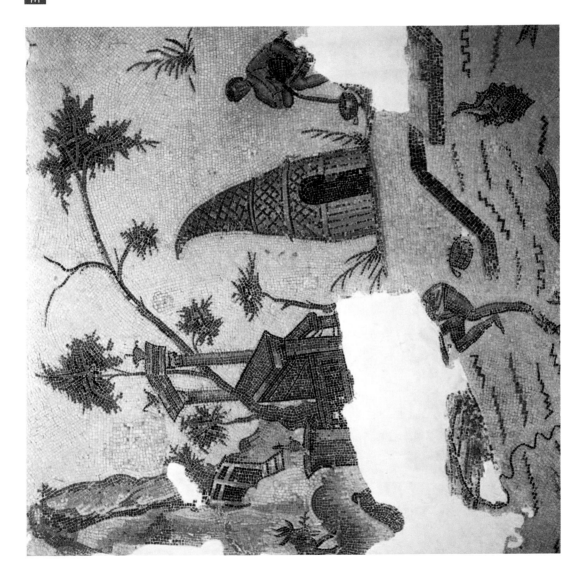

Mali Gwandusu figure

Figures such as this, depicting a mother with her child, are traditional carvings with great religious meaning for the Bambara people, who lived in the upper Niger River valley. Gwandusu is a Bambara word that encapsulates the great courage, strength and conviction that is necessary to accomplish great deeds.

Gwandusu sculptures occur in groups of mother and child, child figures, male father figures and other male/female groups. The figures are intended to represent the idea of parenting rather than birth and infancy. For the Bambara men, the possession of a wife gave him prestige and the purpose of marriage was to produce children. Children bestow completeness on an individual's social position and they can be expected to care for their parents. As important as this role of the child was, the Bambara were vitally concerned that their burials were carried out in the proper fashion. They depended on their children to ensure that the funerary rites were conducted properly, thus ensuring their transition into the afterworld and their place with the ancestors.

REGION

Mali

MEDIUM

Wood

RELATED WORKS

Cook Islands fisherman's god

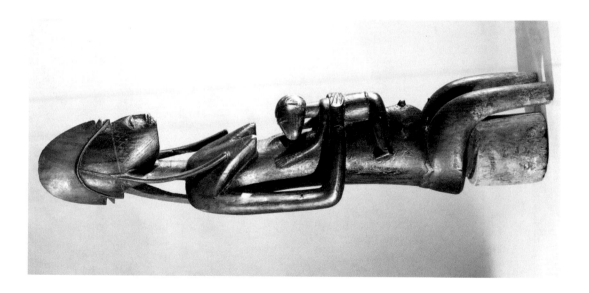

334

Vendel brooch, c. AD 600s

© Werner Forman Archive/Universitetets Oldsaksamling, Oslo

This brooch dates from the early Vendel period (AD 500–800) and is typical of the flamboyant artistry of artefacts from this time and this region of northern Europe. It is worked in a highly ornate cloisonné design of silver-plated iron. The Cloisonne is set with enamel and precious stones. The Vendel period is named after the area in Sweden, north of Stockholm, that was once occupied by peaceful sun-worshippers and where 15 ship burials were found in the late nineteenth century. This chance discovery yielded an amazingly rich hoard of artefacts, indicating that these were the graves of powerful chieftains. Some of these must have been elite mounted warriors, as wooden saddle trees and ornate stirrups were buried here. The Vendel period was a time of great wealth and plenty and these people had control of many mining districts, which were the source of the metals used in the making of their weapons and accoutrements.

REGION

Norway

MEDIUM

Iron, silver, enamel, stones

RELATED WORKS

Tiahuanaco silver diadem, c. AD 500–800

Phoenician ivory inlay, c. AD 700s

This ivory and gold carving shows a lion attacking a Nubian or Ethiopian slave. Known as the Lion of Nimrud, this famous artefact was stolen from the Museum of Baghdad during the 2003 Iraq war. It is believed to be linked to one of the great kings of antiquity, King Nimrud is mentioned in the Bible, in the Book of Genesis, and was the ruler of Abgar. Descended from the Assyrian dynasty,he founded the city of Urhoy or Edessa (modern Urfa). Nimrud was an ancient city of Assyria south of present-day Mosul in Iraq, and the loss of this and so many other treasures represents the loss of the history of Mesopotamia – the 'Cradle of Civilization'; here the Garden of Eden was believed to have been situated, where the first writing was formed; it is the place of Abraham's birth, and the place of the legendary Hanging Garden of Babylon.

REGION

Middle East

MEDIUM

Gold, ivory and plaster

RELATED WORKS

Marquesas Islands ivory tiki

Viking figure, c. AD 1000

This tiny bronze talisman dating from the tenth century is one of many such figures that have been found in Viking graves in Scandinavia and Iceland. It represents the god Thor – 'The Thunderer', the best-known of the old Norse gods and these little figures were often worn as pendants. Thor was a symbol of supernatural strength, and one of these little figures was found in a grave, still on its cord around a warrior's neck.

The proliferation of these amulets was probably part of the heathens' response to the Christian wearing of crucifixes. The two religions appear to be melded together in this small bronze; Thor holds his beard, which becomes his magic hammer Mjollnir, which in turn is of a distinctly cruciform shape. There are other examples of this kind of religious mixing. When Viking settlers came to North East Iceland they placed a group of religious symbols at several sites, these symbols were an axe for Thor, an eagle for Odin and a cross for Christ. When the Norwegian Christian king, Haakon the Good, was forced to drink a libation to the heathen gods, he made a sign of the cross over the bowl. When questioned about this, he claimed that he was making the sign of Thor's 'hammer.

REGION

Iceland

MEDIUM

Bronze

RELATED WORKS

Inuit hunter statue

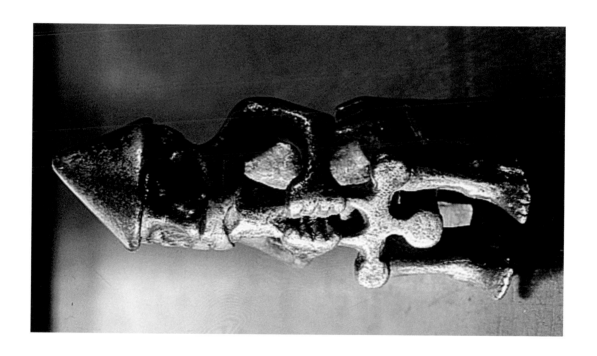

Viking church carving, c. 1100s

This twelfth-century Stave church carving is a depiction of a scene from one of the best-known Scandinavian legends. The story of Sigurd and Regin tells how Sigurd asks the master swordsmith Reagin to forge a sword that will enable him to kill the dragon Fafnir. Sigurd kills the dragon and Regin asks him to cook the dragon's heart. While doing this, Sigurd tastes the blood and is endowed with the power to understand the talk of birds. He hears two birds discussing how Regin plans to betray him, and he kills Regin and makes off with the dragon's treasure. This scene shows Sigurd and Regin forging the sword and is a recurring motif in the Stave churches. Norwegian Stave churches had their beginnings in the eleventh century, and within 300 years more than 1,000 had been built. The churches were built to a regular construction method, using only timber, on conspicuous and prominent sites such as the bend of a river or on a site overlooking a fiord. They were built over a period that spanned 400 years, until the plague came and the population declined drastically.

REGION

Norway

MEDIUM

Wood

RELATED WORKS

Totonac relief from ball court, c. AD 500–900

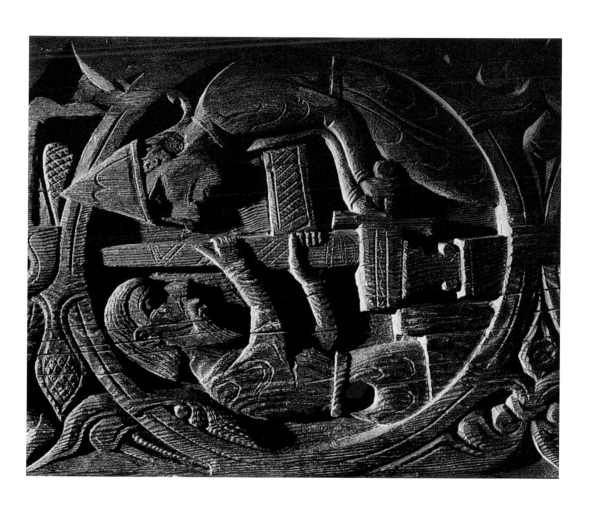

Mali terracotta horse, c. 1200s–1300s

This terracotta figure is from the rich archaeological site at ancient Djenne, in the extensive inland delta region of the Niger River in Mali. This is an area of tremendous annual floods and the people who live here have built their villages on high mounds. The modern town of Djenne is set on a mound that rises 6 metres (20 feet) above the floodplain. These are the descendents of the people who inhabited the ancient town of Dejirne which was built on a mound a short distance away. These ancestral people were part of a civilisation that lasted for 2,000 years, and the thousands of artefacts buried there include many terracotta figures of extraordinary craftsmanship. Until this discovery, little was understood of the history of the previous cultures here, and archaeologists are battling to retrieve these vitally important artefacts before they are lost. Continuous erosion is sweeping them out of the mound and into gullies. There is a hungry market for such treasures and much of this priceless hoard representing Malian history is also being lost to looting and plunder.

REGION

Mali

MEDIUM

Terracotta

RELATED WORKS

Djenne artefacts

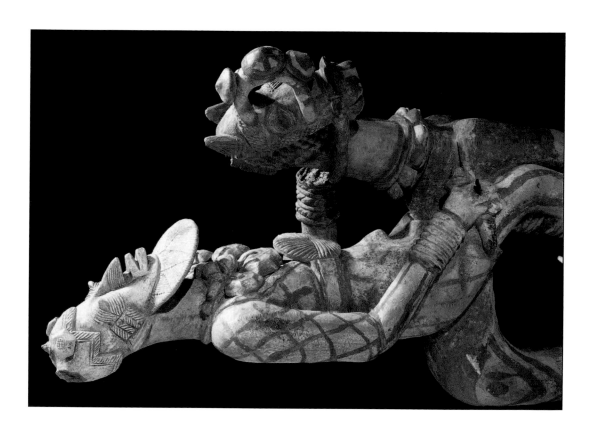

Japanese Noh mask, 1280

Japanese Noh masks were used in the traditional Noh performances of Japan. These were musical dramas, performed from around the thirteenth century. A Noh play takes place on a bare stage made out of Hinoki wood. The only adornment on the stage is a painting of a pine tree that forms the backdrop to the action. The actors tell the tale in slow chants, with a limited tonal range. Although the stage set is sparse, Noh performances were distinctive because of the lavish costumes worn by the actors, often rich silk and brocade. The Noh masks were the most important part of the costume, and they are considered to be the most artistic of all the many Japanese masks. They usually showed a neutral expression, although some, like this one, are more caricatural and fearsome. Masks were only worn by the main actor, and they were meant to represent a stylized version of the character being played, depicting only his essential traits. Noh masks fall into five categories: gods, demons, men, women and the elderly.

REGION

Japan

MEDIUM

Wood

RELATED WORKS

Iroquois false face mask

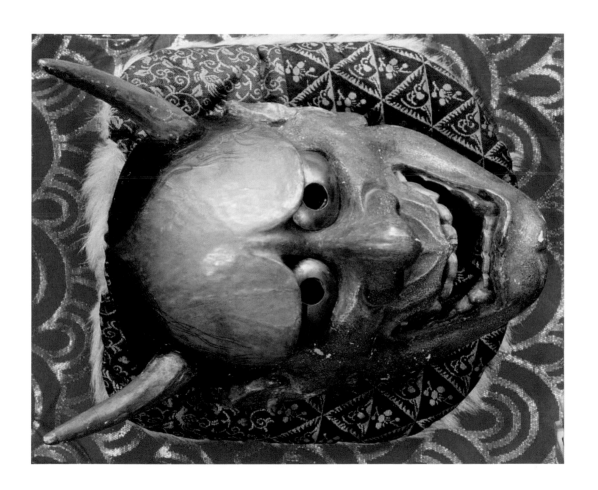

Hindu wall painting, c. 1600s

This wall painting can be found in the Rajah's palace in Cochin, a former princely state in south-west India, on the Arabian Sea. The wall painting, which dates from the seventeenth century, is still vivid in colour, and depicts scenes from the *Ramayana*. Illustrations from this Hindu epic were often used to adorn the walls of the lavish palaces inhabited by the princely rajahs of this period, and can be found in many places across India.

The central figure here is likely to be Ravana – the demon king, and one of Hindu mythology's villainous characters. Ravana was of noble birth, and a brahmin. He gained great powers when he prayed to Brahma, but started using these powers for evil. Ravana kidnaps Sita, wife of Rama, but as the epic unfolds, Ravana meets his doom at the hands of the hero. In Hindu art, Ravana is often shown with up to 10 heads – an indication of his great knowledge.

REGION

India

MEDIUM

Wall painting

RELATED WORKS

Teponitila wall painting, c. AD 100–700

Indian birdcage, c. 1700

This finely-wrought birdcage dates from the eighteenth century, and is fashioned from openwork ivory. Ivory-carving is one of the most intricate handicrafts, and India has an abundance of skilled artisans in this craft. It is also one of the oldest artistic practices in the country, and ivory pieces have been used since ancient times as trade goods.

Today, ivory carving has been banned to help preserve the elephant population in India, but in centuries past, beautifully crafted ivory pieces could be found in the homes of the wealthy. Among the favourite items produced were jewellery boxes, statuettes of gods, cufflinks, napkin rings, and powder boxes. All manner of jewellery was also crafted from ivory, including earrings, brooches, bracelets and necklaces. Birdcages such as this were common among the better-off in Indian society, and are among the finest and most complicated of all ivory pieces.

REGION

India

MEDIUM

Ivory

RELATED WORKS

Marquesas Islands ivory tiki

Kullu folk painting, c. 1700s

Kullu is an district in the Himachal Pradesh region of India, and it is an ancient seat of kings. This charming painting was created in Kullu in the late eighteenth century. It shows two young Indian girls flying kites. Most Indian art is intrinsically linked with the social, cultural and religious beliefs of the peoples of the region in which it was created. In Kullu, Hinduism, Buddhism and Sikhism are all practised.

Folk paintings in India are characterized by colourful designs, often tinged with mystical beliefs. The Indian epics, including the *Ramayana* and tales about Krishna and the many other deities from these various religions, often provided a source of inspiration for both rural and urban artists. The gods and goddesses are shown in all manner of scenes from these tales, and a variety of techniques were used. This simple painting uses more everyday subject-matter, but the style is typical of Indian art of this region in the eighteenth century.

REGION

India

MEDIUM

Painting on paper

RELATED WORKS

Buffalo hunt pictograph, c. 1800s

Turkish embroidery, c. 1700s

This piece of eighteenth century Turkish embroidery follows a long tradition reaching back to the days of the Ottoman Empire. No examples of fourteenth and fifteenth century embroidery, has survived, but it is known that the women of the court circle created some superb pieces. Even everyday clothing and mundane household items were beautifully embellished. The most artistic work was preserved for the palace furniture such as divan coverings and floor coverings, as well as curtains and cushions. Embroidery was used outside the royal household and even the humblest artisans used embroidered items to make their homes more attractive. Even military campaign tents were decorated with embroidery. The designs have altered over the centuries, with the earlier geometric designs making way for floral patterns. Materials have changed too, and from the sixteenth century the most popular yarn was coloured silk worked into fine linens and cotton. European art began to influence the style at the beginning of the eighteenth century resulting in more floral designs.

REGION

Turkey

MEDIUM

Embroidery

RELATED WORKS

Chilkat blanket

Japanese samurai print, 1795

This eighteenth century Japanese print was made by Toyokuni, one of the foremost exponents of the Utagawa School of Japanese woodblock artists. He was born the son of a puppet maker and learned the art of printmaking as a student of Toyoharu. Toyokuni learned much from the great artists who had pre-dated him and his studies of their various styles culminated in some masterful works of his own. He was renowned for his *ukiyo-e* of beautiful women and of actor portraits associated with the Kabuki theatre. His style of portraying the actors was innovative. As the popularity of his pictures and portraits grew, so did the prestige of the Utagawa School. This attracted many talented students and two of the best known were Kunisada and Kuniyoshi. The picture shows a woodcut print of a Samurai on horseback fording a river. Toyokuni died in 1869, surrounded by many of his devoted pupils.

REGION

Japan

MEDIUM

Woodcut print

RELATED WORKS

Bark paintings

Cobra dance mask, c. late 1700s–early 1800s

Masks have been used in the folk-dances of Sri Lanka for centuries, and this fearsome mask, surmounted by two cobras, in striking positions was used for one of the many different rituals. In common with other peoples, there was a belief that disease and misfortune were caused by demons and these dances were performed to rid the stricken of the malignant spirit. Other dances were thought to appease the gods.

Masks are an essential part of the Sri Lankan type of folk theatre known as Kolam. Although its origins and age are unclear, there are many Kolam texts that dictate the order in which characters appear. In Kolam performances, all the participants are exclusively male and each wears a mask. There are many traditional characters, including kings and queens, soldiers and animals. The masks representing superior demons called Rakshas incorporate cobras as in the illustrated mask. Unfortunately, the art of folk theatre in Sri Lanka is waning in popularity, and these lively performances are now rare.

REGION

Sri Lanka

MEDIUM

Pigment on wood

RELATED WORKS

Japanese Noh mask, 1280

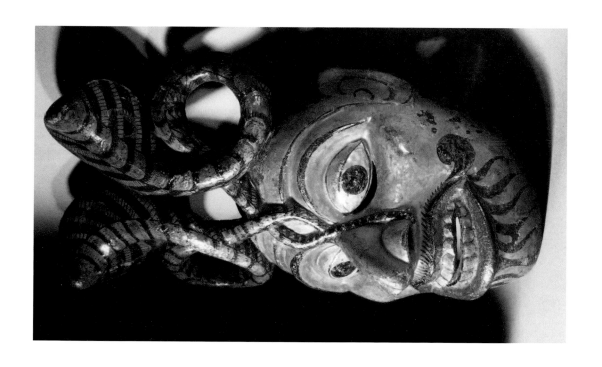

Nicobar scare devil, c. 1800s

This nineteenth-century carving of a Scare Devil was made by the people of the Nicobar islands. This archipelago of 22 islands is situated in the Bay of Bengal, and only 12 of the islands are inhabited.

The Nicobarese have a rich culture and religious belief system that have been isolated from outside influences for thousands of years. Their lives are harmonious with nature, and the chasing away of devils is an important part of their rituals and ceremonies. On Chaura island, the people welcome the south-west monsoons in May with a chicken festival, which begins with the ritual chasing away of the devils and evil spirits who may be hidden about the island. The captured devils are then put aboard a raft and pushed off in the direction of an uninhabited island, where many devils are reputed to live. There is more ritual involving the beating of their bodies to rid them of any devils who may still be clinging to them. This festival lasts for four days.

REGION

Nicobar

MEDIUM

Wood

RELATED WORKS

Totonac Lord of the Dead figure

Hindu shadow puppet, c. 1800s

The origins of the shadow puppet are uncertain but it is widely thought that they originated in India and then spread throughout the region. Indonesia has developed a very distinctive form of puppet theatre called Wayang Kulit. China, Malaysia, Cambodia and Thailand all have their own shadow-puppet traditions, and further afield they are to be found in Turkey and Greece.

Each nation traditionally uses flat figures that have been cut from leather, which has been treated to make it transluscent. The audience sits in front of the screen and the puppets are pressed against it with a strong light behind. The silhouettes created on the screen act out the story or play. This nineteenth-century puppet comes from India, where the shadow-puppet theatre enactment of the *Ramayama*, telling the story of how Prince Rama rescues his beloved wife, Sita from the clutches of the demon Ravana, is the enduring favourite.

REGION

India

MEDIUM

Leather

RELATED WORKS

Hindu wall painting

Congolese carved tusks, c. 1800s

These tusks were ornately carved by Congolese tribesmen during the nineteenth century. African carvings were much sought-after by Victorian visitors who referred to this kind of work as 'Bakongo'. This is the common language of several differently named tribes of the Congo area, and the description refers to the carvings produced by them all. These Europeans had developed a hunger for new and exotic destinations and were the first collectors of souvenirs. The Africans quickly took advantage of this souvenir-hunting and produced prodigious numbers of carvings solely for the trade.

The people of the Congo area began by producing many carvings in wood expressly for these customers and only later turned to 'ivory' carving, but these examples were made at an early period. The figures are carved around the tusks in a spiral fashion and depict scenes from the lives of the tribespeople. The male figures are shown wearing some European clothing, thus preserving their modesty, and the women are shown half-naked, demonstrating that the artists who were generally regarded as 'savages' by the men who paid for their work, well understood their Victorian market.

REGION

Congo

MEDIUM

Ivory

RELATED WORKS

Marquesas Islands ivory tiki

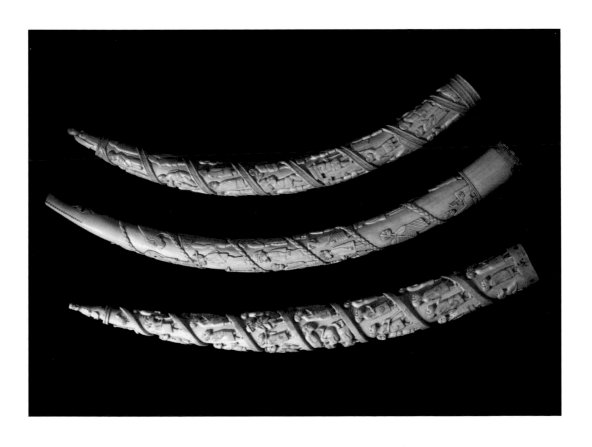

Jamawar shawl, c. 1850s

Shawls are perhaps the best-known of all handicrafts from Kashmir, in the valley of the Himalayas. The word shawl is derived from the Persian 'shal', and these items of clothing have been used for centuries. The Indians wore shawls as shoulder mantles, and the finer the material, the more important the social status of the wearer. This was during the era of the great Mogul Empire, and fine woolen shawls began to be made in Kashmar that surpassed all others.

The first mention of Kashmir shawls dates from the eleventh century, but it is believed that it was only in the fifteenth century that the particular style and quality that become so popular was invented. The ruler of Kashmir, Zein-al-Abidin, ordered the production of these shawls in fine tapestry weaves. Zein-al-Abadin had spent time at the court of Tamerlane the Mongol, and when he returned to take up his throne, he encouraged the finest weavers in the Islamic world to come to Kashmir and create these beautiful items.

REGION

Kashmir

MEDIUM

Cloth

RELATED WORKS

Chilkat blanket

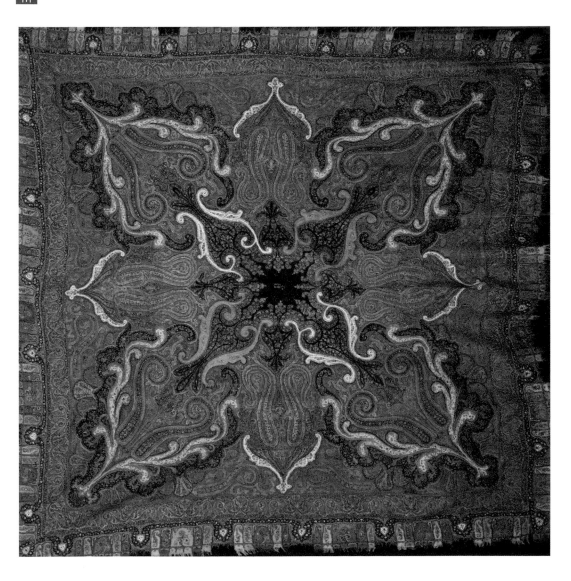

Pounou funerary mask, c. 1800s–1900s

This female funerary mask was used by the Punu people of the upper Ngoume river region of Southwest Gabon. Ceremonial masks of this type are called Okuyi and represent ancestors' faces. They are worn by tribal witch doctors or sorcerers. As they perform their ritual dances they embody the spirits of the ancestors. Sometime the masks are painted black, but the funerary masks are painted white, signifying that the ancestor has passed on to the world of the spirits. This mask is in the typical Punu style, showing the high elaborate hairstyle worn by the women. The diamond shape on the forehead indicates an association with a female ancestor, and the red markings and curved slits representing eyes are common features of the Punu masks. The old beliefs have fallen out of favour in modern times, and these traditional tribal rituals are now often performed as entertainment for tourists, but there are still country dwellers who follow the religions of their ancestors.

REGION

Gabon

MEDIUM

Pigment on wood

RELATED WORKS

Tlingit wooden mask

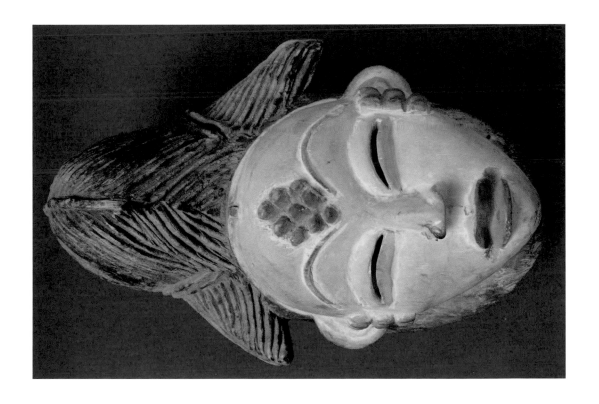

Javanese shadow puppet, c. 1900

Wayang is the Indonesian word for 'puppet' and there are many different kinds of Wayang within the Indonesian island group. Puppetry has long been bound up in the religion of the region, pre-dating Hinduism. These ancient people believed that the spirits of their ancestors could be called upon for assistance, and the puppets were used in religious ceremonies and rituals. They were carved and dressed and manipulated by the use of strings. The old beliefs were supplanted when Hinduism came to Indonesia and the puppet rituals were heavily influenced by the new religion. With the rise of Islam, the representation of God in human form was prohibited, so the Wayang were converted into shadow puppets. They were made from thin leather shapes and displayed only as silhouettes. This was followed by the development of many different regional styles of Wayang. The best-known type of shadow puppets are used in Java and Bali, and are used to tell stories such as the *Ramayana*. These became known as Wayang Kulit.

REGION

Indonesia

MEDIUM

Leather, wood and paint

RELATED WORKS

Hindu shadow puppet, c. 1800s

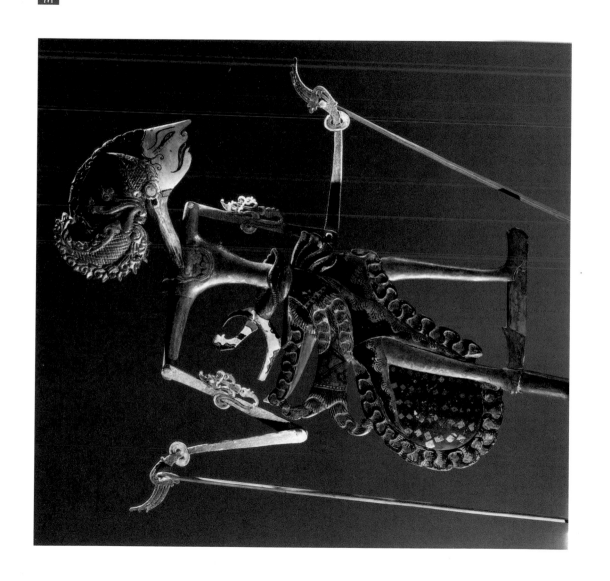

Nigerian Igbo mask, c. 1900s

The Igbo are one of the largest groups in Nigeria, and there are around 15 million of them living mainly in the south-east region of Nigeria today. They were originally settled in a number of autonomous villages, but they managed to derive a united culture and many shared beliefs.

Igbo spirit masks, like this one, were fearsome-looking creations, and came in several different types. The best-known of these are the 'Maiden Spirit' masks. These are used by men at ceremonial occasions, particularly agricultural festivals, and the funerals of prominent men of the village. Often surmounted by elaborate 'hairstyles', these masks are intended to reflect the beauty and purity of deceased Igbo maidens. Spirit masks are often painted white – the colour of the spirit. Lavish headdresses were often included as part of the mask, and usually demonstrated all manner of imagery, combining traditional Igbo beliefs, as well as colonial and folk imagery.

REGION

Nigeria

MEDIUM

Wood

RELATED WORKS

Iroquois mask

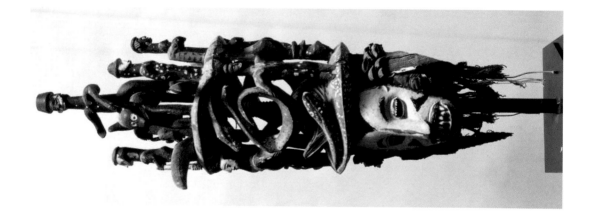

Gunyege mask, c. 1900s

The Dan people inhabited the western part of the Ivory coast and Liberia. The Dan were well known for their striking face masks long before this twentieth-century example was made. The Dan believed that they could connect with ancestral spirits through their masks. The styles varied according to their purpose and the powers invoked depended on the prestige of the wearer. An ancestral mask became more powerful, as it retained the prestige of the original owner in life. Those masks that have been handed down through many generations are considered to be extremely powerful.

The Gunyege mask shown here has large circular eyes and is in the traditional style known as a 'racer' mask; its wearer runs away from pursuers and when he is caught, the 'catcher' takes the mask and becomes the 'racer' himself. This style may not have been used in special ancestor rites, but it could have provided ancestor spirits with a means of participating in the lives of the living.

REGION

Sri Lanka

MEDIUM

Wood

RELATED WORKS

Kaigani Haida face mask, c. 1820

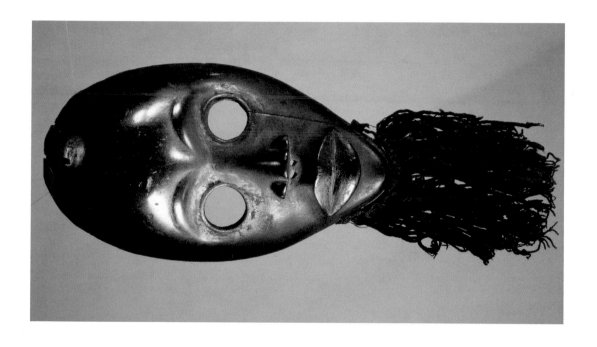

Dayak amulets, c. 1900s

The Dayak are the indigenous people of Borneo. Even today, they are an isolated group, and have maintained their traditional culture, arts and beliefs largely uninfluenced by the outside world. The Dayak truly live as communities, and in each village, a few huge longhouses provide accommodation for the entire village. They have a complex system of shamanistic and animistic beliefs and cults, and headhunting remains a common practice for these warfaring people.

Amulets like these were believed to have special powers of protection, and were used to ward off enemies from other tribes, protect the bearer in times of war, and to bring health and good fortune. Each village would have a shaman, and in times of personal or community illness or distress, he could take a chip of wood from amulets like this, and prepare a remedy from it.

REGION

Borneo

MEDIUM

Wood

RELATED WORKS

Jalisco hollow-ware figures, c. 250 BC–AD 400

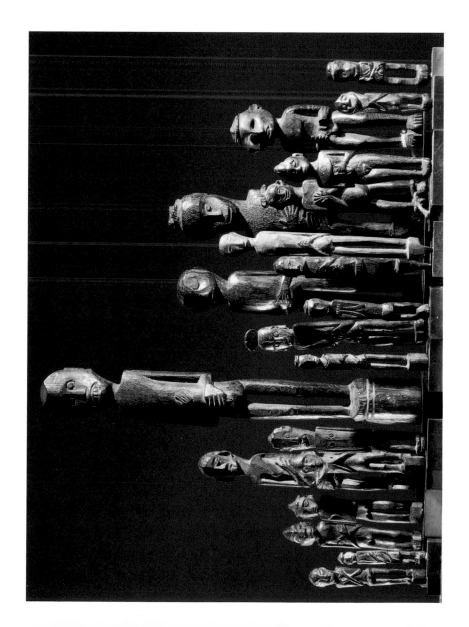

Yaka anthropomorphic mask, c. 1900s

The Yaka inhabit the south-western Democratic Republic of Congo and Angola. Like the Dayak, they have maintained their own distinct cultural identity. Masks like this would have been used for centuries in cultures like this (and indeed in many parts of Africa) for traditional ritual and ceremonial purposes. Carved from wood, and adorned with other media, including raffia, cloth, pigment and reed, this mask would cover the whole head and shoulders of the wearer. It is likely that masks such as this were used at ceremonies like the initiation of young men of the tribe, welcoming them to adulthood. At these festivals, the initiates would dance for the gathered villagers in their newly carved masks. Initiation, which includes circumcision, is one of the most important of the Yaka rites, and is mandatory for all young men. The initiation services and subsequent ceremonies are organized by the two main secret societies – *ngoni* and *yiwilla*.

REGION

Africa

MEDIUM

Wood, cloth, raffia, fibre, pigment and reed

RELATED WORKS

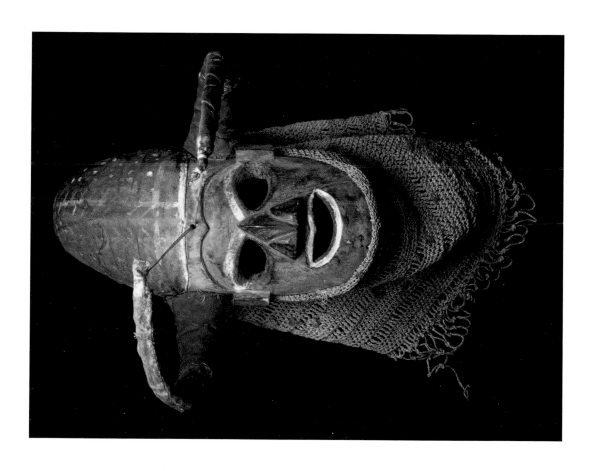

Author Biographies

Susann Linn-William (author)

Susann Linn-Williams has a degree in Cultural Anthropology from George Washington University, Washington, D.C. and an masters degree in Spiritual Psychology from the University of Santa Monica, California. She has worked as a research assistant in the Department of Anthropology at the Smithsonian Institution. Formerly from southern California, where she ran writing and publishing businesses, she now continues to write in Wiltshire, UK. Susann would like to thank writer and artist Anna Newland for her invaluable assistance in compiling this book.

Stephen C. Wehmeyer (foreword)

Stephen C. Wehmeyer is a folklorist and ethnographer specializing in the areas of religion and belief. His diverse scholarly interests include contemporary Iroquois supernatural narratives, the material and ritual arts of the African Diaspora, and the history and development of the American Spiritualist movement. His work has appeared in *Western Folklore*, *New York Folklore*, and *African Arts*, and he has served as a on-camera consultant for numerous television programmes on The Learning Channel, NBC, and HBO. He currently lives with his wife and daughter in the wilds of Los Angeles.

Picture Credits: Prelims and Introductory Matter

Pages 1 & 3: Mica hand ©Werner Forman Archive/Field Museum of Natural History, Chicago

Page 4: Narriri (Worm) Dreaming © Estate of Clifford Possum Tjapaltjarri/Corbally Stourton Contemporary Art, London, UK/Bridgeman Art Library

Page 5 (l to r top): Journey of the Soul bark painting © Private Collection/Bridgeman Art Library; Emu cove painting © TopFoto.co.uk; Snake Dreaming © Turkey Tolson Tjupurrula/Corbally Stourton Contemporary Art, London, UK/Bridgeman Art Library

Page 5 (l to r bottom): Easter Island monolithic statues © Ken Welsh/Bridgeman Art Library; Torres Straits mask © Private Collection, © Heini Schneebeli/Bridgeman Art Library; Maori war-canoe head ©Royal Geographical Society, London, UK/Bridgeman Art Library

Page 6 (l to r top): Kwakiutl revelation mask © American Museum of Natural History, New York, USA/Bridgeman Art Library; Buffalo hunt pictograph © Private Collection, The Stapleton Collection/Bridgeman Art Library; Inuit shaman's mask © Werner Forman Archive/formerly G. Terasaki Collection, New York

Page 6 (l to r bottom): Totonac relief from ball court © Werner Forman Archive; Huari discs © Werner Forman Archive; Mexican Day of the Dead costume (detail) © Mexico City, Mexico, Ken Welsh/Bridgeman Art Library

Page 7 (l to r): Algerian rock painting © Werner Forman Archive/Bardo Museum, Algeria; Turkish Embroidery © Private Collection/Bridgeman Art Library; Viking church carving © Werner Forman Archive/Universitetes Oldsaksamling, Oslo

Page 12: Japanese Noh mask © Werner Forman Archive/Noh Theatre Collection, Kongo School, Kyoto

Page 15: Aztec mask of Xipe Totec © British Museum, London, UK/Bridgeman Art Library

Page 16: Maori Hei-Tiki pendant © Private Collection, © Bonhams, London, UK/Bridgeman Art Library

Page 17: Scandinavian rock painting © Werner Forman Archive

Pages 18-19: Aztec mosaic serpent © TopFoto.co.uk

Further Reading

Bacquart, Jean-Baptiste, *The Tribal Arts of Africa: Surveying Africa's Artistic Geography*, Thames and Hudson Ltd., 2002

Caruana, Wally, *Aboriginal Art (World of Art S.)*, Thames and Hudson Ltd., 2003

Morphy, Howard, *Aboriginal Art (Art & Ideas S.)*, Phaidon Press

Phillips, Tom, *Africa: The Art of a Continent*, Prestel Publishing Ltd 1999

Meyer, Laure *Black Africa: Masks, Sculpture, Jewelry*, Editions Pierre Terrail, 1994

Segy, Ladislas, *Masks of Black Africa*, Dover Publications, 1976

Kleinert, Sylvia, (Ed.), Neale, Margo,(Ed.), *The Oxford Companion to Aboriginal Art and Culture*, OUP Australia and New Zealand, 2001

Gillow, John, *African Textiles: Colour and Creativity Across a Continent*, Thames and Hudson Ltd, 2003

Morphy, Howard, *Aboriginal Art (Art & Ideas S.)*, Phaidon Press, 1998

Quilter, Jeffrey, *Treasures of the Andes: The Glories of Inca and Pre-Columbian South America*, Duncan Baird Publishers, 2005

Young-Sanchez, Margaret, *Tiwanaku: Ancestors of the Inca*, University of Nebraska Press, 2004

Tucker, Jonathan, *The Silk Road: Art and History*, Philip Wilson Publishers Ltd., 2003

Berlo, Janet C., Phillips, Ruth B., *Native North American Art (Oxford History of Art S.)*, Oxford University Press 1998

Swinton, George, *Inuit Art: An Introduction*, Douglas & McIntyre, 2003

Wyatt, Gary, *Mythic Beings: Spirit Art of the Northwest Coast*, University of Washington Press

Macdonald-Taylor, Margaret, (Ed.), *A Dictionary of Marks*, Ebury Press, 1992

Wood, Juliette, *The Celts: Life, Myth and Art*, Duncan Baird Publishers, 2001

Megaw, Ruth, Megaw, Vincent, *Early Celtic Art in Britain and Ireland (Shire Archaeology S.)*, Shire Publications Ltd, 2005

Index by Work

Aboriginal dancing scene 53
Algerian rock painting 313
Aranda churinga 41
Aranda churinga 49
Arapaho Ghost-Dance dress 225
Arapaho war bonnet 219
Arnhem Land figure 45
Athenian amphora 319
Austral Islands Tangaroa 105
Aztec incense burner 277
Aztec mask of Xipe Totec 287
Aztec mosaic serpent 297
Aztec pot 293
Aztec solar disk 295
Aztec statue of earth goddess 279

Barramundi fish painting 29
Bella Coola humanoid mask 177
Buffalo hunt pictograph 187

Caroline Islands statue of Sope 117
Celtic bronze fitting 327
Cherokee Tsalagi pipe tomahawk 163
Chilkat blanket 221
Chippewa owl 217
Churinga 37
Cobra dance mask 357
Cocle plate 275
Congolese carved tusks 363
Cook Islands fisherman's god 89
Cook Islands god staff 87
Creek or Seminole shoulder bag 199
Crow Mother Kachina doll 233
Crow quiver and bowcase 207
Crow war-medicine shield 195
Dayak amulets 375

Dingo Dreaming 69

Easter Island command staff 79
Easter Island monolithic statues 73
Easter Islands ancestral statue 141
Emu cave painting 31

Fiji pillows 95
Fijiula (throwing clubs) 135

Guangala fish earrings 263
Gunyege mask 373

Haida bowl 229
Haida dance rattle 189
Haida eagle clan totem pole 167
Haida feast dish 181
Haida sailor mask 205
Hair ornament 47
Hawaii feather god 77
Hawaiian armlets 119
Hawaiian cluster of god figures 149
Hindu shadow puppet 361
Hindu wall painting 347
Hopewell mica hand 153
Hopi basket 183
Huari discs 271
Huaro church mural 303

Inca jaguar head 291
Inca kero 299
Indian birdcage 349
Inuit hunter statue 171
Inuit shaman's mask 209
Irian Jaya house door panel 97
Irian Jaya painted bark cloth 143

Iroquois false face mask 203
Iroquois mask 179
Iroquois pipe 161

Jalisco hollow-ware figures 245
Jamawar shawl 365
Japanese Noh mask 345
Japanese samurai print 355
Javanese shadow puppet 369
Journey of the Soul bark painting 27

Kaigani Haida face mask 201
Kangaroo bark painting 55
Key Marco cat 155
Korean lacquered baskets 323
Kullu folk painting 351
Kwakiutl revelation mask 175

Lizard and emu bark painting 51

Mali Gwandusu figure 333
Mali terracotta horse 343
Maori Hei-Tiki pendant 115
Maori meeting-house figure 131
Maori moko signature 129
Maori post of rainbow god 75
Maori toiaha staff 123
Maori toboggan 139
Maori war cloak 127
Maori war-canoe head 133
Maori whalebone comb and pendant 113
Marquesas Islands ivory tiki 93
Maya cylindrical vessel 269
Mayan relief panel 281
Mexican Day of the Dead costume (detail) 309

Michoacan lacquered tray 301
Mimi spirit bark painting 61
Mixtec page from Codex Cospi 289
Mochica sacrificer god 257
Mochica square stirrup-spouted vessel 249
Mochica stirrup-spouted portrait jar 251
Mochica vessel 255
Mochica zoomorphic jar 253
Murray River broad shield 35

Narriri (Worm) Dreaming 65
Nasca vase 247
Navajo bracelets 193
Navajo chief's blanket 215
New Britain dance masks 111
New Caledonia mask 83
New Guinea mask 85
New Ireland mask 125
Nicobar scare devil 359
Nigerian Igbo mask 371
Nootka basket 159
Nootka war club 165

Oaxaco Day of the Dead mariachi 307
Ojibway Headdress 237
Olmec colossal head 241
Orokolo mythical ancestor figure 107

Papua New Guinea ancestor board 147
Papua New Guinea chest ornaments 109
Paracas textile (detail) 243
Penobscot powder horn 197
Petroglyph 25
Phoenician glass pendant 321
Phoenician ivory inlay 337
Plains Indians Equipment for Buffalo Hunt 231
Potowatomi spoon 211
Pounou funerary mask 367

Pubic shield 39
Pueblo Kachino dolls 235

Queensland shield 33

Rock art 57
Roman mosaic pavement 331
Roman Neptune Mosaic 325

San Blas Cuna painted bark-cloth 305
Santa Cruz chest ornament 121
Sarmatian diadem 329
Scandinavian rock painting 315
Sinu spiral breast ornament 285
Sioux cradleboards 157
Sioux pipe bowl 213
Sioux pouch 185
Snake Dreaming 63
Solomon Islands canoe house figure 99
Solomon Islands canoe paddles 101
Solomon Islands canoe-prow figureheads 103
Solomon Islands forehead ornament 145
Spirit figures rock art 23
Sumerian hair ornaments 317

Tahiti double-headed figure 81
Tepantitla wall painting 259
Tiahuanaco silver diadem 265
Tlingit robe 227
Tlingit shaman's rattle 191
Tlingit soul catcher 169
Tlingit wooden mask 173
Toltec mosaic disc 283
Torres Straits crocodile mask 137
Torres Straits mask 91
Totonac Lord of the Dead figure 273
Totonac relief from ball court 267
Totonac stele 261

Turkish embroidery 353
Turtle rock art 59

Vendel brooch 335
Viking church carving 341
Viking figure 339

Wampum belt 223
Western Kimberley pendant 43
Witchetty Grub and Snake Dreaming 67

Yaka anthropomorphic orphic mask 377

General Index

Aitutaki, Polynesia 86
Algeria 312, 324
Algonquian 162, 236
alpacas 252, 254
amphora 318
amulets 374
ancestor boards 106, 146
ancestors 22, 24, 36, 40, 44, 62, 66, 72, 80, 96, 98, 106, 120, 124, 140, 146, 176, 182, 214, 232, 234, 306, 366
Andes 246, 250, 252, 262, 298
animal hides 52, 186, 194, 198, 206, 224, 288
Aranda 40, 48
Arapaho 224
Arawa 126
Ardagh Chalice 326
Arnhem Land, Australia 44, 54
Austral Islands 104
owls 216
Aztecs 260, 276, 278, 286, 288, 292, 294, 296

bags 60, 198, 248
Barak, William 52
bark painting 26, 50, 52, 54, 60
basketry 182, 254
beads 198, 206
Bell, Archibald 30
Bella Coola 176
Bible, The 336
birdcages 348
birds 76, 78, 136, 174, 212, 274
black magic 80, 110, 190
blankets 220, 226

Bolivia 270
Borneo 374
bowls 134, 210, 216, 228, 250
Brancusi, Constantin 116
British Columbia 158 174
bronze 326
buffalo 186, 194, 206, 230
Burrungui 22

Caesar, Julius 330
Calendar Stone 294
Calusa 154
Canada 152, 170, 226
canoes 88, 98, 100, 102, 130, 132, 136, 146, 158, 166
canoe prow ornaments 98, 102
canvas 64, 230
Capac, Huayana 298
Caroline Islands 116
Carthage 320, 324
Celtic art 320, 326
ceremonies 36, 42, 52, 62, 78, 82, 84, 90, 106, 110, 120, 124, 142, 160, 164, 166, 174, 176, 180, 188, 200, 202, 212, 218, 230, 232, 248, 294, 366, 376
charcoal 42, 50, 142
Chaura Island 358
Chavin 242
Cherokee 152, 162
chest ornaments 108, 120, 144, 256, 282, 284, 296
Chickasaw 152
Chicomecoatl 292
chiefs 72, 78, 82, 92, 94, 122, 130, 132, 158, 220, 222, 284

Chilkat 223
Chippewa 216
Choctaw 152
Christianity 90, 298, 338
churingas 36, 40, 48
circumcision 44, 136, 376
clay 142, 146, 212 272
clothing 196, 206, 250
clubs 78, 112, 134, 164, 170
Coatlicue 260, 278, 296
Cochin, India 346
Cocle 274
codices 288
Collier, Captain W. O. 154
Columbus, Christopher 160
Confucius 322
Congo 362
Cook Islands 86, 88
Cook, Captain James 86
copper 256, 316
Cortez, Hernán 260
cradleboards 156
Creek 152, 198
crocodiles 136, 274
Crow 94, 206
Crow Mother 232
Cuna 304
Cushing, Frank Hamilton 154

Dan 372
dance 46, 52, 84, 110, 118, 120, 138, 140, 176, 178, 188, 220, 232, 306
Darwin, Australia 26
Dayak 376
diadems 264, 328

dingoes 66, 68
disease 204, 220, 256, 298
Djenne 342
dot paintings 62
dragons 228, 252
Dreamtime (Dreaming) 24, 26, 34, 36, 44, 46, 56, 62, 64, 66, 68
eagles 164, 166, 172, 218, 288, 292
ear spools 270, 286
earrings 260, 316
Easter Island 72, 78, 140
Ecuador 262
embroidery 198, 352
Emu Cove, Australia 30
emus 30, 38, 50
Escalante, Tadeo 302
eucalyptus tree 32, 50
Europeans 52, 54, 56, 64, 132, 160, 186, 194, 196, 198, 204, 210, 214, 216, 222, 224, 228, 362
Fafnir 340
False Face 178, 202
feathers 84, 100, 108, 126, 132, 140, 162, 178, 194, 218, 282
Fiji 94, 134
fish 28, 38, 78, 116, 120, 136, 170, 262
fishing 88, 98, 154, 164
frigate bird 120, 142
frogs 172
Gahadaka gagosa 208
Garramantes 312

Ghost Dance 224
gold 250, 256, 262, 270, 284, 298, 316, 326
Guangala 262
Gwandusu 332

Haasts Bluff, Australia 66
Haida 166, 180, 188, 200, 204, 228
hair ornaments 46, 108
Hanging Gardens of Babylon 336
Hasaw Chan K'awiil 280
Hawaii 76, 80, 118, 148
headdresses 82, 136, 218, 248, 250, 264, 282, 316
headhunting 96, 98, 100, 374
Hei-Tiki 114
Hinduism 346
Hopewell 152
Hopi 182
horses 186, 192, 194, 230
Huari 270
Huitzilopochtli 294
hula 118
hummingbird 246, 252, 294
hunting 34, 66, 152, 158, 170, 210, 290

Igbo 370
Illinois, USA 160
Incas 270, 290, 298
incense burner 276
Indonesia 360
initiation 44, 84, 106, 376
Inuit 170, 208
Iraq 314
Irian Jaya 96, 142
Iroquois 160, 178, 202
Ivo 106
ivory 92, 336

jaguars 240, 258, 274, 290
Jalisco, Mexico 244
Japan 344, 354
Java 368
jewellery 84, 192, 282, 284, 316, 326

Kachinas 232, 234
Kai Tahu 128
Kakadu National Park, Australia 22, 56, 58
Kalakaua, King David 118
kangaroos 30, 68
Kashmir 364
Kentucky, USA 162
Kills Two 230
Kimberley, Australia 42
Kiwirrkura 62
Korea 322
Korowai 96
Krishna 350
Kukalimoku 76, 148
Kullu, India 350
Kuniyoshi 354
Kwakiutl 174

lapis lazuli 270, 316
leather 156, 184, 216, 368
Lebanon 320
Lenin Lenape 222
Leura, Tim 68
Lion of Nimrud 336
lizards 50, 128
llamas 252, 254

maces 248
maize 152, 260, 276, 292, 298
Malaita Island 144
Mali 342

Maori 74, 80, 86, 112, 114, 122, 126, 128, 130, 132, 138
Marco Island, USA 154
Marquesas Islands 92
masks 82, 84, 90, 110, 124, 136, 154, 172, 174, 176, 178, 190, 200, 204, 208, 256, 262, 286, 356, 370, 372
Maya 268, 280, 288
Mesopotamia 314
Mexican Day of the Dead 306, 308
Mexico 192, 240, 244, 258, 260, 272, 282, 288, 294, 300
mica 152
Michoacan 244
Mictlan 272
Mictlantecuhtli 272
Minica 96
Mixtec 288, 296
Mjollnit 338
Mo'o 128
Mochica 248, 250, 252, 254, 256
Mogul Empire 364
Mohawk 160, 178
moko 128, 138
Montezuma 260
Mootzka, Waldo 234
Morrisseau, Norval 236
mosaics 324, 330
munga munga 46
Murray River, Australia 34
mythology 24, 76, 112, 114, 128, 166, 174, 184, 228, 296, 324, 346

Nahuatl 296
Najombolmi 56
Namandjolg 56
Nammarkun 56

Narriri 68
Nasca 246
Navajo 192, 214
Ngarit 244
Neptune 324
New Britain 110
New Caledonia 82
New Guinea 84, 90, 96, 124, 142
New Ireland 124
New South Wales, Australia 24, 26
Ngaiterangi 126
Ngarrindjeri 34
Ngati Kaipoho 130
Nigeria 370
Noh masks 344
Nootka 158, 164, 174
Nourlangie Rock, Australia 22, 28, 58

ochre 42, 50, 132, 146
Odin 338
Ojibwa 216, 236
Olmec 240, 266
Oneida 160, 178
Oro 80, 86
Ottoman Empire 352

Papua New Guinea 106, 108, 146
Paracas 242
pearlshells 42, 98, 102, 144, 270
pendants 42, 112, 114, 144, 256, 270, 320
Pennsylvania, USA 222
Penobscot 196
Peru 242, 246, 248, 254, 256, 270
petroglyphs 24, 140
Phoenicians 320
pigment 50, 54, 186, 250, 300, 312, 314

Pintupi 62, 64, 66, 68
pipes 160, 162, 184, 212
Pizarro, Francisco 298
platinum 262
Polynesia 76, 80, 86, 104, 116, 148
Potlach 166, 180, 220, 226
Potowatami 210
Pounou 366
powder horns 196
Prado, Diego de 136
Pu-Abi, Queen 316
pubic shield 38
Pueblo 182, 234
Queensland, Australia 32
Quetzalcoatl 260, 296
quillwork 156, 184

Raharu hi Rukupo 130
Rama 346, 360
Ramayana 346, 350, 360, 368
Rano Raraku 72
Rarotonga, Cook Islands 88
rattles 188, 190
Rau-Hiva-Aringa Erua 78
Rouparoha 132
Ravana 346, 360
Raven 172, 226
rituals 42, 44, 62, 106, 118,
208, 212, 226, 232, 262,
286, 332, 376
rock paintings 22, 28, 30, 54, 56,
58
Roman Empire 330
salmon 164, 180
Sarmatia 328
Scandinavia 314, 338
score devil 358
Seminole 198

Seneca 160, 178
shadow puppets 360, 368
Shagodyowehgowah 202
shamans 160, 188, 190, 202,
208, 230, 252, 274, 290, 374
sharks 80, 120, 146
shawls 364
shields 32, 34, 96, 194, 326
ship burials 334
Sigurd 340
silver 192, 250, 256, 262, 270, 316
Sinu 284
Sioux 156, 184, 212
Sita 346, 360
snakes 38, 314
soapstone 146, 170
Solomon Islands 98, 100, 102,
120, 144
Sope 116
sorcerery 80, 96, 276
soul catchers 168
Spanish Conquest 264
spirits 58, 60, 80, 90, 96, 106, 110,
128, 140, 168, 194, 202, 230
spoons 210, 216
Sri Lanka 356
staffs 78, 86, 122
Stave churches 340
stelae 240, 280
Sumeria 316
Sweden 314, 334

Tahiti 80, 104
Tangaroa 86, 104, 112
Tonga 126
Tara brooch 326
Taringa-Nui 88
Tasmania, Australia 26
tattoos 78, 88, 108, 116, 128,

130, 138, 250, 262
Te Hau-Ki-Turanga meeting
house 74, 130
Teotihuacan 258, 276, 278
Tepontitla 258
Tezcatlipoca 276
Thor 338
Thunderbirds 184
Tiahuanaco 264, 270
Tikal, Guatemala 260
Tiki 88, 92, 104
Timarri 66
Tippaltjarr, Clifford Possum 64, 68
Tippaltjarr, Goodwin Kingsley 66
Tjupurrula, Turkey Tolson 62
Tjungga 66
Tlaloc 258, 292
Tlalocan 258
Tlazolteotl 278
Tlingit 168, 172, 150, 226
tobacco 90, 160, 184, 198, 212
Toltec 260, 282
tomahawks 162
tools 114, 140
Torres Strcits 90, 136
tortoiseshell 90, 102
totems 44, 48, 62, 110, 136, 164,
166, 226, 252
Totonac 260, 266, 272
Toyokuni 354
trading 42, 162, 220, 222
Tree of Life 302, 328
tridacna shell 144
Tuhawaiko 128
Tula 282
Tunghak 208
Turkey 352
turquoise 192, 282
turtles 58, 90

Uenukutuwhata 74
Ukaipi 106
Undargo, Australia 66
vases 246
Vendel period 334
vesi tree 94
Victoria, Australia 26
Viking art 338, 340
Viracocha 264
Virginia, USA 162
Vistula River 328
Waikato 74
wallabies 22, 60, 66
wampum 180, 222
warfare 72, 74, 76, 78, 110, 120,
126, 130, 134, 196, 248
Warpiri 30
weapons 114, 122, 134, 154,
164, 244, 316, 326, 334
weaving 126, 214, 254
whales 158, 164
witchety grub 66
wool 220, 226, 254
Woolley, Sir Leonard 316
Wurundjer 52
Xiucoatl 296
X-ray paintings 28, 54, 96
Yoka 376
Yax Ch'oktek 280
Yeks 208
Yellow Calf 218
Zapotec 288
Zein-al-Abidin 364
zoomorphic creatures 78, 252